MACKINTOSH WATERCOLOURS

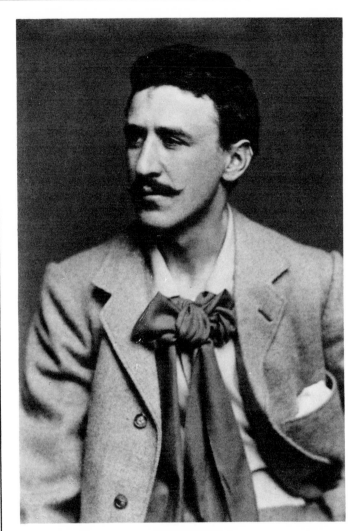

CHARLES RENNIE MACKINTOSH
1868–1928

Roger Billcliffe

MACKINTOSH
WATERCOLOURS

John Murray

Designed by Ian Cameron
House Editor: Elizabeth Kingsley-Rowe

Produced by Carter Nash Cameron Ltd, 25 Lloyd Baker Street, London WC1X 9AT.
Setting by SX Composing Ltd, 22 Sirdar Road, Weir Industrial Estate, Rayleigh, Essex.
Printed by de Lange/van Leer b.v., Deventer, Holland.
Printed in Holland.

Paperback edition first published 1979.
Reprinted 1981
0 7195 3678 2

Pictures are reproduced with the permission of their owners, who are credited in the captions. Photographs of untraced pictures from the Memorial Exhibition of 1933 are by T. & R. Annan & Sons Ltd.

In memory of Andrew McLaren Young

Contents

PREFACE 7

MACKINTOSH AS A WATERCOLOURIST 9

NOTES, ABBREVIATIONS & BIBLIOGRAPHY 22

CATALOGUE 24

INDEX OF PICTURES 48

PLATES 49

(All pictures listed below are by Charles Rennie
Mackintosh except those marked MM, Margaret
Macdonald, or FM, Frances Macdonald.)

An Antique Relief	49	Scabious and Toadflax, Blakeney	75
Tomb, Elgin	50	Tobacco Flower, Bowling	75
The Baptistry, Siena Cathedral	51	The Shadow	76
Campanile Martorana, Palermo	52	In Fairyland	77
The Palazzo Pubblico, Siena	52	Tacsonia, Cintra, Portugal	78
Palazzo Ca d'Oro , Venice	53	Japonica, Chiddingstone	79
Church Tower	53	Faded Roses	80
Orvieto Cathedral; Part of the		At the Edge of the Wood	81
North Façade	54	Borage, Walberswick	82
Cloisters, Monreale	55	Cactus Flower, Walberswick	83
The Lido, Venice	56	Centaurea, Withyham	84
Cabbages in an Orchard	57	Spurge, Withyham	84
The Harvest Moon	58	Cuckoo Flower, Chiddingstone	84
The Descent of Night	59	Cowslip, Chiddingstone	84
The Fountain (MM or FM)	60	Bugloss, Holy Island	85
Stylised Plant Form	61	Leycesteria, Walberswick	85
Summer (MM)	62	Sorrel, Walberswick	85
Ill Omen (FM)	63	Chicory, Walberswick	85
Winter	64	Gorse, Walberswick	86
Porlock Weir	65	Anemone and Pasque, Walberswick	87
Wareham	65	Aubrietia, Walberswick	88
Summer (MM)	66	Larkspur, Walberswick	88
Spring (FM)	66	Green Hellebore, Walberswick	88
Autumn (FM)	67	Pine Cone and Needles, Walberswick	88
Winter (MM)	67	Pine, Walberswick	89
The Tree of Personal Effort	68	Venetian Palace, Blackshore	
The Tree of Influence	69	on the Blyth	90
Reflections	70	Palm Grove Shadows	91
Fairies	70	A Palace of Timber	92
The Sleeping Princess (FM)	70	Walberswick	93
Part Seen, Imagined Part	71	Anemones	94
Ophelia (FM)	72	Begonias	95
The Wassail	73	Fritillaria, Walberswick	96
Sea Pink, Holy Island	74	Veronica, Walberswick	96
Pimpernel, Holy Island	74	Iris Seed, Walberswick	96
Yellow Clover, Holy Island	74	Rosemary, Walberswick	97
Hound's Tongue, Holy Island	74	White Tulips	98
Woody Nightshade, St Mary's Scilly	75	Peonies	99
Ivy Geranium, St Mary's, Scilly	75	White Roses	99
		The Choice (FM)	100
		'Tis a long path which wanders	
		to desire (FM)	101
		Yellow Tulips	102

The Grey Iris 103
The Mysterious Garden (MM) 104
The Child (MM) 104
The Pool of Silence (MM) 105
Collioure, Pyrénées Orientales—
 Summer Palace of the Queens of
 Aragon 106
A Southern Farm 107
A Basket of Flowers 108
Pinks 109
A Southern Town 110
Blanc Antoine 111
Ships 112
Fetges 113
The Village, Worth Matravers 114
The Downs, Worth Matravers 115
A Hill Town in Southern France 116
The Fort 117
Mimosa, Amélie-les-Bains 118
Fig Leaf, Chelsea 119
Mont Alba 120
Port Vendres 121
A Spanish Farm 122
Port Vendres, La Ville 123
Summer in the South 124
Héré de Mallet, Ille-sur-Têt 125
The Boulders 126
A Southern Port 127
Mont Louis—Flower Study 128
The Poor Man's Village 129
Mountain Village 129
The Village of La Lagonne 130
Slate Roofs 131
Village in the Mountains 132
Mountain Landscape 133
The Church of La Lagonne 133
Palalda, Pyrénées-Orientales 134
Boultenère 135
Steamer at the Quayside 136
Man Unloading a Steamer at the
 Quayside 136
Steamer Moored at the Quayside, with
 two Gendarmes Standing on the Quay 137
La Rue du Soleil, Port Vendres 138
Port Vendres 138
The Little Bay, Port Vendres 139
The Road through the Rocks 140
Le Fort Mauresque 141
Le Fort Maillert 142
The Rocks 143
Mixed Flowers, Mont Louis 144

Preface

Although I had long been interested in the architectural work of Charles Rennie Mackintosh, it was not until I saw Andrew McLaren Young's Centenary Exhibition of Mackintosh's work in 1968 that I became aware of the wide range of his talents as a watercolourist. The following year I joined Andrew's staff at the University of Glasgow and began to see at first hand that the works he had been able to include in the exhibition were only the tip of the iceberg. Together we planned a series of illustrated books on Mackintosh, as well as an annotated edition of the lectures housed at Glasgow University, but Andrew's untimely death in February 1975 meant that the project was never fulfilled as he envisaged it. The only one of the series to get as far as publication was my short book on Mackintosh's architectural sketch books, published in 1977

Shortly after Andrew's death in 1975, Ian Cameron asked me to write a book outlining the whole of the Glasgow phenomenon in the decorative arts of the period 1890–1914. This was eventually narrowed in scope, but greatly enlarged in scale, to a *catalogue raisonné* of Mackintosh's furniture and interiors. The work on Mackintosh's watercolours, prepared for the Glasgow Style book, was put on one side, but I returned to it after leaving the University for Glasgow Art Gallery, where I was able to plan a large-scale exhibition of Mackintosh's watercolours for 1978 to mark the fiftieth anniversary of his death. Again, Ian Cameron suggested that we produce a companion volume to the furniture catalogue, which will be published later this year, detailing not only those drawings to be included in the exhibition, but all of Mackintosh's known watercolours. The idea was readily taken up by Duncan McAra at John Murray, who had been interested in such a project for some time.

That is the genesis of the present volume, which lists all those watercolours I have been able to trace during the last eight years I have spent in Glasgow. I hesitate to claim that it is absolutely complete, for I feel that there are almost certainly other works which were never documented and which may still come to light, particularly flower drawings, watercolours from the Italian tour or Mackintosh's 'symbolist' period of c1893–97. However, it seemed best to publish now those I had traced, rather than wait five years or more to be able to include two or three extra works. To those for whom completeness is paramount, may I say that this should be treated as a checklist of work in progress—perhaps its publication will bring forth a clutch of unrecorded works which otherwise would never have come to light. At the very least, I hope it will enlighten, please and even surprise all those interested in Mackintosh, not only as an architect, but as a painter as well. For too long, his watercolours have been relegated to a secondary place in the general assessment of his work. As long ago as 1952, Thomas Howarth recognised their importance, but was prevented by his particular terms of reference from giving them more than a token account; and McLaren Young's catalogue contained too few illustrations to provide a lasting reminder of the impact of his exhibition.

The works are arranged in chronological order, with a small supplement of watercolours by Frances and Margaret Macdonald included in the 1978 exhibition as comparative material. I have not dealt with watercolours which are in fact designs for interior decorations or furniture. Thus the scale drawings for the Buchanan Street Tea Rooms (collection: Glasgow University) are excluded, although the watercolour drawings which inspired them and the gesso panels at the Ingram Street Tea Rooms are included. Nor have I included the occasional pencil sketch with tiny dabs of wash.

Without the goodwill and generous assistance of a great many people, this book would never have been completed in its present form. Andrew McLaren Young had encouraged my work on Herbert MacNair before I went to work with him. After I moved to the University, he was generous with the knowledge he had accumulated while preparing the Centenary Exhibition. My own interests in Mackintosh, in his furniture and the later watercolours, were not Andrew's, and I hope we both learned something from our disagreements over the relative values of our own favourite aspects of Mackintosh's oeuvre. Our disputes were always friendly, and his kindness, generosity and friendship will always be remembered.

Many other people had a more direct role in the production of this book and the exhibition. The Director of Glasgow Art Gallery, Trevor Walden, enthusiastically encouraged the project, as did Andrew McIntosh Patrick of The Fine Art Society in showing the exhibition at the Society's Galleries in Edinburgh and London; also most helpful in making arrangements to show the exhibition in their respective galleries were John Morley and Duncan Simpson at Brighton Art Gallery and Museum, and James Boyd and Gerald Deslandes at Dundee Art Gallery. All the owners, both past and present, of Mackintosh's work freely gave me access to their collections, and many have kindly lent their pictures to the 1978 exhibition; I am especially grateful to Her Majesty Queen Elizabeth, The Queen Mother for the loan of a hitherto little-known late work by Margaret Macdonald (and to Alan Irvine who helped solve a mysterious reference to it in the Glasgow University Mackintosh Collection). It would be invidious to single out any other lenders by name (and many wish to remain anonymous) and so my sincere thanks go equally to them all. The small group of people who knew Mackintosh, or whose interest in his work goes back long before his popular acclaim, have all been extremely kind in answering my questions and commenting on my theories: Mrs Alison Walker and Mrs Ruth Hedderwick (both née Blackie), Mrs Mary Newbery Sturrock, Thomas Howarth, James Meldrum, George Smith, Allan Ure, Michael and Winifred Davidson (the descendants of William Davidson), and Harry Jefferson Barnes, who, as Director of the Glasgow School of Art, uncomplainingly accepted my pillaging of the Art School's collection and its records, an enterprise which was made possible by the ever courteous help of his assistant, Drew Perry; so also did Frank Willett, Director of the Hunterian Museum and Art Gallery, and Chris Allan, Assistant Keeper in charge of the University of Glasgow art collections. Many other people have contributed directly or indirectly to my researches and I am grateful to them all. I hope they will forgive me if I single out only one of them for special mention: Kathy Jordan of the Art Gallery of Ontario, who, with the permission of Professor Howarth, very kindly catalogued his collection for me, a task which I despaired of ever being able to complete myself. I need not have worried, for Kathy Jordan's notes are as helpful, and certainly more legible, than any I have taken myself. For deciphering my manuscript I am most grateful to June Barrie, Valerie Ford and Irene Taylor; for some splendid colour transparencies I am indebted to Raymond G. Fulton, and many of the black and white photographs were taken by Robert Cowper. That my manuscript was ever finished at all, however, is due to the encouragement of my wife, Bronwen: without her patience and assistance over the last two years, when every spare moment seemed to have been claimed either by Mackintosh's furniture or his watercolours, I doubt whether either project would have been completed.

Roger Billcliffe
Glasgow, January 1978.

Mackintosh as a Watercolourist

Howarth, p. 11.

Elizabeth Bird, 'Ghouls and Gaspipes', Scottish Art Review, XIV, 4, 1975, pp. 13–16.

In 1891, Charles Rennie Mackintosh showed a few pictures at an exhibition of student work at the Glasgow School of Art. They were watercolours he had made while on a tour of Italy earlier in the year and were virtually his first attempts in the medium. They won first prize, and one of the assessors, Sir James Guthrie, when told that the winner was an architectural student, exclaimed, 'But hang it, Newbery, this man ought to be an artist!' Fra Newbery, the director of the School, possibly agreed, but he was to become a major supporter of Mackintosh's work as an architect. Four years later, the watercolours of Mackintosh and his friends were described as unintelligible by his fellow students, and his posters were received by the public with a mixture of incredulity and disgust. His architecture and furniture all too often met with a similar reception and, twenty-five years later, Mackintosh gave up architecture to return to watercolour painting. He rarely showed his later work, saving it for a revelatory London exhibition, but died in 1928 before realising this ambition. In 1933, in Glasgow, city of his birth and early career, an exhibition was arranged of many of the later watercolours—almost all were sold, albeit at prices as low as £10 to £25.

Mackintosh would never have agreed with Guthrie's simple division of students into painters, sculptors, potters, or architects. He would have been dismayed by the way his architectural work has been allowed to overshadow his painting. Too many critics and scholars have relegated Mackintosh's graphic work to a distinctly second place in his oeuvre, seeing the avant-garde only in his architecture. Mackintosh could not divide his personality or his talents in this way; indeed his success and originality as an architect and designer are dependent upon his artistic response to formal problems. His whole architectural and design vocabulary is based upon his reaction as an artist to nature, and his skills in recording nature are second only to his ingenuity in adapting natural forms to new purposes. He could not separate art from architecture; in fact he believed that this unnatural divorce was the underlying cause of so much that was bad or unoriginal in the work of very many architects and craftsmen of his day. While this belief was popular among the avant-garde architects of the 1890s, Mackintosh was unrivalled in his ability to excel in both painting and architecture. Who else among his contemporaries produced such symbolist paintings while planning a building which was to become a milestone in the development of twentieth-century architecture? Who else, after a brief but dynamic career as architect and designer, turned to painting at the age of fifty and developed a new vocabulary in a totally different medium?

Mackintosh's training as an architect, involving his attendance at art school courses in all the branches of the arts, would have fostered his natural ability as a draughtsman. His early sketches, somewhat wooden and stereotyped, nevertheless show that he was prepared to look and draw. He was never without a pencil and sketch-book, especially in later life when the pressures of an architectural practice prevented him from spending as much time with his colour-box as he would have liked. But in the later 1880s, Mackintosh hardly ever used colour on his drawings. They were an architect's notes: details of buildings drawn as fine examples of vernacular architecture, or, increasingly, because they illustrated a feature which he wanted to use in his own designs. His art school classes probably introduced him to colour, as they introduced him to metal and glass, ceramics and fabric, for he would have been expected to attend classes in all these subjects. Watercolour, after pencil, was

the obvious medium for a man who made his sketches travelling around from village church to ruined monastery, but it was used only to highlight or pick out detail, and rarely as an end in itself.

His first use of watercolour outside these descriptive drawings is his *Glasgow Cathedral at Sunset* (catalogue 13) of 1890. The Cathedral was close to his home in Dennistoun, and Mackintosh would have spent quite a lot of time in the graveyard, the Glasgow Necropolis, from where this particular view of the Cathedral was painted. The Necropolis is an incredible concoction of structures, with tombs and monuments in almost every architectural style imaginable (Mackintosh even seems to have designed a Celtic headstone for the Necropolis as early as 1888). The Cathedral is seen quite differently from his early sketches of it in 1887–89; it has been carefully drawn, the perspective ensured by use of a ruler, but the finished work is more than a coloured pencil drawing. The mood of this eerie cemetery, with the huge bulk of the Cathedral behind it, is caught by the artist as a haven of somewhat disquieting peace in a busy and sordid area of a great city. All this is achieved through colour, and we are to meet the same colours and tones throughout Mackintosh's work in the 1890s: bright blue, rich browns, orange and acid greens set against brilliant red.

Memorial to Chief Constable McCall, who died in 1888. The commission almost certainly came via Mackintosh's father who was a Superintendent in the Glasgow police.

The Italian watercolours, so praised by Guthrie in 1891, follow this broad pattern; some of them are little more than coloured *aides-mémoire*, others use colour intelligently to convey a vivid impression of the polychromy of Italian architecture, while two or three attempt to capture the atmosphere of strange and wonderful cities which Mackintosh might never have expected to see. He travelled around Italy on a scholarship won in 1890 for the design of a public hall. (This first visit to Europe was not to be repeated until 1900 when he and his wife, Margaret Macdonald, were invited to Vienna by the Secession.) He drew everything which caught his eye, making careful notes in his diary. The sketches, although often very pretty, show no great advance upon his earlier work in content, but his technique has become more fluid and assured. He even begins to display an awareness of style, as in the watercolour *The Lido, Venice* (catalogue 28, illustrated on pp. 56–57) for instance; this work has affinities with Whistler which are reinforced by Mackintosh's choice of a Whistler moulding for the frame.

All these early works are straightforward and competent pieces of draughtsmanship, but none shows any element of imagination or invention. Yet the following year Mackintosh was to begin the first of a series of watercolours in which he invented a whole new world which almost defies description, let alone analysis. He devised an unearthly landscape, populated with strange, languid figures, winged human forms and distinctly evil-looking plants. Most of these strange drawings were contained in a quarterly handwritten periodical which was passed around the students of the Glasgow School of Art. The first issue of The Magazine (November 1893) contains no works by Mackintosh and does not mention his name in the text. It does, however, include a bookplate by Frances Macdonald (1874–1921) and a preview of a forthcoming exhibition which was to include work by both Frances and her elder sister, Margaret (1865–1933). Mackintosh must have known of the two sisters by this time, if for no other reason than that they designed the invitation card for the School of Art Club 'At Home' of 25 November 1893. Howarth suggests how Mackintosh, his friend Herbert Mac-Nair (1868–1955) and the Macdonald sisters came together, to be called by their friends The Four. It could well be that the School of Art Club show in the autumn of 1893 was the first time they exhibited together, but as no catalogues survive of any of the shows, it is impossible to know what Mackintosh or any of the others

Howarth, p. 25.

exhibited. Sadly, virtually the only surviving works of the period 1892–96 are those contained in copies of The Magazine. Was all of Mackintosh's pictorial output for this period in a similar vein; did he produce many such watercolours which were not included in The Magazine, for none was exhibited outside the school—at the Glasgow Institute, for instance—between 1892 and 1897? One sole surviving drawing suggests that other similar watercolours were made and helps to provide a link between the work of 1891 and the symbolist watercolours of the mid-1890s.

The Harvest Moon (37, 58) was painted in 1892 and given two years later to John Keppie, brother of Mackintosh's close friend, Jessie Keppie, and a friend and partner in the firm in which Mackintosh was working. It is distinctly different from the Italian drawings, being stronger in colour, larger, and not simply a topographical drawing. The winged figure, hovering over a nocturnal landscape, is like nothing seen so far in Mackintosh's work. This is the first of a series of watercolours to depend upon the imagination, but, unlike the later drawings, The Harvest Moon is firmly based on reality. The figure is well and carefully drawn, showing that awareness of Michelangelo which is apparent in Mackintosh's card for a Glasgow School of Art Club meeting of November 1892. The viewpoint, from below and through a thicket of branches and leaves, suggests an unearthly setting, a feeling enhanced by the way the figure seems to stand on a cloud with the moon behind her encircled by her wings. The picture has all the features of an incipient Art Nouveau work, with its bright colour, the arabesques of dress and hair, and the mysterious subject matter. But the picture, compared to works from 1893 to 1895, is relatively straightforward and its subject is easily identified. Not so with the watercolours for The Magazine. The basis of the symbolist watercolours produced by The Four has been frequently identified. The work of the Pre-Raphaelites, particularly Rossetti and Burne-Jones, Toorop, Beardsley and Carlos Schwabe was known in Glasgow, but the last three all made their impact early in 1893. Newbery owned a copy of Zola's 'Le Rêve', with illustrations by Schwabe (published in December 1892), and Beardsley and Toorop were both illustrated in the first issue of The Studio in April 1893. The Four were, no doubt, also strongly influenced by a group of artists much nearer home even than Beardsley. The works of the artists known as The Glasgow Boys would have been well known to them, especially as Fra Newbery was a keen supporter of their work. Two artists in the group in particular, George Henry and E. A. Hornel, must have made a substantial impact upon the more receptive students at the School of Art. Hornel's Brownie of Blednoch of 1889 (collection: Glasgow Art Gallery) took its subject matter from ancient Galloway legend and The Four were later to create for some of their own works similar creatures from mythical worlds; but their particular iconography, if it was not of their own invention, has never been satisfactorily identified. Two works, painted jointly by Henry and Hornel, would have been of direct relevance to The Four: The Druids of 1890, and Star in the East of 1891 (both collection: Glasgow Art Gallery). The subject matter and its emphasis upon mysticism (albeit religious, in these two works) and the deliberate use of pattern in the composition—in particular tooled gesso and gold paint—would certainly have caught the attention of the young designers, especially the Macdonald sisters. Yet the work of The Four was not straightforwardly plagiaristic, for it synthesised all of these sources and developed a style peculiarly its own.

The Glasgow Style, as it became known, is at its most typical, and its most Symbolist, in the works of Margaret and Frances Macdonald. The sexuality of Beardsley's line drawings was echoed,

in colour, by the sisters—less explicitly, but in by no means a naive pastiche. *Ill Omen* (ii, 63), *Summer* (i, 62) and *The Fountain* (iii, 60) virtually defy explanation, but the intended effect is all too clear. Distorted figures—emaciated and elongated—strong colour (concentrating on blue and green) and symbols of mystery disclose fertile and impressionable imaginations. In later years the girls were to attempt book illustrations in this style, but The Bodley Head, to whom they were sent for publication, preferred the more feminine and decorative designs of Jessie King, whose work typifies that of the slightly younger group of Glasgow artists who were influenced by The Four.

The work of the Macdonald sisters is as important as that of Mackintosh at this date. Mackintosh does not seem to have been prepared to go to their extremes, and perhaps he was not capable of it. Watercolours such as *The Descent of Night* (39, 59), *Spring* (38) and *Winter* (47) use imagery which is relatively easy to explain (for us, at least, although *Cabbages in an Orchard* (40, 56–57) was accompanied by an explanatory text to assist his fellow students who read The Magazine), and when it does become less intelligible, it is obviously based upon nature, as in *The Shadow* (49, 76) and the two mysterious drawings of 1895, *The Tree of Influence* (45, 69) and *The Tree of Personal Effort* (44, 68). The attribution of abstract concepts to natural forms was not unusual in the Symbolist movement, but rarely were such forms stylised to the degree seen here. Mackintosh's meaning in these drawings has eluded all commentators. Presumably the drawings would have meant something to Mackintosh's circle and, as they appear without comment in The Magazine, they probably represent some of the ideas discussed by its readers. None of his drawings, however, is as melancholic or as despairing as some of those by the sisters, especially Frances, and although they have in recent years received new regard as Symbolist work they do not, in my view, form a serious contribution to the multi-faceted Symbolism which swept through Europe from 1870 to 1910. Mackintosh soon forsook the style for a gentler imagery, fairies, but even that was shortlived because his architectural and design work increasingly absorbed his time and energies.

As a group, The Four also moved away from the eerie and male-volent subject matter of 1893–96, although figures in the illuminated *Christmas Story* (collection: Glasgow University) by Frances and Margaret are only slightly more fleshy. A fairy-tale world took its place, with the Sleeping Beauty theme and the stories of Maeterlinck most popular. Margaret turned to this imagery in her later work, which became ever more populated with cherubs or ladies in crinolines, returning only occasionally to the symbolism of the mid-1890s. Mackintosh produced virtually no figurative work from 1900 until he left Glasgow in 1914. MacNair, never a particularly skilful watercolourist although in some ways the most innovative of The Four, worked in a style that changed little through the 1900s and which was, financially at least, virtually a failure. His lack of success greatly affected Frances, whom he married in 1899, and the hardships of her life, both material and emotional, are mirrored in the totally original watercolours she produced from about 1905. McLaren Young described these later pictures as retaining some of the earlier whimsy of the 1890s combined with a toughness akin to northern European Expressionism. The figures in the watercolours of the 1890s are distorted as much to create a pattern on the page as to convey emotion, but the inhabitants of her genuinely stark landscapes of *c*1910–15 are suffering more tangible pain. The MacNairs' later life together in Liverpool and Glasgow, struggling against poverty and Herbert's excesses, is surely represented in these anguished figures.

See Billcliffe, 'J. H. MacNair in Glasgow and Liverpool', Annual Report and Bulletin, I, 1970–71, pp. 48–74, Walker Art Gallery, Liverpool.

McLaren Young, p. 29, no 97.

Again, Mackintosh does not commit himself to the fairy-tale world as whole-heartedly as the sisters, and contemporary work of his continues to reflect his greater skills as a draughtsman. *Princess Ess* (54) and *Princess Uty* (55) are lost, but *Fairies* (58) and *In Fairyland* (52, 77) give an adequate indication of his style in the later 1890s. It is, perhaps, in these works that he comes closest to Margaret and Frances, but his figures are always more substantial. By 1901 he had given up this genre altogether, his last work in this vein being the watercolour, *The Wassail* (62, 73), later enlarged into a gesso panel for Miss Cranston's Ingram Street Tea Rooms opened in 1900. Another commission for Miss Cranston, for the Buchanan Street Tea Rooms in 1896–97, is also based upon the fairy pictures of the period. *Part Seen, Imagined Part* (51, 71) became the basis for the stylised female figures stencilled on the walls of the dining room. The life-size figures, wreathed in flowering tendrils, were obviously inspired by this small drawing and by the figures in his posters for the Glasgow Institute of Fine Arts and the Scottish Musical Review. But there was little time or opportunity for Mackintosh to develop this decorative style. On the few occasions when it reappears, for instance at the Turin Exhibition of 1902 or in the Willow Tea Rooms in 1904, the figures are far more stylised and elongated than those at Buchanan Street.

It has been suggested that the reason why, with rare exceptions, Mackintosh produced no figurative watercolours after 1900 was his greater involvement in his firm, in which he became a partner in 1901. This is, to a certain extent, true, but a comparison of the numbers of watercolours produced before and after 1900 (and before 1914) will show little variation. In fact, examples from the earlier period are only more numerous because of the large number of sketches made on his Italian tour. Mackintosh would have considered his architectural and design work of this period as much a manifestation of his artistic talent as his watercolours. In a lecture entitled 'Seemliness', probably from *c*1901–05, he exhorted craftsmen to treat their work as art: 'The architect must become an art worker . . . the art worker must become an architect . . . the draftsman of the future must be an artist . . . Art is the flower—Life is the green leaf. Let every artist strive to make his flower a beautiful living thing—something that will convince the world that there may be— there are—things more precious—more beautiful—more lasting than life.' From 1900 to 1905 Mackintosh was probably busier with his architectural commissions than at any other time: Dunglass Castle, Bowling; the Vienna Secession Exhibition; Ingram Street Tea Rooms, Glasgow; Windyhill, Kilmacolm; the Turin Exhibition; 14 Kingsborough Gardens, Glasgow; the Wärndorfer Music Room; The Hill House, Helensburgh; the Willow Tea Rooms and Miss Cranston's home at Hous'hill, Glasgow. In all but the last two of these jobs, nature, and wild flowers in particular, inspired the furniture and decorative details; nature was also the inspiration for his watercolours of this period. In 'Seemliness' he wrote: ' . . . you must offer real, living—beautifully coloured flowers—flowers that grow from but above the green leaf—flowers that are not dead— are not dying—not artificial—real flowers—you must offer the flowers of the art that is in you—the symbols of all that is noble—and beautiful—and inspiring—flowers that will often change a colourless leaf—into an estimated thoughtful thing.'

He took his own advice seriously, and in 1901 began to add colour to the flower drawings he made while on holiday on Lindisfarne, the Holy Island. Mackintosh had drawn flowers ever since his student days, but they were always in pencil on pages of his sketch books. Like the drawings of buildings on adjacent pages, these sketches of flowers were recorded as much for their value in giving

Manuscript, undated (collection: Glasgow University).

Billcliffe, pp. 21–24.

Mackintosh a design vocabulary as they were for their own beauty. The carved decoration on a chair, the leaded glass panels in cabinets and doors, all drew their inspiration from petals, seed-pods and the gently bending stems of flowers. Gradually, however, this analytical phase of his flower drawings passed. At the same time (c1900), his sketches of buildings began to acquire the polish of more finished works—houses. and castles would be shown in their setting and a more consciously artistic drawing would result.

The addition of colour, however, was not the only change in the flower drawings: Mackintosh began to produce many more of them after his 1901 visit to Lindisfarne, conceived as pictures in their own right and not as material for a pattern-book of decorative details. The Holy Island flowers are transitional, with their tentative use of colour, but by 1904, on his visit to the Scilly Isles, the drawings had become more stylised 'and a format for the next ten years was established. Over a pencil outline was laid a colour wash, often with specific details picked out in solid colour. The pencil outline is made with great assurance, sometimes with different parts of the flower or different views of it superimposed on the first lines, rather like an analytical Cubist painting. Mistakes, if any, are not erased but incorporated into the design. The much greater formal element with emphasis on the pattern and structure of the plants, is reinforced by the careful positioning of the cartouche or box which encloses Mackintosh's signature and the inscription which identifies the subject, the date, and the place where the flower was drawn.

Until 1915, virtually all the botanical drawings are of wild flowers found in the meadows, hedgerows and woods which Mackintosh visited on his annual holidays. The drawings were made in sketch-books, alongside drawings of village streets and squares, church-yards and manor houses, and these books became a record of the holidays Margaret and Charles took together after their marriage in 1900. Their marriage was probably the catalyst which brought about this change of style in the sketch-book drawings. As a bachelor, Mackintosh made whistle-stop tours around the countryside, filling his books with dozens of sketches. As a married man, his annual holiday was more often spent in one place with Margaret, and occasionally with Herbert and Frances MacNair. With more time available to him, the drawings became increasingly pictorial, and the colour washes on the flowers were probably added in the seclusion of their cottage or hotel room. At the time, Mackintosh also began to sign and elaborately inscribe his drawings, often including his wife's initials, a practice which has led to suggestions that the colour washes on his drawings were added by Margaret. However, as nobody was allowed to touch Mackintosh's work, not even his wife, the initials simply indicate—in what was by then practically a family album—the people who were with him when he made the drawing. Hence the appearance of Herbert and Frances MacNair's initials, and those of Charles Macdonald, in some of the Holy Island sketches of 1901.

Compared with the figurative watercolours of the mid-1890s, the flower paintings demonstrate the increasing maturity and sophistication of Mackintosh as a designer. The elegance of the interiors and furniture at The Hill House, Helensburgh, echoes that of the flower drawings, where delicacy of line and colour contrasts· with bold pattern and skilful presentation. Similarly, the eclectic designs for the Glasgow Herald Building, Martyrs' Public School, and Queen Margaret Medical College, Glasgow, with their transposition of familiar vernacular features into modern buildings, expressively modelled, recall the symbolist watercolours of the same period, inspired by emotion. and myth, awkwardly expressing abstract concepts in a graphic medium. Both are hesitant, both have their

roots in a liking for things medieval, either material or spiritual, and both buildings and watercolours show Mackintosh's capacity for synthesising influences from other men's work. The design for the Glasgow School of Art cuts across both spheres—the vernacular is mixed with the modern, a new style, and at the same time Mackintosh begins to forsake the symbolic elements of his painting. By 1900 this process is complete: the historical elements in his architecture have become generic, not specific, and in his painting he concentrates on design and pattern, line and colour, rather than content and emotion.

In 1914 Mackintosh and his wife closed their house at 78 Southpark Avenue, Glasgow, and left for the south of England. The reasons for their leaving are too complex to be discussed here, but they were concerned mainly with Mackintosh's inability to work in an office with partners, to conform to a routine, and his failure to gain commissions for his own practice when he left Honeyman, Keppie & Mackintosh in 1913. Behind all this was a crisis of confidence—Mackintosh's confidence in himself, the confidence of clients and colleagues in him, and a more general crisis which was to affect the whole of the architectural profession in Glasgow, where never again would there be such vitality and quality in building design as had been seen during the fifty years before the outbreak of war in 1914. Mackintosh had never been popular with the majority of his colleagues in Glasgow, inside or outside his own practice. He had never been afraid to voice his belief in the search for a new architectural style and his opinion of those fellow architects who were content to wallow in historicism, sham and hypocrisy. In the early 1890s, at lectures he gave at the Glasgow Art Club and to the Glasgow Institute of Architects, he displayed his enthusiastic and youthful—if not entirely accurate—knowledge of those English architects whose work he admired: Sedding, Lethaby, Belcher and others. Ten years later in 'Seemliness' he would not have endeared himself to the 'leaders' of his profession in Glasgow: 'The Architect must become an art worker, and be content to forego the questionable distinction and pleasure of being respected as the head (perhaps the founder) of a large and successful business . . . Architecture must no longer begin and end with the mechanical possibilities of the tee square, the set square, the pencil bows, the dividers . . . But to do this requires conviction.'

Few people in Glasgow would have been sorry to see Mackintosh leave. In the years that followed, those who knew him slightly, and occasionally those who knew him well, did him disservice with scurrilous tales of an arrogant, proud and drunken man whose skills were based upon those of his office and who was carried by his partners and his juniors. His friends could do little to stop this character assassination and, as the years passed, one by one they died while his enemies acquired positions of greater power, thus ensuring that their stories were given greater credence. Sadly, Glasgow accepted this distortion of fact all too readily, particularly the myth of a man whose invention came out of the whisky bottle. Mackintosh did drink, so did Keppie, so did most of their contemporaries, and heavy drinking is still today a Scottish disease. If Mackintosh had not been the genius he was, his drinking would have been ignored—as was his partner's—but it was too easy to see the incredible, inventive output of his pencil as merely the result of an alcoholic's addiction. It was rumoured that Mackintosh was so drunken that his draughtsmen had to work up details of his jobs from the tiny sketches he would produce at the end of a long drinking session. In fact the only surviving evidence of his juniors doing any of his work are about a dozen drawings for furniture and fittings for the School of Art and the Ingram Street Tea Rooms in 1910, all

obviously enlargements of his own detailed designs. By 1914 he was supposedly so incapable of producing a drawing that he was forced to leave Glasgow in the hope of setting up a practice in the South. His incapacity was not physical, however—witness the superb drawings made in Kent in 1910 or the exquisite flower paintings he did at Walberswick in 1914 and 1915. For whatever reasons he left Glasgow, it was not because he could no longer draw.

The thirty or so flower pictures made at Walberswick are the finest of his career. Desmond Chapman-Huston says these were intended for a book of flower studies to be published in Germany. Much of Chapman-Huston's information came from Margaret and, although his article has many inaccuracies, there seems no reason to doubt this explanation for the dramatic increase in flower drawings made in 1914. The outbreak of war prevented publication of the book, but Mackintosh carried on producing other watercolours throughout the war. All of these drawings are more finished, more stylised and decorative than the pre-Walberswick watercolours. *Fritillaria* (128, 96), *Cactus Flower* (123, 83) and *Anemone and Pasque* (142, 87) are all highly finished and have little of the spontaneity of the earlier watercolours. This is to be expected, of course, if the drawings were intended for a much wider audience than Mackintosh's family and small circle of friends. The positioning of each flower on the page is more deliberate than before and colour is used to define specific parts of the plants rather than as an overall wash. Pattern, in the flower itself and in the way it is drawn, is emphasised at the expense of the natural shape of the plant, as Mackintosh seems to have in mind the final printed reproduction and the general effect of the book. The natural shapes seen in the earlier drawings have been sacrificed for greater finish; a private pastime has been swamped by the more positive demands of public taste.

Desmond Chapman-Huston, 'Charles Rennie Mackintosh', *Artwork*, no 21, 1930, p. 30.

That Mackintosh was reconciled to changing his style to earn a living, in this case by publishing his flower drawings, is shown by the appearance of some of them in public exhibitions. *Petunia* (111) was shown at The International Society in 1917, and Mackintosh started to produce a different type of watercolour in the hope of stimulating sales and thus increasing his income. In 'Seemliness' he decried the painting of cut flowers, and until 1915 (with few exceptions) his watercolours are all of flowers growing wild. Perhaps perceiving the public taste for larger, more finished paintings of the flowers which adorned their houses or grew in their gardens, Mackintosh turned to painting bunches of cultivated flowers arranged in vases. His way of painting them, however, was just as uncompromising as one would expect, and his paintings of *Anemones* (152, 94), *Begonias* (153, 95), *Peonies* (165, 99) and *White Roses* (166, 99) and all the others found no purchasers.

The earliest of these, *Anemones* and *Begonias*, were painted in about 1916 when Mackintosh was working on 78 Derngate, Northampton, for W. J. Bassett-Lowke, and they reflect his concern there with strongly coloured, formalised patterns. The flowers are arranged boldly in a vase, usually placed on a table, often with a realistic background, such as part of a room, or a wall hung with pictures or a mirror. The blooms are chosen for their depth of colour (*Anemones*), their grandeur (*Begonias*), or their structure (*White Tulips*, 156, 98). The tulip had been a favourite motif in the carved decoration on Mackintosh's furniture, and he was to use it again in several of the textile designs he made during and shortly after the war. From about 1919, even these paintings became formalised as Mackintosh substituted an abstract pattern for the more naturalistic backgrounds of works like *White Tulips*. In *Peonies* and *White Roses* he introduced a patterned background similar to his many textile designs, while in *Pinks* (175, 109) and *Grey Iris* (174, 103) a plain background contrasts

with the details of the vase or the still life on the table.

With these works Mackintosh established himself as an accomplished watercolourist, but cut flowers seem to have offered him little challenge. No major commissions arose out of the work for Bassett-Lowke, and Mackintosh resolved to give up architecture for a full-time career as a watercolour painter. Similarly the formalised bouquets (157–163, *108*)—a strange hybrid of the recent flower paintings and the stylised textile designs—offered no serious future for Mackintosh. He found his solution in landscape, though not in panoramic vistas of fields, rivers and hills. In Walberswick he had painted two or three watercolours of Suffolk barns, riverside wharves and warehouses, the kind of building, in fact, that he would have drawn in pencil a few years earlier. These predate the large-scale flower paintings, but the technique is the same: broad washes contrasted with detailed passages of strong colours. *Venetian Palace* (118, *90*) and *Palace of Timber* (120, *92*) are two of the more spectacular of these, but Mackintosh was forced to leave the Suffolk Broads before he could further develop his new style. Howarth records how Mackintosh was taken for a spy in the early months of the war, a not unnatural conclusion for a country police force to arrive at when confronted with a stranger with a foreign-sounding accent who wandered around the countryside, sketch-book and pencil in hand, and who had considerable correspondence with Austria and Germany. Mackintosh spent the rest of the war in London; this was possibly the reason why he turned from landscape to bouquets of flowers for his subject matter.

Howarth, p. 196.

In 1920 he returned to landscape painting while on holiday in Dorset with Margaret, and Randolph Schwabe and his family. The countryside and villages of Dorset are substantially different from those of Suffolk. The hills, stone walls between fields and distant glimpses of the sea provided Mackintosh with a formal landscape ideally suited to his search for pattern in natural forms. He knew Dorset reasonably well, having visited it during the 1890s, and was much influenced by its vernacular buildings. The village of Worth Matravers and the surrounding countryside with its tranquil mixture of unspoilt natural features and harmonious farmhouses and cottages would have attracted him immediately, for in the surviving watercolours of this period it is man's effect upon nature which has intrigued Mackintosh. In *The Village, Worth Matravers* (167, *174*) the village is seen rising up the hillside, but it does not look alien and man-made. The houses are randomly placed, with grey stone walls and tiled or thatched roofs; there are no formal streets, no artificial arrangement of squares or roads, just narrow lanes all leading quite naturally, even tortuously, to the village church high on the hillside. Mackintosh was obviously fascinated by the organic growth of the village and its natural-seeming presence in the countryside. The pattern of the houses, with their flat walls punctuated by small square-paned windows and their irregular roofs, is played against the irregular surface of the road and the uneven line of the horizon. The colours are subdued greys, greens and browns with the occasional spot of red. *The Downs, Worth Matravers* (168, *115*), however, is a very different picture, with much brighter greens and blues to give it a sparkling effect. Mackintosh has this time chosen a landscape which is both disturbed and enhanced by a man-made object, a telegraph pole. From his chosen viewpoint the pole pulls the picture together, stretching from the foreground up to the horizon at the top of the picture. The pole provides the only straight lines in the picture and imposes an unnatural formality on the gentle Dorset landscape. In both these pictures, as in the paintings of cut flowers, every object is painted in considerable detail. The distance is as clear as the foreground, although the scale obviously changes; in

this way, Mackintosh creates the illusion of depth in the landscape and one is aware of the considerable distance captured in the drawing, while at the same time the two dimensions of the paper are emphasised by the overall surface detail. The pattern he has created of nature and architecture is emphasised by the consistency of his detailing; one is always aware, because of the detail of supposedly distant objects, that they are in fact in the same flat plane as those items in the foreground. That this is deliberate there can be no doubt, for in the Mediterranean watercolours of 1923–27, Mackintosh refines the technique. Like these Dorset watercolours, the French paintings have a surreal atmosphere, the landscape is almost tangible but, at the same time, obviously flat and two-dimensional. The uneasiness which is awakened in the viewer is reinforced by the conscious emphasis on pattern in the landscape and by the almost total lack of human life in any of these watercolours. There are no figures in the street, no carts on the road, no ploughmen in the fields—the man-made features in the landscape, the houses and forts, have no men about them to indicate scale. Everywhere is deserted and an eerie stillness pervades the pictures.

Mackintosh did not set out to capture movement. It is a concept which he totally avoids, even in his flower drawings, for their petals are unruffled by the wind, their stems unswaying; and in the views of Port Vendres the ripples of the water in the bay are frozen into a static diagram. His method of working was partly responsible, for these works were not impressionistically made in a few hours, they were executed *en plein air*, and his letters to Margaret in 1927 indicate that he would often take two to three weeks to finish a watercolour, and occasionally much longer. As in early photographs produced in the 1840s, his pictures do not register human, or even animal, movement; his concentration was fixed on the immovable and permanent. Unlike the flower sketches, mistakes were not incorporated into the final design. Mrs Sturrock, daughter of Fra Newbery, worked alongside Mackintosh at Walberswick in 1914; while she and her mother preferred a David Cox paper, Mackintosh worked on a Whatman hot-press, mounted on card, which he soaked with colour, often scrubbing it with a toothbrush to get the effects he wanted. This is the technique he almost certainly used on the French pictures, and in Dorset too.

He was undoubtedly pleased with the Worth Matravers pictures, which probably inspired him to give up architecture altogether and turn to painting full-time. Very few of his projects for studios and theatres in Chelsea were carried out, and he must have been dismayed by these further rebuffs. In about 1920, he had confided to J. D. Fergusson, the Scottish painter who was a Chelsea neighbour, that if his projects for Fergusson's wife, Margaret Morris, were turned down by the building authorities, then he would give up architecture and become a painter. In 1923, severely depressed by his treatment, Mackintosh accepted the advice of friends and left London for a long holiday in the south of France. He was to stay there until the autumn of 1927. Fergusson undoubtedly had some influence upon his choice of refuge, for he made annual visits there from 1919 until 1939 and had lived in France for seven years before the war. The Mackintoshes settled on the Mediterranean coast a few miles from the Franco-Spanish border.

We know little about the Mackintoshes' stay in France, as only a few letters exist which give any idea of their movements before the spring of 1927. No watercolours bear any dates other than 1927, and few even have signatures. In May 1927, however, Margaret returned to London to undergo medical treatment and Mackintosh's letters to her have survived (collection: Glasgow University). She returned to France in July, and they stayed for a while in Mont Louis until

Mackintosh in turn fell ill and they both returned to London. What the letters suggest is that they had usually spent the summer months at Mont Louis, where it was cooler, less busy and therefore cheaper in midsummer, returning in the early autumn to Port Vendres, which became their base for the rest of the year. In a letter written to Fra Newbery (collection: Mrs M. Newbery Sturrock), Mackintosh mentions a visit to Florence, but there is no way of knowing how extensive their Italian travels were; certainly no watercolours of Italian scenes survive from the 1920s. A letter to J. D. Fergusson (collection: Margaret Morris Fergusson), dated 1 February 1925, discloses that they had been at Ille-sur-Têt for a few weeks and intended to stay until the end of May, when, Mackintosh wrote, they would be travelling to Mont Louis for a stay of two or three months. From Ille-sur-Têt and Mont Louis they could easily reach La Lagonne and Amélie-les-Bains, and dated drawings show that they were in Amélie in 1924 (203, *118*) and Mont Louis in 1925 (205–207, *128, 144*). A letter to Margaret from Queen Mary was forwarded to Collioure in April 1924, so it seems likely that they settled there first, after leaving London. From Collioure they discovered Port Vendres, where they had settled by early 1927 (indeed, in letters to Margaret in 1927, Mackintosh records how he could walk there and back in an evening) and from there they would walk out to forts along the coast and a short distance inland. *Fetges* (180, *113*) indicates that they also made at least one visit across the border to Spain.

In the large watercolours of this period, the organic pattern and the relationship between simple buildings and the countryside which can be seen in the Dorset works of 1920 have become Mackintosh's major aesthetic concern. Whether he is painting distant views of mountain fields with the patchwork of crops contrasting against the dark spread of trees or scrub, or the steeply rising village of Port Vendres, with houses tumbling down the hilly streets, the overall effect is one of pattern, natural or man-made, with mass and form taking priority over line and colour. Colour was obviously important, however, for Mackintosh has used it to catch the strong light of the Mediterranean and his palette is much clearer and brighter than it was in his Chelsea and Dorset pictures. These strange, flat landscapes, with their bold colours and busy surface patterns are the exciting culmination of the ornate flower pictures and the experimental views of Walberswick and Worth Matravers.

There is no obvious development in a single direction; in a letter to Margaret of 28 May 1927, Mackintosh wrote: 'I find that each of my drawings has *something* in them but none of them have everything.' And so, we see in some drawings the strength of colour, as in *Summer in the South* (195, *124*); in others, like *La Rue du Soleil* (208, *138*), a superb almost abstract, sense of design; *A Southern Town* (193, *110*) emphasises his fascination with 'organic' building; and *The Rocks* (216, *143*) his delight in the complexities of the accidental structures of nature. There are too many works to analyse individually, and one or two alone cannot give any indication of Mackintosh's intentions or achievements. They must all be seen and judged as one gigantic work. They all have obvious similarities, the most striking being the relationship of the finished pictures to architectural forms. This is not surprising, given the characteristic harsh, yet at times gentle, landscape of the Pyrenees combined with the specific skills and weaknesses of Mackintosh himself. But these watercolours are none the worse for having been painted with an architect's eye: indeed, this is one of their great strengths. Like other great artist-architects—such near contemporaries as Le Corbusier or predecessors like Bernini—Mackintosh brought to painting something no pure painter ever could.

The letters he wrote to Margaret in the summer of 1927 throw a little more light on Mackintosh's way of working. He always painted outside, but only when the sun was shining; in bad weather he rarely worked on his drawings indoors. He was a slow worker, some drawings would take weeks, others a few days at the very least. *The Rocks* troubled him for a long time: it was begun before Margaret left at the beginning of May, but by the 30th he had still not managed to finish it, although a fort picture, probably *Fort Maillert* (215, *142*), had been completed in a much shorter period; he spent another four hours on it on 4 June, and thought it needed just one more still morning to paint a ripple-free sea; 11 June, still not finished; 13 June, finished all but the signature. Other letters show that Margaret was concerned that he had not signed his work. While in London, she had decided to take a few drawings to show to dealers and the Leicester Galleries agreed to exhibit them. She pointed out to Mackintosh that they were unsigned, and he suggested that *she* sign them. Mackintosh was not too happy with the prices offered—the highest being £30 for *Fetges* (180, *113*). There are few other insights, but his letter of 28 May has a particularly interesting passage; he had been working on a picture of a fort, probably *Fort Maillert*, and wrote: 'This drawing is now practically finished and I think it is very good of its kind—I shall give it another short morning as there are one or two things that still might be done—little points of closer, observation . . . The last drawing had no green [I have] an insane aptitude for seeing green and putting it down here, there and everywhere the very first thing—this habit complicates every colour scheme that I am arriving at so I must get over this vicious habit. *The Rocks* has some green, and now I see that instead of painting this first I should have painted the grey rock first then I probably would have no real green. But that's one of my minor curses—green—green, green—if I leave it off my palette—I find my hands—when my mind is searching for some shape or form— squeezing green out of a tube—and so it begins again.'

Through the letters we can also see that Mackintosh was not altogether forgotten by his profession, or at least the younger members of it. A contributor to The Architects' Journal had asked him to write a series of articles on present-day English architecture. Mackintosh was not too keen to do them, if for no other reason than 'it doesn't exist—nor will there be any daylight until it is impossible for pompous bounders like a well known (at least well advertised) professor at Liverpool to have any say in architectural education— He is teaching efficiency but even there he is only a 23rd rater because they do it already better in America'—which was no compliment, as Mackintosh had little time for things American. His dislike of C. H. Reilly, the Liverpool professor, was shared by Barman at The Architects' Journal. Mackintosh goes on to say how he had waited twenty years to get revenge against Reilly—perhaps he had played a major part in Mackintosh's failure to win the Liverpool Cathedral Competition. In any case, Mackintosh never wrote the articles. More ominously, the letters give us the first indication of the illness that was to force Mackintosh to leave France and return to London. On 13 May he complained about French tobacco, now being made by the Americans, he said, and he found it sickening and sordid. Three days later he told Margaret how his tongue was swollen and blistered and it was weeks before it returned to normal. Later that year he was taken ill, and returned to London where he was diagnosed as suffering from cancer of the tongue. Despite radium treatment and a long convalescence in London he died, aged sixty, on 10 December 1928. Four years later, on 10 January 1933, Margaret died alone in London.

Howarth, p. 291.

Howarth has recorded how Mackintosh's work was exhibited in Glasgow in 1933 in a Memorial Exhibition dedicated to himself and his wife. Virtually all the later watercolours were sold to old friends, colleagues and admirers. Little of his earlier work was included in the exhibition, however, and this omission was not adequately amended until Andrew McLaren Young organised the Centenary Exhibition in 1968. By this time the watercolours had been eclipsed by popular interest in his buildings and furniture, and few people were aware of the range of Mackintosh's artistic output. Too often since then it has been ignored because it is not, unlike Mackintosh's architectural projects, deemed to be original in the overall context of the art history of the later nineteenth and early twentieth centuries. Perhaps, if judged by the effect his work had upon other painters—which was slight—that view is a defensible one; but if considered in the light of the influence his pre-1914 pictures had on his architecture, then his paintings deserve a different assessment. That Mackintosh was eclectic one cannot deny, but no one else arrived at the same pictorial conclusions as he did; and from his watercolours grew part of his inspiration for his greater role as an architect. But Mackintosh would not have separated the two—his architecture was another dimension of the same talent, influenced by his pictures, just as his watercolours of the 1920s are influenced by his architecture.

If we do separate the different facets of his creative life, there can be little doubt of the relative influences his architecture and design work, as opposed to his painting, had upon his contemporaries and successive generations. Nor can one answer the charges that his work did not reflect the advances in painting made by the Cubists and the Fauves. But one can counter them by noting his awareness of the work of Klimt, which he knew well, and his possible knowledge of the early work of Egon Schiele, whose landscapes of c1910–13 have much in common with Mackintosh's French watercolours. In the final analysis, we must accept that Mackintosh arrived at his mature style of painting without the benefit of knowledge of the work of other painters, unlike during his development in the 1890s. These watercolours are original and isolated works in the context of British—even European—painting of the 1920s: in British art, only the landscape watercolours of Paul Nash approach them in intensity or skill of draughtsmanship. It was a spiritual isolation which separated Mackintosh from his colleagues in Glasgow and officialdom in London, and geographical isolation which separated Glasgow from his followers in Vienna; and finally Port Vendres isolated him from the artistic establishment, and meant that the last outburst of his talents would pass unnoticed. The Port Vendres watercolours are, in fact, the final flowering of a genius which had seemed at its greatest working in three dimensions, but which also excelled at committing those three to the two dimensions of watercolour and paper. It is impossible to assess the importance of these watercolours without a knowledge of Mackintosh's career as an architect, but one does not need that knowledge to gain pleasure from the works or to perceive that, once again, he strove for, and achieved that excellence of artistic endeavour that he tried in vain to encourage in his fellow artists and architects in Glasgow.

Notes, Abbreviations and Bibliography

The works are arranged in chronological order with a supplement of some relevant works by Margaret and Frances Macdonald. The support for each drawing is white paper unless otherwise stated; measurements are given in millimetres, height before width.

Those items included in the exhibition of Mackintosh watercolours shown at Glasgow Art Gallery. The Fine Art Society (Edinburgh and London), Brighton Art Gallery and Museum and Dundee Art Gallery, July 1978—January 1979, are marked with an asterisk.

The most important works on C. R. Mackintosh in which the water-colours are discussed or illustrated are noted in each catalogue entry and listed in the abbreviations below. Page numbers in italics indicate that the work is illustrated on that page.

Alison	Filippo Alison, *Charles Rennie Mackintosh as a Designer of Chairs*, London 1974 (English edition of Triennale catalogue—*see* below, Milan, 1973).
Billcliffe	Roger Billcliffe, *Architectural Sketches and Flower Drawings by Charles Rennie Mackintosh*, London, 1977.
Edinburgh, 1968	'Charles Rennie Mackintosh: Architecture, Design, Painting', a Centenary Exhibition sponsored by the Edinburgh Festival Society and the Scottish Arts Council, at the Royal Scottish Museum, Edinburgh, 1968. Catalogue by Andrew McLaren Young. Also shown at the Victoria and Albert Museum, London; smaller versions of the exhibition toured to Zurich, Vienna and Darmstadt.
Glasgow University	Mackintosh Collection, Hunterian Museum, University of Glasgow.
GIFA	(Royal) Glasgow Institute of the Fine Arts.
Glasgow, 1977	'Flower Drawings by Charles Rennie Mackintosh', Hunterian Museum, University of Glasgow, 1977. Catalogue by Roger Billcliffe.
Howarth	Thomas Howarth, *Charles Rennie Mackintosh and the Modern Movement*, London, 1952; reprint, with new Introduction and enlarged Bibliography, 1977. The standard work on Mackintosh with an excellent bibliography.
ISSPG	International Society for Sculptors, Painters and Gravers, London.
Mackintosh Estate	The collection at Glasgow University, which had passed from Mackintosh to his wife on his death in 1928; following her death in 1933, the Estate, after the sale of certain items at the Memorial Exhibition, was held in trust in Glasgow for her heir, Sylvan MacNair. On the death of the senior executor, William Davidson, in 1945, his heirs and the remaining executor asked Sylvan MacNair to relinquish his claim to the residue of the Estate in favour of Glasgow University. In 1946 MacNair agreed to this proposal and the University became the owner of the collection and residuary legatee of the Estate.

McLaren Young	Catalogue of Centenary Exhibition (*see* above, Edinburgh, 1968).
Macleod	Robert Macleod, *Charles Rennie Mackintosh*, London, 1968.
Memorial Exhibition	'Charles Rennie Mackintosh, Margaret Macdonald Mackintosh, Memorial Exhibition', McLellan Galleries, Glasgow, 1933.
Milan, 1973	'*Le Sedie di Charles Rennie Mackintosh*', an exhibition organised by Filippo Alison for the Triennale, Milan, 1973. The catalogue was published by Casabella (*see* Alison, above, for details of English edition).
Pevsner, 1968	'Charles Rennie Mackintosh' in *Studies in Art, Architecture and Design*, Volume II, London, 1968. This is a translation by Adeline Hartcup of Pevsner's pioneering study first published by Il Balcone, Milan, 1950.
RA	Royal Academy, London.
RSW	Royal Scottish Society for Painters in Watercolour, Glasgow.
RSA	Royal Scottish Academy, Edinburgh.
Saltire	Exhibition of work by Charles Rennie Mackintosh organised by Thomas Howarth for the Saltire Society and Arts Council of Great Britain, Edinburgh, 1953.
Toronto, 1967	University of Toronto, School of Architecture, 'Charles Rennie Mackintosh: Works from the Collection of Professor Thomas Howarth', 1967.

Catalogue

1 A Study of Leaves *c*1883–86

Pencil and watercolour 171 × 184

Signed, lower right, CRM.

Provenance: C. R. Mackintosh; by family descent.

Collection: Miss Moira Dingwall.

One of three drawings by Mackintosh originally contained in an album which he put together between 1885 and 1890 (exhibited: Edinburgh, 1968, 1). The album contains several drawings by other hands, variously dated between 1886 and 1890, and when McLaren Young saw the book in 1968, this drawing, and 2 and 3, had been removed. These three works are his earliest known in any medium and are very much the product of an untrained hand; their hesitant draughtsmanship and weak handling certainly pre-date the ink drawing of the church at Stoke Poges (collection: Glasgow University, Edinburgh and London, 1968, 52, plate 2) and *An Antique Relief* (4).

2 Flower Study *c*1883–86

Pencil and watercolour 182 × 274

Provenance: C. R. Mackintosh; by family descent.

Collection: Miss Moira Dingwall.

See 1.

3 Cottage in a Landscape *c*1885

Watercolour 176 × 252

Signed, lower right, CRM, in monogram.

Provenance: C. R. Mackintosh; by family descent.

Collection: Miss Moira Dingwall.

Slightly more assured than 1 and 2, but still very much a juvenile work.

4 An Antique Relief *c*1886

Watercolour 723 × 548

Signed, lower right, CRM; paper blindstamped ESK inside an oval.

Literature: Howarth, p. 4, plate 2a.

Provenance: Mackintosh Estate.

Collection: Glasgow University.

Illustrated on p. 49.

Howarth records how, in 1886, Mackintosh was commended for his studies from the casts housed in the School of Art, part of the prescribed course for the part-time students of architecture at the School. This particular example was exhibited at South Kensington; no others have been traced.

5 Free Copy of Part of an Indian Carpet *c*1888–91

Pencil and watercolour 342 × 485

Exhibited: Edinburgh, 1968 (22, plate 3).

Provenance: Mackintosh Estate.

Collection: Glasgow University.

McLaren Young, in the catalogue of the 1968 Centenary Exhibition, suggested that this drawing might be based upon an Indian carpet in the Victoria and Albert Museum. Mackintosh's work was exhibited frequently at South Kensington from the mid-1880s, and it is likely that he would have visited the annual exhibitions at least once, when he could have made this drawing.

6 Free Copy of Part of an Indian Carpet

Pencil and watercolour 340 × 480 *c*1888–91

Provenance: Mackintosh Estate.

Collection: Glasgow University.

7 Window in Chapter House, Elgin Cathedral

Pencil and watercolour 270 × 184 1889

Signed, lower right, CRM (in monogram); inscribed, and dated, lower left, WINDOW IN CHAPTER HOUSE/ ELGIN CATHEDRAL./1.7.89.

Exhibited: Edinburgh, 1968 (5).

Provenance: Mackintosh Estate.

Collection: Glasgow University.

Mackintosh probably made many pencil sketches of buildings he saw on his visit to north-east Scotland in 1889, but the majority of those which survive have watercolour additions.

8 Window in South Aisle, Elgin Cathedral 1889

Pencil and watercolour 270 × 184

Signed, lower right, CRM (in monogram); inscribed, lower left, WINDOW. SOUTH AISLE/ELGIN CATHEDRAL..

Provenance: Mackintosh Estate.

Collection: Glasgow University.

9 Old Tomb, Cathedral Graveyard, Elgin 1889

Watercolour and pencil 318 × 241

Signed, lower right, CRM (in monogram); inscribed, lower left, OLD TOMB/CATHEDRAL GRAVEYARD.

Provenance: Mackintosh Estate.

Collection: Glasgow University.

10 Tomb, Elgin* 1889

Watercolour 318 × 241

Signed, lower right, CRM (in monogram); inscribed, lower left, OLD TOUMB (*sic*)/ELGIN.

Exhibited: Edinburgh, 1968 (6).

Provenance: Mackintosh Estate.

Collection: Glasgow University.

Illustrated on p. 50.

11 Window, Spynie, Morayshire 1889

Pencil and watercolour 254 × 175

Signed, lower right, CRM; inscribed, lower left, SPYNIE.

Literature: Billcliffe, p. 26.

Exhibited: Edinburgh, 1968 (7).

Provenance: Mackintosh Estate.

Collection: Glasgow University.

12 Old High Church, Stirling *c*1889–91

Watercolour

Signed, lower right, CRM.

Exhibited: Memorial Exhibition, 1933 (166).

Provenance: owned in 1933 by Andrew Allan, Esq.

Collection: untraced.

13 Glasgow Cathedral at Sunset* 1890

Watercolour 393 × 284

Signed and dated, lower right, CHAS. R. MCINTOSH 1890.

Literature: Billcliffe, p. 26.
Exhibited: Memorial Exhibition, 1933 (162; lent by Miss Nancy Mackintosh); Edinburgh, 1968 (8, plate 3).
Provenance: owned during Mackintosh's lifetime by his sister, Miss Nancy Mackintosh; Mrs Ellen Gibb, another sister, from whose estate purchased 1966.
Collection: Glasgow University.

Mackintosh made several pencil sketches of details of the Cathedral during the later 1880s. This work, however, is concerned with the pictorial impact of the building and is Mackintosh's earliest surviving water-colour which interprets, rather than records.

The signature shows the original form of his sur-name; it became *Mackintosh* about 1892–93.

14 Doorway, Trinità Maggiore, Naples 1891
Pencil and watercolour 242 × 178 (sight)
Signed and dated.
Exhibited: Toronto, 1967 (114).
Collection: Professor T. Howarth.

Mackintosh started his Italian tour, financed by his winning the Alexander Thomson Travelling Scholar-ship in 1890, at Naples. At this early stage in his tour he was most concerned with recording details of buildings, his pencil drawings often enhanced with watercolour, but as he travelled through Italy his approach changed and many of the later sketches seem to have been conceived as watercolour paintings, such as *Palazzo Pubblico, Siena* (22) and the Venetian studies (27–29). Mackintosh sent some of these sketches back to Glasgow where they were shown at the School of Art Exhibitions (Howarth, p. 11) and in 1892 he exhibited some at the Glasgow Institute of Fine Arts.

Mackintosh was in Naples from 5 to 9 April, and his diary (collection: Glasgow University) records that he made this sketch on the morning of 8 April 1891.

15 Cloisters, Monreale* 1891
Pencil and watercolour 368 × 165
Provenance: acquired by William Meldrum after the Memorial Exhibition, 1933; by family descent.
Collection: James Meldrum, Esq.
Illustrated on p. 55.

Mackintosh recorded in his diary that he sketched the cloisters of the convent at Monreale on 14 April 1891; he was most impressed by the beauty of the carved capitals. He counted 112 capitals in the cloister and noted that they were all different; perhaps they in-spired the variety of the capitals of the pilasters in the Glasgow School of Art Boardroom in 1906 and the variations in the incised decoration of the pendants in the Library of 1909.

16 Campanile Martorana, Palermo 1891
Pencil and watercolour 318 × 178 (sight)
Signed, dated and inscribed, lower right, *C. M. Palermo, 1891/Campanile/Martorama* (sic).
Exhibited: Toronto, 1967 (116).
Collection: Professor T. Howarth.
Illustrated on p. 52.

Mackintosh stayed in Palermo from 12 to 18 April. He was much more impressed with this town than with Naples, and his diary records that he made several

sketches there, but it does not distinguish the water-colours from the pencil drawings. This watercolour was made on 15 April; Mackintosh was surrounded by a crowd of onlookers who refused to go away, and he records how he had to finish the sketch in the seclusion of his hotel room.

17 Arch of Titus, Rome 1891
Watercolour
Collection: untraced.

In his diary (collection: Glasgow University) Mackintosh records that he made a watercolour sketch of the Arch of Titus on 22 April 1891. He also men-tions sketches of the Coliseum and the house of Nero, but it is not clear whether these were also watercolours or merely pencil sketches.

18 Orvieto Cathedral: Part of the North Façade*
Pencil and watercolour 318 × 242 1891
Signed and dated, lower right, CRM/1891; inscribed, lower left, ORVIETO.
Exhibited: Edinburgh, 1968 (13).
Provenance: Mackintosh Estate.
Collection: Glasgow University.
Illustrated on p. 54.

Mackintosh was in Orvieto from 5 to 9 May 1891. The banding of the different coloured stone has caught his attention: pattern plays an important part in most of the Italian watercolours which he produced.

18a Spiral Column, Orvieto Cathedral 1891
Pencil and watercolour 223 × 305
Inscription, upper centre, *Orvieto Cathedral/Mosaic Bands in Spiral Column/Front Door.*
Collection: Professor T. Howarth.

18b Mosaic Bands, Orvieto Cathedral 1891
Pencil and watercolour 223 × 305 (sight)
Inscription, upper centre, *Mosaic Bands,* and, lower centre, *Orvieto Cathedral./Interior.*
Collection: Professor T. Howarth.

19 The Baptistry, Siena Cathedral* 1891
Pencil and watercolour 391 × 279
Signed, lower left, C. R. McINTOSH.
Provenance: acquired by William Meldrum after the Memorial Exhibition, 1933; by family descent.
Collection: James Meldrum, Esq.
Illustrated on p. 51.

Mackintosh was at Siena from 10 to 19 May and spent most of his time sketching in and around the Cathedral.

20 Siena Cathedral: Detail of Buttress 1891
Pencil and watercolour 305 × 115 (sight)
Exhibited: Toronto, 1967 (113).
Collection: Professor T. Howarth.

21 Doorway of Library, Siena Cathedral 1891
Pencil and watercolour 382 × 269
Signed and dated, lower right, CRM MAY 1891; inscribed, lower centre, ENTRANCE TO LIBRARY. SIENA CATHEDRAL.
Exhibited: Memorial Exhibition, 1933 (77).
Provenance: owned in 1933 by Professor Randolph Schwabe; by family descent.
Collection: Mr and Mrs H. Jefferson Barnes.

22 The Palazzo Pubblico, Siena 1891
Watercolour, folded to 369 × 165
Exhibited: Memorial Exhibition, 1933 (127); Edinburgh, 1968 (12).
Provenance: C. R. Mackintosh; by family descent.
Collection: Miss Moira Dingwall.
Illustrated on p. 52.

Mackintosh sketched the Palazzo Pubblico on 11 May 1891.

23 Tomb of Carlo Marsuppini, Santa Croce, Florence 1891
Pencil and watercolour 370 × 255 (sight)
Signed and dated.
Exhibited: Toronto, 1967 (117).
Collection: Professor T. Howarth.

Mackintosh was in Florence from 19 to 26 May, and at Santa Croce on 21 and 22 May.

23a Decoration from Roof of S. Miniato, Florence 1891
Pencil and watercolour 280 × 370 (sight)
Signed and dated, lower left, *C.R.M. May 1891*; inscribed, left centre, *Decoration from Roof of/S. Miniato Florence*.
Collection: Professor T. Howarth.

24 The Pitti Bridge, Florence 1891
Watercolour
Collection: untraced.

On 25 May, Mackintosh made a watercolour of the Pitti Bridge which he worked on again the following day.

24a Della Robbia Frieze, Florence 1891
Pencil and watercolour 387 × 280
Signed and dated, lower right, *C.R.M., May 1891*; inscribed, *A Della Robbian* (sic) *Frieze/Museo Nationale/Florence/1 Third full size*.
Collection: Professor T. Howarth.

25 Detail of Angel and Saints from a Mosaic in Sant'Apollinare Nuovo, Ravenna 1891
Pencil and watercolour 432 × 342
Exhibited: Edinburgh, 1968 (15).
Provenance: Mackintosh Estate.
Collection: Glasgow University.

Mackintosh was in Ravenna from 28 May to 1 June.

26 Mosaics in Sant'Apollinare in Classe, Ravenna 1891
Pencil and watercolour 472 × 330
Signed, lower right, *Chas R Mackintosh*; inscribed, lower left, *Mosaic Decoration/St Apollinaris in Classe/Ravenna*.
Provenance: Mackintosh Estate.
Collection: Glasgow University.

27 Palazzo Ca d'Oro, Venice 1891
Watercolour
Exhibited: GIFA, 1892 (775, not for sale); Memorial Exhibition, 1933 (164).
Provenance: Miss Nancy Mackintosh, 1933.
Collection: untraced.
Illustrated on p. 53.

Probably drawn on the first day of Mackintosh's stay in Venice; he was in the city from 2 to 10 June.

28 The Lido, Venice* 1891
Watercolour 117 × 343
Exhibited: Memorial Exhibition, 1933 (115); Edinburgh, 1968 (17, plate 3).
Provenance: by family descent to Mrs Ellen Gibb, from whose estate purchased.
Collection: Glasgow University.
Illustrated on pp. 56–57.

McLaren Young (Edinburgh, 1968) notes Mackintosh's indebtedness to Whistler in his choice of subject matter and his handling of the composition.

29 Venetian Palace 1891
? Watercolour
Exhibited: GIFA, 1892 (796).
Collection: untraced.

30 St Jerome, Milan Cathedral 1891
Pencil and watercolour 305 × 216 (sight)
Signed and dated, lower right, CRM/JUNE 1891; inscribed, upper right, S. GEROLAMO/MILAN/CATHEDRAL.
Exhibited: Toronto, 1967 (115); Edinburgh, 1968 (18).
Collection: Professor T. Howarth.

Mackintosh was in Milan from 27 June to 7 July.

31 Detail of a Buttress, Milan Cathedral 1891
Pencil and watercolour 337 × 235 (sight)
Signed and dated, lower right, *C.R.M./June 1891*; inscribed, centre right, *A Buttress/Milan/Cathedral*.
Exhibited: Toronto, 1967 (120).
Collection: Professor T. Howarth.

See 30.

32 Blind Window, Certosa di Pavia 1891
Pencil and watercolour 675 × 380 (including original mount)
Signed and dated, on mount, lower right, CRM JULY 1891; inscribed, lower left, CERTOSA DI PAVIA.
Exhibited: Edinburgh, 1968 (20).
Collection: Glasgow School of Art.

The last entry in the diary of Mackintosh's Italian tour indicates that he left Milan for Pavia on 9 July, but no details are given of any drawings made after that date.

32a Entrance Gateway, Certosa di Pavia 1891
Pencil and watercolour 342 × 245 (sight)
Inscribed, lower centre, *Entrance Gateway/Certosa di Pavia*.
Collection: Professor T. Howarth.

32b Doorway, Certosa di Pavia 1891
Pencil and watercolour 330 × 242 (sight)
Signed, dated and inscribed, lower right, *C.R.M./July 1891/Doorway/Certosa di Pavia*.
Collection: Professor T. Howarth.

32c Study of a Carved Angel, Certosa di Pavia 1891
Pencil and watercolour 317 × 242
Inscribed, lower right, *Certosa di Pavia*.
Collection: Professor T. Howarth.

33 Ceiling Decoration, Certosa di Pavia 1891
Pencil and watercolour 337 × 235 (sight)
Inscribed, lower right, *ceiling decoration/Certosa di Pavia*.
Exhibited: Toronto, 1967 (118).
Collection: Professor T. Howarth.

See 32.

33a Intarsia Panel, Certosa di Pavia 1891
Pencil and watercolour 240 × 345 (sight)
Inscribed, upper right, *Intersia palel* (sic)/*Certosa di Pavia*.
Collection: Professor T. Howarth.

33b Intarsia Panel, Certosa di Pavia 1891
Pencil and watercolour 240 × 318 (sight)
Inscribed, lower right, *Intersia* (sic) *panel/Certosa di Pavia/½ Full size.*
Collection: Professor T. Howarth.

33c Intarsia Panel, Certosa di Pavia 1891
Pencil and watercolour 240 × 358 (sight)
Inscribed, centre, *Intersia* (sic) *panel/Certosa di Pavia.*
Collection: Professor T. Howarth.

33d Intarsia Panel, Certosa di Pavia 1891
Pencil and watercolour 240 × 343 (sight)
Inscribed, lower left, *Intersia* (sic) *panel/Certosa di Pavia.*
Collection: Professor T. Howarth.

33e Intarsia Panel, Certosa di Pavia 1891
Pencil and watercolour 240 × 318 (sight)
Inscribed, right, *Intersia* (sic) *panel/Certosa di Pavia.*
Collection: Professor T. Howarth.

34 Triumphal Arch 1891
Pencil and watercolour 235 × 235 (sight)
Signed and dated.
Exhibited: Toronto, 1967 (119).
Collection: Professor T. Howarth.

35 Angel 1891
Pencil and watercolour
Exhibited: Memorial Exhibition, 1933 (84).
Provenance: with W. Davidson at time of Memorial Exhibition.
Collection: untraced.

A drawing of a piece of sculpture or leaded glass window depicting an angel or saint, possibly from the Italian tour.

36 Church Tower c1891
Watercolour 365 × 171
Exhibited: Memorial Exhibition, 1933 (129); Edinburgh, 1968 (21).
Provenance: C. R. Mackintosh; by family descent.
Collection: Miss Moira Dingwall.
Illustrated on p. 53.

It has been suggested by McLaren Young (Edinburgh, 1968) that this unidentified church might be in Lombardy and that the watercolour dates from 1891. Stylistically, the work appears to date from 1890 to 1893 which would support this theory.

37 The Harvest Moon* 1892
Pencil and watercolour 352 × 276
Signed and dated, lower right, CHAS. R. McINTOS/H/ 1892; inscribed, verso, on a decorative label, THE HARVEST MOON/CHAS. R. MACKINTOSH/1893/TO JOHN KEPPIE/OCTOBER/1894.
Literature: Howarth, p. xxx–xxxi.
Exhibited: GIFA, 1894 (864); Edinburgh, 1968 (53, plate 4).
Provenance: given to John Keppie, 1894; A. Graham Henderson, by whom presented.
Collection: Glasgow School of Art.
Illustrated on p. 58.

The first of a series of mystical drawings by Mackintosh which culminated in the drawings for The Magazine of the Glasgow School of Art. McLaren Young (Edinburgh, 1968) was the first to point out the date, 1892, which was apparently forgotten by the artist when he gave the picture to John Keppie in 1894. Howarth does not accept that *The Harvest Moon* pre-dates the figure in the frieze of Mackintosh's bedroom (illustrated Howarth, plate 5a), although the differences between the two are quite clear. The angel is seen here silhouetted against the moon, with arms outstretched and hair and draperies swirling about her. She appears to stand on a cloud, and another band of mist or cloud passes between her and the moon. The foreground is a tangle of bracken, twigs and leaves. All of this, however, is quite carefully drawn and the figure in particular is fairly naturalistic. This is not obvious at first glance, because the delicate pencil lines have less impact than the bright colours of the foreground and the subtle colour wash of the sky. As McLaren Young says, it is a prelude to the so-called Spook School, but the figure is not—as he would have it—unequivocally Art Nouveau.

The figure in the frieze is archetypal of that family of eerie, emaciated figures which The Four made a *leitmotif* in the mid-1890s. Instead of the controlled arabesques of hair and wings of *The Harvest Moon* angel, the gown of the figure in the frieze hangs in stylised fashion, hiding rather than delineating the body beneath it, while its hair streams out across the top of the frieze in unnaturalistic profusion. On stylistic grounds alone, the frieze must date from c1896, and Howarth's admittedly circumstantial dating of the room to c1890 can be challenged by other evidence suggesting a date of 1895–96 (*see* Billcliffe, *Charles Rennie Mackintosh: The Complete Furniture, Furniture Drawings and Interior Designs*, 1978).

The colours used in *The Harvest Moon*, many of which first appear in Mackintosh's oeuvre in *Glasgow Cathedral at Sunset* (13), were to be re-used in most of the drawings for The Magazine in 1894–96. Deep purples and blues, often thinning to a limpid colour wash, are highlighted by touches of orange and red and contrasted with acid greens. They are chosen to match the subject-matter, a mystical world peopled with melancholic figures and even more tormented plant-life.

38 Spring 1894
Watercolour and pencil
Literature: Howarth, p. 26, plate 7a.
Provenance: Miss Lucy Raeburn (Mrs Ritchie), with whom in 1945.

Collection: untraced—no longer contained in the April 1894 issue of The Magazine.

The first cover of the April 1894 issue of The Magazine, hand-written by Lucy Raeburn and circulated among students at the Glasgow School of Art. Mackintosh made three watercolours for The Magazine which depicted the seasons (38, 42, and 47), and he also provided several other illustrations for various issues.

Spring and *Winter* (47) are variations on a theme of two nude figures, both female. Like the angels in *The Harvest Moon* (37) and *Descent of Night* (39) these figures are carefully drawn and, as Howarth points out, by no means as emaciated and stylised as those in contemporary drawings by MacNair or the Macdonald sisters. Each of the figures is shown living below ground, stretching as if wakening from a long sleep and thrusting a hand through the soil. Other buds and stems have just broken through and their long underground stems reach down to bulbs and tubers at the bottom of the picture. The sun is just appearing above the horizon to welcome the first signs of life of the new year.

Mackintosh was to use similar motifs elsewhere; the awakening bulb, with its long green stems and unopened flower buds became a favourite motif and was used even on posters and designs for furniture.

39 The Descent of Night* c1893–94
Pencil and watercolour 240 × 170
Literature: Alison, p. 91.
Exhibited: Edinburgh, 1968 (60, plate 4); Boymans Museum, Rotterdam, and subsequent tour, 'Symbolism in Europe', 1975–76 (99).
Provenance: Lucy Raeburn (Mrs Ritchie); Katherine Cameron (Mrs Arthur Kay), by whom presented c1950.
Collection: Glasgow School of Art.
Illustrated on p. 59.

From the April 1894 issue of The Magazine. As with *Spring* (38) the symbolism is relatively simple to interpret, unlike the strange designs of 1895. The central figure is based upon that used in the 1893 design for a diploma for the Glasgow School of Art Club (Howarth, plate 7c) and, like that in *The Harvest Moon* (37), has wings like an angel. Here, however, she appears naked and her outstretched arms and hair merge and are transformed into barren tree-like forms. These descend to the horizon, behind which the sun is gradually disappearing under the feet of the winged figure. From the bottom of the picture, and directly beneath the sun, rises a flight of menacing birds. They are presumably nocturnal birds of prey and they seem to be flying directly towards the viewer. This is one of Mackintosh's earliest uses of this strange bird, which was to become more and more stylised and to appear in many different forms, in several media, in his oeuvre.

40 Cabbages in an Orchard* 1894
Pencil and watercolour 86 × 236
Inscribed, verso, *Cabbages in an Orchard*.
Literature: Pevsner, 1968, p. 156; Alison, p. 19; Scottish Art Review, XI, 4, 1968, p. 1.
Exhibited: Edinburgh, 1968 (61).
Provenance: as 39.

Collection: Glasgow School of Art.
Illustrated on pp. 56–57.

From the April 1894 issue of The Magazine. In the text which accompanies the drawing, Mackintosh indicates that he drew the cabbages in the early spring of 1894. The text, reprinted below, suggests that he had already encountered public hostility to his work, possibly even from his fellow students, on the grounds of incomprehensibility. This is his somewhat tongue-in-cheek reply:

Cabbages in an Orchard
The above title explains the picture on the opposite page, but to satisfy the ordinary ignorant reader I am forced to give the following explanation—

The before mentioned kind of reader may imagine that the cabbages here shewn are the usual kind of every day cabbage, or as some people call it "Common or garden cabbage", but that is just because they never see cabbages unless when they are not growing. The cabbages in this orchard are different—they have stood through a severe winter of snow, and hail, and frost, and thunder: they have stood through a spring lasting three months, and raining all the time, and before they had time to dry in an ordinary way the sun came out with frizzling ferocity—yet still they stand.

A glance at the sketch will convince any one—(although it conveys but a poor idea of the rich variety of colour, the beautiful subtlety of proportion and infinity of exquisite form)—that the cabbages here shewn are a particularly hardy and long suffering kind.

Neither is the orchard a common kind of orchard. I explain this because some people may not distinguish between cabbage and orchard, and will grumble accordingly. They may be right, the trees are old trees, very old trees, they are far away from any other trees, and I think they have forgotten what trees should be like.

You see they have lived alone for a long time with nothing to look at but cabbages and bricks, and I think they are trying to become like these things. That at least is what their present appearance would suggest (and the sketch suggests the same thing in a less perfect way). I know this much, I have watched them every day this winter and I have never once seen an apple, or an orange, or a pear on one of them, and I have seen clothes—and what is more I have seen mud—and a brickmaker once told me that bricks were made of mud. The mud I saw must have been the beginning of bricks.

I would explain before concluding, that anything in the sketch you cannot call a tree or a cabbage—call a gooseberry bush. And also that this confusing and indefinite state of affairs is caused by the artist—(who is no common landscape painter, but is one who paints so much above the comprehension of the ordinary ignorant public, that his pictures need an accompanying descriptive explanation such as the above).
C. R. Mackintosh.'

41 Stylised Plant Form c1894
Pencil and watercolour 255 × 107
Provenance: as 39.
Collection: Glasgow School of Art.
Illustrated on p. 61.

From the November 1894 issue of The Magazine. Mackintosh has reduced the stems and flowers of this

plant to a diagrammatic pattern in what is his most stylised work of the period.

42 Autumn 1894
Pencil and watercolour on buff paper 282 × 132
Signed, dated and inscribed, right, CHAS. R. MACKINTOSH NOVEMBER 1894, and, left, AUTUMN.
Literature: Alison, p. 78.
Exhibited: Edinburgh, 1968 (66).
Provenance: as 39.
Collection: Glasgow School of Art.

From the November 1894 issue of The Magazine. Behind a stylised tree stands another of Mackintosh's mysterious female figures, but this is the first one to appear that is not meticulously drawn. Only the head is shown in any detail, and the shape of the body is hidden by a voluminous cloak from which not even its limbs appear. This figure was to be repeated many times, becoming more and more stereotyped until, with the banners designed for the Turin Exhibition in 1902, the head is the only recognisably human part of a figure with a twelve-foot-long, pear-shaped torso.

In 1895–96 Mackintosh was to develop this drawing into a poster for the Scottish Musical Review (Howarth, plate 9f). The same cloaked figure appears again with similar formal emblems at the ends of the branches of the bush.

43 A Tree* 1894
Watercolour 338 × 189
Signed and dated, lower left, (vertically) CRM/1894.
Exhibited: Saltire, 1953 (B29).
Provenance: Mackintosh Estate.
Collection: Glasgow University.

Less stylised than some of the natural forms in the drawings of 1894–96 for The Magazine, but not as successful. The colour washes have not been very carefully controlled and the subtleties of The Tree of Influence (45) have been lost in the resulting flood of colour.

44 The Tree of Personal Effort* 1895
Pencil and watercolour, painted area 211 × 174, sheet 322 × 236
Signed, dated and inscribed, right, vertically, THE TREE OF PERSONAL EFFORT THE SUN OF INDIFFERENCE/CHARLES RENNIE MACKINTOSH JANUARY 1895.
Literature: Howarth, p. 27.
Exhibited: Edinburgh, 1968 (72, plate 5); Boymans Museum, Rotterdam, and subsequent tour, 'Symbolism in Europe', 1975–76 (101).
Provenance: as 39.
Collection: Glasgow School of Art.
Illustrated on p. 68.

From the Spring 1896 issue of The Magazine. The exact meaning of the symbolism of this work, and its companion The Tree of Influence (45), has eluded all commentators on Mackintosh's early watercolours. It seems possible that it relates to discussions held by the students, as several of the drawings in The Magazine relate to topical student causes and beliefs, but it is equally possible that it was just as unintelligible to even the small clique who read The Magazine (see Mackintosh's earlier written description of Cabbages in an Orchard, 40).

The obvious source of the symbolism is nature, and Mackintosh here reaches his most extreme distortion of organic forms.

45 The Tree of Influence* 1895
Pencil and watercolour, painted area 214 × 172, sheet 318 × 232
Signed, dated and inscribed, right, vertically, THE TREE OF INFLUENCE THE TREE OF IMPORTANCE THE SUN OF/COWARDICE. CHARLES RENNIE MACKINTOSH—JANUARY 1895.
Literature: Howarth, p. 27, plate 6b.
Exhibited: Edinburgh, 1968 (71, plate 5); Boymans Museum, Rotterdam, and subsequent tour, 'Symbolism in Europe', 1975–76 (102).
Provenance: as 39.
Collection: Glasgow School of Art.
Illustrated on p. 69.

From the Spring 1896 issue of The Magazine. See 44.

46 Wareham 1895
Watercolour
Signed, lower right, CHARLES RENNIE MACKINTOSH.
Exhibited: Toronto, 1967 (49, under title Worth Matravers).
Collection: Professor T. Howarth.
Illustrated on p. 65.

Mackintosh visited Wareham in 1895 while on a sketching tour of Dorset. The inn in front of the church, with its sign swinging above the door, also appears in a pencil sketch, but superimposed on a different view of the church tower (Billcliffe, p. 10).

47 Winter 1895
Pencil and watercolour on tracing paper 318 × 240
Signed, dated and inscribed, vertically, right, WINTER CHAS R. MACKINTOSH—1895.
Provenance: as 39.
Collection: Glasgow School of Art.

From the Spring 1896 issue of The Magazine. The symbolism is similar to that of Spring (38), but here the two figures are seen asleep, awaiting the return of life in spring.

48 Winter* 1895
Pencil and watercolour on tracing paper 313 × 208
Signed, dated and inscribed, vertically, right, WINTER CHAS R MACKINTOSH 1895.
Literature: L'Arte Moderna (Milan) II, 1967, p. 252.
Exhibited: Edinburgh, 1968 (67, plate 4).
Provenance: Mackintosh Estate.
Collection: Glasgow University.
Illustrated on p. 64.

This drawing is a study for 47, from the Spring 1896 issue of The Magazine.

49 The Shadow* c1895–96
Pencil and watercolour on blue paper 300 × 180
Signed, lower right, CRM.
Exhibited: Edinburgh, 1968 (70, plate 4); Boymans Museum, Rotterdam, and subsequent tour, 'Symbolism in Europe', 1975–76 (100).
Provenance: as 39.
Collection: Glasgow School of Art.
Illustrated on p. 76.

From the Spring 1896 issue of The Magazine. More stylisation of organic shapes, but strangely—or ominously—the shadow does not correspond with the object in front.

50 Porlock Weir* c1895–98
Watercolour 274 × 413
Signed, lower right, C. R. MACKINTOSH; inscribed, verso, PORTLOCK (sic) WEIR.
Provenance: anonymous sale, Sotheby's Gleneagles, 25 August 1972, lot 279; J. & R. Edmiston, Glasgow, 21 February 1974, lot 72.
Private collection.
Illustrated on p. 65.

There is no other evidence to suggest that Mackintosh visited Porlock Weir, although he was in Dorset and the South-West in 1895 and the West Country in 1898. Stylistically, there has been some doubt about the authenticity of this watercolour: the signature is similar to the signatures of the 1920s; the composition is unusual for Mackintosh; and the choice of subject is unusual for the 1890s, although it cannot belong to the London period either. However, the colours are similar to those used in *Glasgow Cathedral at Sunset* (13) and those in the watercolours for The Magazine, c1894–96. Enigmatic as this work is, the recent discovery of the inscription on the back of the drawing— hidden beneath an old piece of framing tape—which is undeniably in Mackintosh's hand and has a characteristic spelling mistake, points to the likely authenticity of the work.

51 Part Seen, Imagined Part* 1896
Pencil and watercolour on tracing paper 390 × 195
Signed and dated, lower right, CHARES (sic)/RENNIE/MACKINT/OSH/APRIL./1896; inscribed, upper right, PART/SEEN/IMAG/INED/PART.
Literature: Howarth, p. 38.
Exhibited: London, Arts and Crafts Exhibition Society, 1896 (589); Memorial Exhibition, 1933 (82).
Provenance: C. R. Mackintosh; Talwin Morris, by whose widow presented.
Collection: Glasgow Art Gallery.
Illustrated on p. 71.

As this drawing is dated April 1896, it seems likely that it preceded the commission from Miss Catherine Cranston to prepare mural decorations for her Tea Rooms in Buchanan Street, opened in 1897. The largest of these murals is obviously based upon the single figure in this drawing (see Howarth, plate 48a; Macleod, plate 40). Mackintosh's figures are rarely as statuesque as this, but he has used again the device of hiding the shape of the body beneath a voluminous gown. Around the trunk-like body are wreathed tendrils and branches like the thicket of twigs in *The Harvest Moon* (37). Glasgow University has scale watercolour drawings for the frieze of ladies and a peacock from the Buchanan Street murals.

The frame around the picture was designed by Talwin Morris.

52 In Fairyland* 1897
Pencil and watercolour 370 × 176
Signed and dated, lower right, CHAS. R. MACKINTOSH/1897.

Exhibited: Memorial Exhibition, 1933 (141).
Provenance: purchased at Memorial Exhibition by James Davidson; by family descent.
Private collection.
Illustrated on p. 77.

After 1896, when more of his time was devoted to architectural design, Mackintosh's output of watercolours decreased. The subject matter in the remaining few also changed from the eerie symbolism of the drawings for The Magazine to a less malevolent fairy-tale world. This change is also apparent in the work of Frances and Margaret Macdonald and it is probably a reflection of The Four's growing interest in the work of Maeterlinck. At Glasgow University are three old and almost indecipherable photographs of similar fairy subjects; the original paintings are lost.

53 Details of the Roof, Napton Church, Norfolk
Pencil and watercolour 560 × 394 1897
Inscribed, lower left, ROOF:/NAPTON/CHURCH/NORFOLK.
Provenance: acquired by William Meldrum after the Memorial Exhibition, 1933; by family descent.
Collection: James Meldrum, Esq.

One of the few drawings made on Mackintosh's many sketching trips of the 1890s to have added watercolour washes.

54 Princess Ess c1897–98
? Watercolour
Exhibited: RSW, 1898 (142, not for sale); GIFA, 1899 (683, not for sale).
Collection: untraced.

This drawing was probably a companion to 55. The subject matter echoes the princesses who appear in several works of this period by the Macdonald sisters.

55 Princess Uty c1897–98
? Watercolour
Exhibited: RSW, 1898 (145, not for sale).
Collection: untraced.

See 54.

56 In Poppyland c1897–98
Watercolour
Exhibited: Memorial Exhibition, 1933 (149).
Provenance: purchased at Memorial Exhibition by William Davidson.
Collection: untraced.

The photographs of the Memorial Exhibition installation show this drawing to be closely related to *In Fairyland* (52).

57 Reflections* 1898
Watercolour, pencil and silver paint 511 × 248
Signed and dated, lower right, CHARLES/RENNIE/MACKINTOSH/1898.
Provenance: Charles Macdonald; by family descent to Mrs L. A. Dunderdale, by whom presented, 1959.
Collection: Glasgow University.
Illustrated on p. 70.

58 Fairies* 1898
Pencil and watercolour 527 × 256

Signed and dated, lower right, CHARLES/RENNIE/
 MACKINTOSH/1898.
Exhibited: Memorial Exhibition, 1933 (167); Saltire,
 1953 (B28); Edinburgh, 1968 (84).
Provenance: purchased at Memorial Exhibition by
 Sam Mavor, by whom presented.
Collection: Glasgow School of Art.
Illustrated on p. 70.

As McLaren Young pointed out, Mackintosh's style
here is the closest he ever came to that of Margaret
Macdonald and her sister, but his figures are always
more substantial and the subject matter less whimsical
or sugary than that of the two girls could be.

59 'Whether the roses be your lips . . .' c1898
Pencil and watercolour on tracing paper 465 × 185
Signed, upper right, CHARLES/RENNIE/MACKINTOSH;
 inscribed, upper left, WHETHER THE ROSES/BE
 YOUR LIPS/OR YOUR LIPS THE ROSES.
Exhibited: Edinburgh, 1968 (85).
Provenance: acquired by William Meldrum after the
 Memorial Exhibition, 1933; by family descent.
Collection: James Meldrum, Esq.

60 The Black Thorn c1898–99
? Watercolour
Exhibited: London, ISSPG, 1899 (216).
Collection: untraced.

61 The Moss Rose c1898–99
? Watercolour
Exhibited: London, ISSPG, 1899 (118).
Collection: untraced.

62 The Wassail 1900
Pencil and watercolour on tracing paper 320 × 680
 (sight)
Signed, lower right, CHAS. R/MACKINTOSH.
Literature: Howarth, p. 132–33, note 1.
Exhibited: Turin, 1902; Saltire, 1953 (B25).
Collection: Professor T. Howarth.

A drawing for the large gesso panel for the Ingram
Street Tea Rooms, Glasgow; Margaret produced a
companion design, *The May Queen* (collection: Pro-
fessor T. Howarth).

63 Purple Mallows, Holy Island 1901
Pencil and watercolour 258 × 202
Signed, dated and inscribed, lower right, PURPLE
 MALLOWS/HOLY ISLAND/JULY 1901/M T.
Provenance: acquired after the Memorial Exhibition,
 1933, by R. W. B. Morris, a partner in Charles
 Macdonald's legal firm and an executor of Margaret
 Macdonald Mackintosh's estate.
Collection: R. W. B. Morris, Esq.

Although the Mackintoshes spent their honeymoon on
Holy Island in 1900, no drawings from that year have
been traced. They returned in 1901 with Herbert and
Frances MacNair and Margaret's brother, Charles, and
Mackintosh produced a memorable series of flower
drawings. Although he had often made pencil drawings
of flowers in his sketch-books, this was the first time
that he added colour. It is used tentatively at first, but
in later drawings of flowers it becomes most important,
not simply illustrating the delicate colours of the

flowers, but also an integral part of the design and
pattern of the picture.

The M and T in the inscription stand for Margaret
and Tosh, Mackintosh's family nickname. The appear-
ance of both sets of initials on a drawing does not mean
that it is a joint work: Mackintosh did not collaborate
with Margaret in such a way and would not allow
anyone to add to his drawings. He was, in fact, simply
using his drawings as a family album, recording those
who were with him when a drawing was made (*see* 67).

64 Milk Thistle, Holy Island 1901
Pencil and watercolour 258 × 202
Signed, dated and inscribed, lower right, MILK
 THISTLE/HOLY ISLAND/JULY 1901/M T.
Provenance: R. W. B. Morris (as 63); Sotheby's
 Belgravia, 7 November 1973, lot 166, bought by
 Piccadilly Gallery, London.
Collection: Piccadilly Gallery, London (1977).

65 Mustard-seed Flower, Holy Island 1901
Pencil and watercolour 258 × 202
Signed, dated and inscribed, lower right, MUSTARD/
 SEED/FLOWER/HOLY ISLAND JULY 1901/M T.
Provenance: R. W. B. Morris (as 63); Sotheby's
 Belgravia, 3 April 1974, lot 46.
Collection: untraced.

66 Flower Drawing, Holy Island 1901
Pencil and watercolour 258 × 202
Provenance: R. W. B. Morris (as 63).
Collection: untraced.

67 Storksbill, Holy Island 1901
Pencil and watercolour 258 × 202
Signed, dated and inscribed, lower right, HOLY
 ISLAND/JULY 1901/MTFBC.
Exhibited: Glasgow, 1977 (4).
Provenance: Mackintosh Estate.
Collection: Glasgow University.

The initials in the inscription stand for Margaret, Tosh
(Mackintosh), Frances (Macdonald MacNair), Bertie
(MacNair) and Charles (Macdonald, brother of Mar-
garet and Frances). *See also* 70 and 72.

68 Sea Pink, Holy Island 1901
Pencil and watercolour 258 × 202
Signed, dated and inscribed, lower right, SEA PINK./
 HOLY ISLAND/JULY 1901/M T.
Literature: Billcliffe, p. *38*.
Exhibited: Glasgow, 1977 (5).
Provenance: acquired by William Davidson after
 Memorial Exhibition; by whom presented, 1933.
Collection: Glasgow University.
Illustrated on p. 74.

Mackintosh has isolated a clump of sea pinks from their
setting against the rocks of the castle on Lindisfarne
which he drew at about the same time (*see* Billcliffe,
p. *68*).

69 Pimpernel, Holy Island 1901
Pencil and watercolour 258 × 202
Signed, dated and inscribed, lower right, PIMPERNEL/
 HOLY ISLAND/JULY 1901/M T.
Provenance: acquired by William Meldrum after the
 Memorial Exhibition, 1933; James Meldrum.

Private collection.
Illustrated on p. 74.

70 Brook Weed, Holy Island 1901
Pencil and watercolour 258 × 202
Signed, dated and inscribed, lower right, BROOKWEED/
 HOLY ISLAND/JULY 1901/MT FB C.
Exhibited: Edinburgh, 1968 (289).
Provenance: acquired by William Meldrum after the
 Memorial Exhibition, 1933; James Meldrum.
Private collection.

For an explanation of the inscription, *see* 67.

71 Yellow Clover, Holy Island 1901
Pencil and watercolour 261 × 203
Signed, dated and inscribed, lower right, YELLOW
 CLOVER/HOLY ISLAND/JULY 1901/M T.
Provenance: acquired by William Meldrum after the
 Memorial Exhibition, 1933; James Meldrum, by
 whom presented.
Collection: Victoria & Albert Museum, London
 (E.844–1968).
Illustrated on p. 74.

72 Hound's Tongue, Holy Island 1901
Pencil and watercolour 258 × 202
Signed, dated and inscribed, lower left, HOUNDS
 TONGUE/HOLY ISLAND/JULY 1901/M/T/F/B/C.
Exhibited: Edinburgh, 1968 (288, plate 8).
Provenance: R. W. B. Morris (as 63); Sotheby's
 Belgravia, 3 April 1974, lot 50.
Collection: untraced.
Illustrated on p. 74.

For an explanation of the inscription, *see* 67.

73 Cranesbill, Holy Island 1901/02
Pencil and watercolour 258 × 202
Signed, dated and inscribed, lower right, HOLY
 ISLAND/JULY 1902/M T.
Exhibited: Glasgow, 1977 (7).
Provenance: as 68.
Collection: Glasgow University.

Although dated 1902, it seems more likely that this
drawing dates from 1901 when Mackintosh revisited
Holy Island. There are no other drawings of Holy
Island dated 1902; indeed, there are no sketchbook
drawings at all for 1902. The date is probably a mis-
take, as Mackintosh frequently mis-spelled names on
his drawings and occasionally put down the wrong
date.

74 Semi-stylised Aconitum c1901–04
Pencil and watercolour 440 × 220
Exhibited: Turin, '*Il Sacro e il Profano nell'Arte dei
 Simbolisti*', 1969 (280).
Provenance: by family descent to Mrs L. A. Dunder-
 dale, by whom presented.
Collection: Glasgow University.

75 Iris c1901–05
Pencil and watercolour 270 × 206
Provenance: R. W. B. Morris (as 63); Sotheby's
 Belgravia, 3 April 1974, lot 45.
Collection: untraced.

76 Wild Carrot c1901–05
Pencil and watercolour 258 × 202
Provenance: R. W. B. Morris (as 63).
Collection: untraced.

77 Orange Blossom, St Mary's, Scilly* 1904
Pencil and watercolour 258 × 202
Signed, dated and inscribed, lower centre, ORANGE/
 BLOSSOM/SAINT/MARYS/SCILLY/1904/M T.
Provenance: R. W. B. Morris (as 63).
Private collection.

Mackintosh was on holiday in the Scilly Isles with
Margaret and was not there for any business purpose.

78 Woody Nightshade, St Mary's, Scilly 1904
Pencil and watercolour 258 × 202
Signed, dated and inscribed, lower left, WOODY
 NIGHTSHADE/BITTERSWEET/WOODY/NIGHTSHADE/ST
 MARYS/SCILLY/M T/1904.
Provenance: R. W. B. Morris (as 63); Sotheby's Bel-
 gravia, 13 March 1975, lot 47, bought in; Fine Art
 Society, London.
Private collection.
Illustrated on p. 75.

79 White Carnation, St Mary's, Scilly 1904
Pencil and watercolour 258 × 202
Signed, dated and inscribed, lower right, WHITE/
 CARNATION/SAINT/MARYS/SCILLY/1904/M T.
Exhibited: Edinburgh, Scottish Arts Council, 'The
 Need to Draw', 1975 (14).
Provenance: R. W. B. Morris (as 63).
Private collection.

80 Ivy Geranium, St Mary's, Scilly 1904
Pencil and watercolour 258 × 202
Signed, dated and inscribed, lower left, IVY/GERANIUM/
 SAINT/MARY'S/SCILLY/M T/1904.
Exhibited: Edinburgh, 1968 (290).
Provenance: R. W. B. Morris (as 63); Sotheby's Bel-
 gravia, 13 March 1975, lot 48.
Private collection.
Illustrated on p. 75.

81 Ixias, St Mary's, Scilly 1904
Pencil and watercolour 258 × 202
Signed, dated and inscribed, lower right, IXIAS/ST
 MARYS/SCILLY/1904/M T.
Exhibited: Edinburgh, Scottish Television, Festival
 Exhibition, '20th Century Scottish Drawings', 1976
 (69); Glasgow Art Gallery, 'Flower Paintings', 1977.
Provenance: acquired by William Meldrum after the
 Memorial Exhibition, 1933; James Meldrum, by
 whom presented, 1969.
Collection: Glasgow Art Gallery.

82 Scabious and Toadflax, Blakeney 1905
Pencil and watercolour 258 × 202
Signed, dated and inscribed, lower centre, SCABIAS
 (*sic*)/BLAKENEY/AUGUST 1905/M T/and inscribed,
 lower right, TOAD FLAX/YELLOW.
Exhibited: Edinburgh, 1968 (291).
Provenance: R. W. B. Morris (as 63); Sotheby's Bel-
 gravia, 7 November 1973, lot 164, bought by
 Piccadilly Gallery, London.
Collection: Piccadilly Gallery, London (1977).
Illustrated on p. 75.

83 **Faded Roses*** 1905
Watercolour 285 × 291
Signed, lower right, CRM/1905.
Exhibited: Memorial Exhibition, 1933 (73); Saltire,
 1953 (A13); Glasgow Art Gallery, 1973, and Ham-
 burg Kunsthalle, 1974, 'Scottish Painting 1880–
 1930' (31); Glasgow, 1977 (32).
Provenance: given by Mackintosh to Sybil Shering-
 ham, 1923; by whom presented, 1938.
Collection: Glasgow Art Gallery.
Illustrated on p. 80.

Mackintosh's first essay at larger-scale watercolour
painting since the late 1890s. 1905 was not a busy year
for him in his architectural practice, and there may
well be other works (untraced) of this type dating from
this period. *Faded Roses* is important because it points
the way to the development of Mackintosh's mature
style of watercolour painting. The colours are strong
and solid, the forms are naturalistic and not distorted,
and the dark background was to be repeated in the
later paintings of cultivated flowers painted in Chelsea
from 1915 to 1923.

84 **Tobacco Flower, Bowling** 1906
Pencil and watercolour 258 × 202
Signed, dated and inscribed, lower right, TOBACCO/
 MMM/CRM/BOWLING/JULY/1906.
Exhibited: Edinburgh, 1968 (292).
Provenance: R. W. B. Morris (as 63).
Private collection.
Illustrated on p. 75.

Bowling was the village on the Clyde where Margaret's
family lived.

85 **At the Edge of the Wood** c1905–06
Watercolour 500 × 370
Inscribed, verso, *At the edge of the wood.*
Literature: Howarth, p. 27, note 2.
Provenance: given by the Mackintoshes to Mrs Elsie
 Lang (*née* Newbery) as a wedding present in 1915;
 by family descent.
Private collection.
Illustrated on p. 81.

As Howarth points out, this watercolour is one of the
most puzzling drawings Mackintosh ever made. Al-
though there are identifiable parts of trees, one cannot
be certain of the species or distinguish tree from back-
ground. Mrs Lang hung the watercolour upside-down,
until her discovery of a group of silver birches growing
in a similar fashion on Arran gave her a clue to the
content of the picture.

86 **Tacsonia, Cintra, Portugal** 1908
Pencil and watercolour 258 × 202
Signed, dated and inscribed, lower left, CRM/MMM/
 CINTRA/JUNE/1908.
Exhibited: Edinburgh, 1968 (293, plate 9).
Provenance: R. W. B. Morris (as 63); Sotheby's
 Belgravia, 7 November 1973, lot 162, bought by
 Piccadilly Gallery, London; Galleria Galatea, Milan.
Collection: untraced.
Illustrated on p. 78.

Apart from his Italian journey (1891) and his visits to
Vienna (1900) and Turin (1902), this holiday visit to

Portugal is the only recorded foreign journey which
Mackintosh made before he settled in France in 1923.

87 **Centaurea, Withyham** 1909
Pencil and watercolour 258 × 202
Signed, dated and inscribed, CENTAURIA (*sic*)/WITHY-
 HAM/JUNE 1909 MMM/CRM.
Provenance: R. W. B. Morris (as 63); Sotheby's
 Belgravia, 3 April 1974, lot 48, bought by Piccadilly
 Gallery, London.
Collection: Piccadilly Gallery, London (1977).
Illustrated on p. 84.

88 **Spurge, Withyham** 1909
Pencil and watercolour 258 × 202
Signed, dated and inscribed, lower centre, SPURGE/
 WITHYHAM/JUNE 1909/C.R.M./MMM.
Literature: Alison, p. 80; Billcliffe, p.37.
Exhibited: Milan, 1973 (36); Glasgow, 1977 (8).
Provenance: Mackintosh Estate.
Collection: Glasgow University.
Illustrated on p. 84.

By 1909, the style and format of the flower drawings
was well established and there was to be little variation
in the drawings—other than in output—up to 1925,
the last recorded date at which Mackintosh was
painting flowers.
 The flowers are laid out to show them at their best
and emphasise their structure, but Mackintosh also
exploits them to create a pattern or design on his paper.
The pencil lines are filled with broad washes of subtle
colours and the inscription, with its enclosing box, is
incorporated into the drawing as an integral part of
the design.

89 **Blackthorn, Chiddingstone** 1910
Pencil and watercolour 258 × 202
Signed, dated and inscribed, lower centre, BLACK-
 THORN/CHIDDINGSTONE/KENT 1910/CRM MMM.
Literature: Billcliffe, p.55.
Exhibited: Glasgow, 1977 (11).
Provenance: Mackintosh Estate.
Collection: Glasgow University.

90 **Hazel Bud, Chiddingstone** 1910
Pencil and watercolour 258 × 202
Signed, dated and inscribed, centre right, HAZEL
 BUD./CHIDDINGSTONE/KENT 1910/CRM/MMM.
Exhibited: Glasgow, 1977 (12).
Provenance: Mackintosh Estate.
Collection: Glasgow University.

91 **Japonica, Chiddingstone*** 1910
Pencil and watercolour 258 × 200
Signed, dated and inscribed, lower centre, JAPONICA/
 CHIDDINGSTONE/CRM/MMM/1910.
Literature: Howarth, plate 80a.
Exhibited: Saltire, 1953 (A14); Edinburgh, 1968
 (294); Glasgow, 1977 (9).
Provenance: as 68.
Collection: Glasgow University.
Illustrated on p. 79.

92 **Cuckoo Flower, Chiddingstone** 1910
Pencil and watercolour 258 × 203
Signed, dated and inscribed, lower right, CUCKOO

FLOWER/CHIDDINGSTONE/APRIL 1910/CRM MMM.
Literature: Billcliffe, p. 56.
Exhibited: Glasgow, 1977 (13).
Provenance: as 68.
Collection: Glasgow University.
Illustrated on p. 84.

93 Flowering Ash, Chiddingstone 1910
Pencil and watercolour 266 × 216
Signed, dated and inscribed, FLOWERING ASH/CHID-
 DINGSTONE/KENT/CRM/MMM/1910.
Exhibited: Edinburgh, Fine Art Society, '100 Years
 of Scottish Painting', 1973, (74).
Provenance: R. W. B. Morris (as 63); Fine Art
 Society, London.
Private collection.

94 Oasthouses, Chiddingstone 1910
Pencil and watercolour on page of a sketchbook
 180 × 228
Literature: Billcliffe, p. 26.
Provenance: Mackintosh Estate.
Collection: Glasgow University.

Mackintosh had occasionally added touches of colour
to his more pictorial architectural sketches which were
made after 1900 (see Billcliffe, pp. 66, 68, 74, 77,
78–79), but these were intended to emphasise small
elements of the buildings which particularly interested
him, or to pick out plans from elevations in his com-
plicated sketches which merged the two. Oasthouses is
—with the exception of Wareham (46) and Porlock
Weir (50)—the first watercolour of a building to be
produced for its own sake since his Italian pictures of
1891. Although by no means as polished as the later
townscapes and landscapes, it does show how Mackin-
tosh was gradually turning away from pencil sketches
to more formal and carefully conceived watercolour
paintings. He does not, however, appear to have
painted any other similar subjects before his visit to
Walberswick in 1914 and 1915 (see 118–120).

95 Porch and Wisteria, Chiddingstone 1910
Pencil and watercolour on page of a sketchbook
 228 × 180
Signed, dated and inscribed, upper left, CHIDDING-
 STONE/KENT 1910/CRM MMM and WISTERIA.
Literature: Billcliffe, p. 66.
Exhibited: Glasgow, 1977 (10).
Provenance: Mackintosh Estate.
Collection: Glasgow University.

96 Beech Leaf, Chiddingstone 1910
Pencil and watercolour 258 × 202
Signed, dated and inscribed, BEECH LEAF/CHIDDING-
 STON/E/KENT./1910/MAY/C.RM MMM.
Provenance: acquired by William Meldrum after the
 Memorial Exhibition, 1933; by family descent.
Collection: James Meldrum, Esq.

97 Flowering Chestnut, Cowden 1910
Pencil and watercolour 241 × 187
Signed, dated and inscribed, lower right, FLOWERING/
 CHESTNUT / COWDEN / KENT / APRIL 1910 / CRM
 MMM.
Provenance: R. W. B. Morris (as 63); Fine Art
 Society, London.
Private collection.

98 Yellow Rose, Chiddingstone 1910
Pencil and watercolour
Signed, dated and inscribed, lower right, YELLOW/
 ROSE/CHIDDING/STONE/KENT/MAY 1910/CRM
 MMM.
Exhibited: Memorial Exhibition, 1933 (86).
Provenance: purchased at Memorial Exhibition by
 D. M. Mitchell.
Lost, probably destroyed.

99 Cowslip, Chiddingstone 1910
Pencil and watercolour 200 × 256
Signed, dated and inscribed, centre left, COWSLIP/
 CHIDDINGSTONE HOATH/KENT APRIL 1910/CRM
 MMM.
Provenance: R. W. B. Morris (as 63); Fine Art Society,
 London; Piccadilly Gallery, London.
Collection: Dr Tazzoli, Milan.
Illustrated on p. 84.

99a Wild Pansy and Wood Violet, Chiddingstone
 1910
Pencil and watercolour 258 × 202
Signed, dated and inscribed, WILD PANSY & WOOD
 VIOLET/CHIDDINGSTONE HOATH/MAY 1910/CRM
 MMM.
Provenance: purchased at Memorial Exhibition, 1933,
 by Jas. McClure & Son, Glasgow; from whom pur-
 chased by present owner.
Private collection.

99b Butterfly Flower, Bowling 1912
Pencil and watercolour 258 × 202
Signed, dated and inscribed, BUTTERFLY FLOWER/
 BOWLING 1912/CRM—MMM.
Provenance: purchased at Memorial Exhibition, 1933,
 by Jas. McClure & Son, Glasgow; from whom pur-
 chased by present owner.
Private collection.

Possibly a picture of Schizanthus.

100 Aster, Bowling 1912
Pencil and watercolour 249 × 203
Inscribed, lower centre, ASTER/BOWLING 1912.
Collection: R. W. B. Morris, Esq.

101 A Yew Tree at Night* 1913
Pen and ink and watercolour 302 × 128
Signed and dated, lower right, C. R. MACKINTOSH/
 1913; inscribed, below, A YEW. TREE. AT NIGHT.
Literature: Howarth, p. 27, note 2 (but wrongly noted
 as being owned by Mrs Lang and with incorrect
 date).
Exhibited: Edinburgh, 1968 (96).
Provenance: given by Mackintosh to the present
 owner.
Collection: Mrs Mary Newbery Sturrock.

A fantasy, worked up from a few marks on a sheet of
blotting paper.

102 Henbane, Holy Island 1913
Pencil and watercolour 258 × 202
Signed, dated and inscribed, HENBANE/HOLY ISLAND/
 1913/CRM MMM.
Provenance: R. W. B. Morris (as 63); Fine Art Society,
 London; Piccadilly Gallery, London.
Private collection.

103 Bugloss, Holy Island 1913
Pencil and watercolour 200 × 256
Signed, dated and inscribed, lower left, Bugloss/
 Holy Island/July 1913/CRM/MMM.
Provenance: R. W. B. Morris (as 63); Fine Art Society,
 London; Piccadilly Gallery, London.
Collection: Dr Tazzoli, Milan.
Illustrated on p. 85.

104 Leycesteria, Walberswick 1914
Pencil and watercolour 258 × 202
Signed, dated and inscribed, lower left, Leycesteria/
 Walberswick/August 1914/CRM MMM.
Provenance: R. W. B. Morris (as 63); Sotheby's
 Belgravia, 7 November 1973, lot 165, bought by
 Albuquerque.
Collection: untraced.
Illustrated on p. 85.

In 1914 the Mackintoshes closed their house in South-
park Avenue, Glasgow, and moved south. Things had
not been going well for some time, and Mackintosh
decided he would move to London and try to establish
a practice there. First of all, however, they moved to
Walberswick, taking a cottage adjacent to the New-
berys who usually took their holidays in Suffolk. This
was a time of convalescence and recuperation for
Mackintosh, and he spent his time painting water-
colours of the Suffolk landscape, and making his
drawings of flowers. It seems likely that, had it not
been for the outbreak of war, he would have gone on to
Vienna, not London. The flower drawings were in-
tended for a book; though it was never published, per-
haps this accounts for the greater attention which the
1914 watercolours received. They are all more finished
than the earlier drawings, and the sense of pattern is
accentuated. This was the time Mackintosh began to
make full-scale watercolours (see 152) and he also began
to exhibit drawings like these as finished pictures (111).

105 Salvia pratensis c1914
Pencil and watercolour
Provenance: R. W. B. Morris (as 63); Fine Art Society,
 London; Piccadilly Gallery, London; Galleria
 Galatea, Milan.
Collection: untraced.

106 Sorrel, Walberswick 1914
Pencil and watercolour 200 × 266
Signed, dated and inscribed, lower centre, Sorrel/
 Walberswick/CRM/1914.
Provenance: R. W. B. Morris (as 63); Fine Art Society,
 London; Piccadilly Gallery, London.
Collection: Dr Tazzoli, Milan.
Illustrated on p. 85.

107 Chicory, Walberswick 1914
Pencil and watercolour
Signed, dated and inscribed, lower centre, Chickory
 (sic)/Walberswick/CRM/1914.
Provenance: R. W. B. Morris (as 63); Fine Art Society,
 London; Piccadilly Gallery, London; Galleria
 Galatea, Milan.
Collection: untraced.
Illustrated on p. 85.

108 Stagthorn, Walberswick 1914
Pencil and watercolour 258 × 210 (sight)

Signed, dated and inscribed, lower left, Stagthorn/
 Walberswick/1914/CRM/MMM.
Literature: Howarth, plate 80c.
Exhibited: Saltire, 1953 (A16); Toronto, 1967 (51).
Collection: Professor T. Howarth.

109 Aubrietia, Walberswick 1914
Pencil and watercolour 269 × 220
Signed, dated and inscribed, lower right, Rock Cress/
 Orbetia (sic)/Walberswick/1914/CRM MMM.
Provenance: R. W. B. Morris (as 63); Sotheby's Bel-
 gravia, 13 March 1975, lot 50.
Private collection.
Illustrated on p. 88.

110 Larkspur, Walberswick 1914
Pencil and watercolour 258 × 202
Signed, dated and inscribed, lower right, Larkspur/
 Walberswick/August 1914/C.R.M. M.M.M.
Literature: Howarth, plate 80b; Macleod, plate XI;
 Alison, p. 81; Billcliffe, p. 57.
Exhibited: Milan, 1973 (38); Glasgow, 1977 (14).
Provenance: as 68.
Collection: Glasgow University.
Illustrated on p. 88.

111 Petunia, Walberswick 1914
Pencil and watercolour 258 × 202
Signed, dated and inscribed, upper right, Petunia/
 Walberswick/1914/CRM MMM.
Literature: Billcliffe, p. 87.
Exhibited: ? ISSPG, 1917 (239); Glasgow, 1977 (16).
Provenance: Mackintosh Estate.
Collection: Glasgow University.

Like *Japonica* (91), this is a cultivated flower, but it is
drawn on a different scale from all the earlier works.
Although it is still recorded in great detail, Mackintosh
has emphasised the formal quality and pattern of the
bloom; the colour is stronger, and there is more of it
than in the other sketches. A drawing or watercolour
entitled *Petunias* was exhibited at the ISSPG in 1917;
no other drawing of petunias is known, so it seems
probable that this was the first of the series of the more
formal paintings of cultivated flowers which were
exhibited during the decade after 1914.

112 Winter Stock, Walberswick 1914
Pencil and watercolour 245 × 190
Signed, dated and inscribed, lower centre, Winter/
 Stock/Walberswick/1914/CRM MMM.
Exhibited: Edinburgh, Fine Art Society, '100 Years of
 Scottish Painting', 1973 (75).
Provenance: R. W. B. Morris (as 63); Fine Art
 Society, London.
Private collection.

113 Winter Stock, Walberswick 1914
Pencil and watercolour 264 × 217
Signed, dated and inscribed, centre left, Winter/
 Stock/Walberswick/CRM MMM/1914.
Exhibited: Glasgow, 1977 (15).
Provenance: Mackintosh Estate.
Collection: Glasgow University.

114 Borage, Walberswick* 1914
Pencil and watercolour 258 × 202

Signed, dated and inscribed, lower right, BORAGE/
WALBERSWICK/CRM/1914.
Exhibited: Edinburgh, 1968 (295).
Provenance: acquired c1933 by W. Somerville Shanks,
from whom to present owner.
Collection: James Meldrum, Esq.
Illustrated on p. 82.

115 Flower Studies c1914
Pencil and watercolour 290 × 245
Exhibited: Memorial Exhibition, 1933 (86).
Provenance: purchased at Memorial Exhibition by
Miss Nancy Mackintosh; by family descent.
Collection: Miss Moira Dingwall.

116 Moth Mullein, Walberswick 1914
Pencil and watercolour
Signed, dated and inscribed, lower right, MOTH
MULLEN (sic)/WALBERSWICK/1914/CRM MMM.
Exhibited: Memorial Exhibition, 1933 (86).
Collection: untraced.

117 Gaillardia, Walberswick 1914
Pencil and watercolour 245 × 182
Signed, dated and inscribed, lower left, GILARDIA
(sic) WALBERSWICK/1914/CRM.
Exhibited: Memorial Exhibition, 1933 (not in
catalogue).
Provenance: purchased at Memorial Exhibition by
Mrs H. K. Henderson; W. H. Gillespie, by whom
presented.
Collection: Glasgow School of Art.

118 Venetian Palace, Blackshore on the Blyth
Watercolour 410 × 564 1914
Signed, dated and inscribed, verso, 'The Venetian
Palace'/BLACKSHORE/ON THE BLYTH (sic)/SUFFOLK./
C. R. MACKINTOSH/1914/Price £35.
Exhibited: Memorial Exhibition, 1933 (52).
Provenance: acquired after Memorial Exhibition by
William Davidson; by whom presented to Jessie
King; by family descent to Merle Taylor; Sotheby's
Belgravia (at Glasgow) 21 June 1977, lot 284.
Private collection.
Illustrated on p. 90.

While he was in Suffolk in 1914, Mackintosh produced
a small number of landscape watercolours, very
different in style and content from the many flower
drawings of the period. These watercolours are by no
means as assured in technique as the later landscapes
of 1920–27, but one can identify, even at this early date,
the motifs which were later to fascinate Mackintosh
in the south of France. The simple warehouse is
typical of the vernacular buildings he had included in
his sketch-books for over twenty years, but here he is
far more concerned with recording the building in its
particular environment rather than noting its specific
features for possible use in his own architectural work.
The flat façade, punctured by dark windows and
topped by its slate roof obviously attracted him, and
he was to paint its French counterparts many times in
later years. The river has also caught his eye, especially
where it reflects the warehouse; but his rendering of the
water is relatively naturalistic compared to the near
abstract patterns of reflection seen in La Rue du Soleil
(208) or Port Vendres (209).

119 Walberswick* 1914
Watercolour 280 × 382
Signed and dated, lower left, C. R. MACKINTOSH/1914.
Literature: Howarth, p. 196.
Exhibited: GIFA, 1929; Glasgow, Empire Exhibition,
Palace of Arts, 1938 (164); Edinburgh, 1968 (327).
Provenance: acquired by William Davidson after
Memorial Exhibition, 1933.
Private collection.
Illustrated on p. 93.

120 A Palace of Timber c1914
Watercolour
Signed, lower right, C. R. MACKINTOSH.
Exhibited: Memorial Exhibition, 1933 (22).
Provenance: purchased at Memorial Exhibition by
David M. Mitchell.
Destroyed.
Illustrated on p. 92.

This watercolour has been destroyed, and is known
only from the photograph taken at the Memorial
Exhibition. Stylistically, it has more in common with
the more loosely handled watercolours of 1914 than
the French works of 1923–27, while the landscape
seems more like the tidal marshes of Suffolk than the
Mediterranean hill or coastal villages which Mackin-
tosh painted in such detail in later years.

121 Grape Hyacinth, Walberswick 1914/15
Pencil and watercolour 261 × 210
Signed, dated and inscribed, lower right, GRAPE/
HYACINTHE (sic)/WALBERSWICK/CRM/MMM.
Provenance: R. W. B. Morris (as 63); Sotheby's
Belgravia, 3 April 1974, lot 47, bought by Piccadilly
Gallery, London.
Collection: Davis & Long, New York (1975).

122 Canary Creeper (Tropaeolum canariense)
 c1914/15
Pencil and watercolour 258 × 202
Inscribed, lower right, TROPIOLEUM CARIERIANCIS (sic).
Exhibited: Edinburgh, 1968 (296).
Provenance: R. W. B. Morris (as 63); Sotheby's
Belgravia, 3 April 1974, lot 49; bought by Piccadilly
Gallery, London.
Collection: Davis & Long, New York (1975).

123 Cactus Flower, Walberswick* 1915
Pencil and watercolour 258 × 202
Signed, dated and inscribed, lower right, CACTUS/
WALBERSWICK/1915 and CRM/MMM.
Exhibited: Edinburgh, 1968 (297).
Provenance: acquired c1933 by W. Somerville Shanks,
from whom to present owner.
Collection: James Meldrum, Esq.
Illustrated on p. 83.

Another of the very few drawings on this scale of a
cultivated flower. As with Japonica (91) and Petunia
(111), Mackintosh seems to have been as much
attracted by the intensity of colour as the structure of
the plant and the result is one of the boldest of his
flower drawings.

124 Green Hellebore, Walberswick 1915
Pencil and watercolour 261 × 210

Signed, dated and inscribed, lower right, HELIBORE (sic) GREEN/WALBERSWICK/1915/CRM/MMM.
Provenance: acquired by William Meldrum after Memorial Exhibition, 1933; James Meldrum, by whom presented, 1968.
Collection: Victoria and Albert Museum, London (E.842–1968).
Illustrated on p. 88.

125 Honeysuckle, Walberswick 1915
Pencil and watercolour 276 × 210
Signed, dated and inscribed, lower right, HONEYSUCKLE JAB/WALBERSWICK/1915. and CRM/MMM.
Exhibited: Edinburgh, 1968 (299).
Provenance: R. W. B. Morris (as 63); Sotheby's Belgravia, 13 March 1975, lot 49, bought in.
Collection: R. W. B. Morris, Esq.

126 Japanese Witch Hazel, Walberswick 1915
Pencil and watercolour 263 × 211
Signed, dated and inscribed, bottom centre, JAPANESE/ WITCH/HASEL (sic)/WALBERSWICK/1915/CRM/ MMM.
Literature: Alison, p. 81, 93; Billcliffe, p. 76.
Exhibited: Edinburgh, 1968 (298); Milan, 1973 (39); Glasgow, 1977 (18).
Provenance: Mackintosh Estate.
Collection: Glasgow University.

127 Hazel Tree, Lambs' Tails, Walberswick
1915
Pencil and watercolour 278 × 207
Signed, dated and inscribed, lower right, HAZEL TREE/ LAMBS TAILS/WALBERSWICK/1915/CRM/MMM.
Literature: Billcliffe, p. 75.
Exhibited: Glasgow, 1977 (19).
Provenance: Mackintosh Estate.
Collection: Glasgow University.

128 Fritillaria, Walberswick* 1915
Pencil and watercolour 253 × 202
Signed, dated and inscribed, bottom centre, FRITILLARIA/WALBERSWICK/1915/CRM/MMM.
Literature: Alison, p. 81; Billcliffe, p. 58.
Exhibited: Milan, 1973 (40); Glasgow, 1977 (17).
Provenance: Mackintosh Estate.
Collection: Glasgow University.
Illustrated on p. 96.

The drawings of wild flowers which he produced in 1915 are probably the most elegant and delicate of all. *Fritillaria* is a flower with such obvious appeal for Mackintosh that it seems odd he had not drawn it before. The chequer-work on its petals is much like many of his decorative stencils, and he acknowledges his debt by repeating the dicing in the signature box.

129 Veronica, Walberswick 1915
Pencil and watercolour 267 × 205
Signed, dated and inscribed, lower right, VERONICA/ WALBERSWICK/1915/CRM/MMM.
Exhibited: Glasgow, 1977 (25).
Provenance: Mackintosh Estate.
Collection: Glasgow University.

130 Pine Cone and Needles, Walberswick 1915
Pencil and watercolour 269 × 208

Signed, dated and inscribed, bottom centre, WALBERS-WICK/1915/CRM/MMM.
Exhibited: Glasgow, 1977 (23).
Provenance: as 68.
Collection: Glasgow University.
Illustrated on p. 88.

131 Veronica, Walberswick 1915
Pencil and watercolour 276 × 209
Signed, dated and inscribed, bottom centre, VERONICA/ WALBERSWICK/1915/CRM/MMM.
Literature: Billcliffe, p. 28.
Exhibited: Glasgow, 1977 (24).
Provenance: as 68.
Collection: Glasgow University.
Illustrated on p. 96.

132 Jasmine, Walberswick 1915
Pencil and watercolour 276 × 209
Signed, dated and inscribed, bottom centre, JASIMINE (sic)/WALBERSWICK/1915/CRM/MMM.
Literature: Billcliffe, p. 88.
Exhibited: Glasgow, 1977 (22).
Provenance: as 68.
Collection: Glasgow University.

133 Rosemary, Walberswick 1915
Pencil and watercolour 269 × 204
Signed, dated and inscribed, lower right, ROSEMARY/ WALBERSWICK/1915/CRM/MMM.
Literature: Billcliffe, p. 28.
Exhibited: Glasgow, 1977 (20).
Provenance: as 68.
Collection: Glasgow University.
Illustrated on p. 97.

134 Arbutus, Walberswick 1915
Pencil and watercolour 272 × 211
Signed, dated and inscribed, bottom centre, ARBUTUS/ WALBERSWICK/1915/CRM MMM.
Exhibited: Glasgow, 1977 (21).
Provenance: as 68.
Collection: Glasgow University.

135 Lupin, Walberswick* 1915
Pencil and watercolour 275 × 212
Signed, dated and inscribed, lower centre, LUPIN/ WALBERSWICK/1915/CRM/MMM.
Provenance: R. W. B. Morris (as 63).
Private collection.

136 Pine, Walberswick 1915
Pencil and watercolour 273 × 209
Signed, dated and inscribed, lower right, WALBERS-WICK/1915/CRM/MMM.
Provenance: R. W. B. Morris (as 63); Sotheby's Belgravia, 3 April 1974, lot 51.
Collection: untraced.
Illustrated on p. 89.

137 Elder, Walberswick* 1915
Pencil and watercolour 262 × 206
Inscribed and dated, lower right, ELDER/WALBERS-WICK/1915.
Provenance: R. W. B. Morris (as 63); Sotheby's Belgravia, 13 March 1975, lot 46.
Private collection.

138 Hellebore, Walberswick 1915
Pencil and watercolour 272 × 220
Signed, dated and inscribed, HELLEBORE (sic)/WALBERS-
WICK/1915/CRM MMM.
Provenance: R. W. B. Morris (as 63); Fine Art Society,
London; Piccadilly Gallery, London.
Private collection.

139 Ivy Seed, Walberswick 1915
Pencil and watercolour 267 × 210
Signed, dated and inscribed, lower right, IVY SEED/
WALBERSWICK/1915/CRM MMM.
Provenance: R. W. B. Morris (as 63); Fine Art
Society, London.
Private collection.

140 Lavender, Walberswick 1915
Pencil and watercolour 268 × 220
Signed, dated and inscribed, lower centre, LAVANDER
(sic)/WALBERSWICK/1915/CRM/MMM.
Provenance: acquired by William Meldrum after the
Memorial Exhibition, 1933; by family descent.
Collection: James Meldrum, Esq.

141 Gorse, Walberswick* 1915
Pencil and watercolour 272 × 210
Signed, dated and inscribed, GORSE/WALBERSWICK/
1915/CRM/MMM.
Literature: Alison, p. 81.
Exhibited: Memorial Exhibition, 1933 (87); Saltire,
1953 (A15); Milan, 1973 (41).
Provenance: Professor Randolph Schwabe, before
1933; by family descent.
Collection: Mr and Mrs H. Jefferson Barnes.
Illustrated on p. 86.

142 Anemone and Pasque, Walberswick* 1915
Pencil and watercolour 263 × 208
Signed, dated and inscribed, lower right, ANEMONE
AND PASQUE/WALBERSWICK/1915/CRM/MMM.
Literature: Alison, p. 81.
Exhibited: Memorial Exhibition, 1933 (87); Saltire,
1953 (A15); Milan, 1973 (42).
Provenance: Professor Randolph Schwabe, before
1933; by family descent.
Collection: Mr and Mrs H. Jefferson Barnes.
Illustrated on p. 87.

143 Willow Catkins, Walberswick 1915
Pencil and watercolour
Signed, dated and inscribed, lower centre, WILLOW/
CATKINS/WALBERSWICK/1915/CRM/MMM.
Exhibited: Memorial Exhibition, 1933 (37).
Collection: untraced.

144 Field Pea, Walberswick 1915
Pencil and watercolour
Signed, dated and inscribed, lower right, FIELD/PEA/
WALBERSWICK/1915/CRM/MMM.
Exhibited: Memorial Exhibition, 1933 (not in cata-
logue).
Provenance: purchased at Memorial Exhibition by
Mrs W. L. Renwick.
Collection: untraced.

145 Flower Drawing (Mallow?), Walberswick
Pencil and watercolour 1915
Signed, dated and inscribed, lower centre, WALBERS-
WICK/1915/CRM MMM.
Exhibited: Memorial Exhibition, 1933 (not in cata-
logue).
Provenance: purchased at Memorial Exhibition by
Mrs W. Selkirk, Glasgow.
Collection: untraced.

146 Berberis, Walberswick 1915
Pencil and watercolour
Signed, dated and inscribed, lower right, BURBERIS
(sic)/WALBERSWICK 1915/CRM/MMM.
Exhibited: Memorial Exhibition, 1933 (61).
Provenance: purchased at Memorial Exhibition by
Tom Kelly, Milngavie.
Collection: untraced.

147 Chionodoxa, Walberswick 1915
Pencil and watercolour
Signed, dated and inscribed, lower centre, GLORY OF
THE SNOW/WALBERSWICK/1915/CRM MMM.
Exhibited: Memorial Exhibition, 1933 (not in cata-
logue).
Provenance: purchased at Memorial Exhibition by
Miss J. W. Robb.
Collection: untraced.

148 Daisy, Walberswick 1915
Pencil and watercolour 262 × 204
Signed, dated and inscribed, lower centre, DAISY/
WALBERSWICK/1915/CRM/MMM.
Exhibited: Memorial Exhibition, 1933 (33).
Provenance: purchased at Memorial Exhibition by
Miss De Courcy Lewthwaite Dewar.
Collection: Glasgow School of Art.

149 Kingcups, Walberswick 1915
Pencil and watercolour
Signed, dated and inscribed, lower left, KING/CUPS/
WALBERSWICK/1915/CRM/MMM.
Exhibited: Memorial Exhibition, 1933 (31).
Provenance: purchased at Memorial Exhibition by
Mr Bowman, Hillhead High School, Glasgow.
Collection: untraced.

150 Iris Seed, Walberswick 1915
Pencil and watercolour
Signed, dated and inscribed, lower right, IRIS SEED/
WALBERSWICK/1915/CRM/MMM.
Provenance: R. W. B. Morris (as 63); Fine Art
Society, London; Piccadilly Gallery, London;
Galleria Galatea, Milan.
Collection: untraced.
Illustrated on p. 96.

151 Bean Flower, Walberswick 1915
Pencil and watercolour 270 × 245 (sight)
Signed, dated and inscribed, lower right, BEAN/
WALBERSWICK/1915/CRM/MMM.
Exhibited: Memorial Exhibition, 1933 (67).
Provenance: purchased at Memorial Exhibition by
Mrs A. Hedderwick, Helensburgh; by family
descent.
Collection: B. Boylan, Esq.

151a **Polyanthus, Walberswick** 1915
Pencil and watercolour 258 × 202
Signed, dated and inscribed, POLYANTHUS/WALBERS-
WICK 1915/CRM MMM.
Provenance: purchased at Memorial Exhibition, 1933
by Jas. McClure & Son, Glasgow; from whom
purchased by present owner.
Private collection.

152 **Anemones** c1916
Pencil and watercolour 505 × 495
Signed, lower right, C. R. MACKINTOSH.
Exhibited: ISSPG, 1916 (748); Memorial Exhibition,
1933 (133); Glasgow, Empire Exhibition, Palace of
Arts, 1938 (221); London, Royal Academy, 'Scottish
Art', 1939 (221); Saltire, 1953 (A6); Edinburgh,
1968 (332); Glasgow, 1977 (33).
Provenance: with Walter Blackie by 1933.
Private collection.
Illustrated on p. 94.

Andrew McLaren Young (Edinburgh, 1968) dated this
picture c1923, contemporary with *Pinks*, and con-
sidered the date 1914 given at the R.A. Scottish
Exhibition impossibly early. The picture was in fact
shown at the ISSPG in 1916; a date of 1914, however,
suggests that the fabric reflected in the mirror was also
produced at that date, but there is no evidence of the
Mackintoshes making fabric designs before c1916.

This type of flower painting, of cut flowers in a
vase on a table, is a new departure for Mackintosh, but
it was soon followed by others using a similar formula.
The early pictures of this series have realistic or three-
dimensional backgrounds like *White Tulips* (156), but
beginning c1919 with *Peonies* (165), the backgrounds
become simpler and more abstract with all the em-
phasis being placed on the flowers and their arrange-
ment.

153 **Begonias*** 1916
Pencil and watercolour 425 × 373
Signed, lower right, C. R. MACKINTOSH; inscribed,
verso, *Begonias Chelsea 1916/ C. R. Mackintosh/
£36.15./2 Hans Studios/43A Glebe Place Chelsea
S.W.3.*
Exhibited: ISSPG, 1918 (434); Glasgow, Empire
Exhibition, Palace of Arts, 1938 (220); Glasgow,
1977 (34).
Provenance: with William Davidson, 1938.
Private collection.
Illustrated on p. 95.

154 **Fig Leaf, Chelsea** 1918
Pencil and watercolour 267 × 204
Signed, dated and inscribed, lower right, FIG/CHELSEA/
1918/CRM/MMM.
Exhibited: Edinburgh, 1968 (300).
Provenance: R. W. B. Morris (as 63).
Collection: untraced.
Illustrated on p. 119.

155 **Laurel, Chelsea** 1918
Pencil and watercolour 267 × 203
Signed, dated and inscribed, LAUREL/CHELSEA/1918/
CRM/MMM.
Provenance: R. W. B. Morris (as 63); Fine Art Society,
London.
Collection: Piccadilly Gallery, London (1977).

156 **White Tulips** c1918–20
Pencil and watercolour 405 × 352
Signed, lower right, C. R. MACKINTOSH.
Exhibited: Memorial Exhibition, 1933 (78); Glasgow,
1977 (35).
Provenance: purchased at Memorial Exhibition by
Miss De Courcy Lewthwaite Dewar; acquired by
present owner, 1966.
Collection: H. L. Hamilton, Esq.
Illustrated on p. 98.

157 **A Basket of Flowers*** c1918–20
Watercolour 317 × 300
Signed, lower right, C.R.M.
Exhibited: Memorial Exhibition, 1933 (101); Edin-
burgh, 1968 (311); Glasgow, 1977 (36).
Provenance: purchased at Memorial Exhibition by
Mrs D. Turnbull; Morrison McChlery, Glasgow,
sale of 2 December 1953, lot 119.
Collection: Glasgow University.
Illustrated on p. 108.

Mackintosh produced a series of these stylised bou-
quets of flowers, painted on a black background. This
particular format is unsuited for use as a textile
pattern, and it seems probable that Mackintosh
produced them for sale as pictures in their own right.
They combine the deliberation of the later flower
paintings with the formal patterns and stylisation of
flowers of his textile designs of 1916–23.

158 **Garden Bouquet** c1918–20
Watercolour
Exhibited: Memorial Exhibition, 1933 (100).
Provenance: purchased at Memorial Exhibition by
Miss Nancy Mackintosh.
Collection: untraced.

159 **Bouquet** c1918–20
Watercolour 298 × 291
Signed, lower right, CRM.
Literature: Howarth, plate 81b.
Exhibited: Saltire, 1953 (A11).
Collection: Glasgow School of Art.

160 **Bouquet** c1918–20
Watercolour 325 × 306.
Exhibited: Memorial Exhibition, 1933 (88).
Provenance: purchased at Memorial Exhibition by
Mrs D. Turnbull; J & R. Edmiston, Glasgow, sale of
24 February 1977, lot 57.
Private collection.

161 **Bouquet** c1918–20
Watercolour 275 × 248
Exhibited: Memorial Exhibition, 1933 (96).
Provenance: purchased at Memorial Exhibition by
Mrs D. Turnbull; J & R. Edmiston, Glasgow, sale of
24 February 1977, lot 56.
Private collection.

162 **Garden Bouquet** c1918–20
Watercolour 311 × 274
Exhibited: Memorial Exhibition, 1933 (83).
Provenance: purchased at Memorial Exhibition by
Mrs D. Turnbull; J. & R. Edmiston, Glasgow, sale
of 24 February 1977, lot 58; bought by Fine Art
Society, London.
Private collection.

163 **Bouquet** *c*1918
Watercolour on black paper 258 × 258 (sight)
Exhibited: Toronto, 1967 (56).
Collection: Professor T. Howarth.

164 **Willow-herb, Buxstead*** 1919
Pencil and watercolour 258 × 200
Signed, dated and inscribed, bottom centre, WILLOW/
HERB/BUXSTEAD/1919/CRM MMM.
Literature: Macleod, plate X; Billcliffe, p. *85*.
Exhibited: Edinburgh, 1968 (301); Glasgow, 1977 (26).
Provenance: Mackintosh Estate.
Collection: Glasgow University.

165 **Peonies** *c*1919–20
Pencil and watercolour 428 × 426
Signed, lower left, C.R.M.
Exhibited: Memorial Exhibition, 1933 (152); Tate
 Gallery, *c*1933; Glasgow Art Club, 1967; Edinburgh,
 1968 (331); Glasgow, 1977 (37).
Provenance: purchased at Memorial Exhibition by
 Miss Shaw; John Watson, 1961.
Private collection.
Illustrated on p. 99.

166 **White Roses*** 1920
Pencil and watercolour 502 × 472
Signed and dated, lower right, C. R. MACKINTOSH/
1920.
Exhibited: Chicago, 3rd International Exhibition of
 Watercolour Paintings, 1923; Memorial Exhibition,
 1933 (28); Glasgow, 1977 (38).
Provenance: purchased at Memorial Exhibition by
 Miss Jessie Keppie, by whom bequeathed, 1968.
Collection: Glasgow School of Art.
Illustrated on p. 99.

The wavy pattern in the background is very similar to
some of the most abstract designs for textiles which
Mackintosh was producing at this time.

167 **The Village, Worth Matravers*** 1920
Watercolour 460 × 569
Signed, lower right, C. R. MACKINTOSH; inscribed,
 verso, *The Village, Worth Matravers*.
Literature: Howarth, p. 215, note 1; Billcliffe, p. 27.
Exhibited: Memorial Exhibition, 1933 (45); Saltire,
 1953 (A7); Edinburgh, 1968 (328).
Provenance: purchased from Memorial Exhibition by
 William Meldrum; James Meldrum, by whom
 presented, 1947.
Collection: Glasgow School of Art.
Illustrated on p. 114.

In 1920, the Mackintoshes spent a holiday in Dorset
at Corfe with the Schwabe family, possibly visiting the
Newberys, who often stayed at Corfe Castle. It is not
known whether Mackintosh produced more water-
colours on this visit than those recorded here, but these
surviving few do indicate a distinct change of style.
The Walberswick watercolours of 1914 had been
relatively straightforward topographical drawings, but
in *The Village* and *The Downs* (168) Mackintosh makes
the first conscious moves towards his mature style of
the Port Vendres period. He is obviously concerned
with the pattern of the landscape, picking out features
like the stepped hillside, the stone walls, paths, and

roofs of village houses. These ordinary motifs are given
an eerie emphasis by being painted in an equally
detailed manner whether they are in the foreground or
the distance. This makes the viewer keenly aware of
the two dimensions of a picture which at first glance
appears to be a perfectly normal landscape painting.
Mackintosh's fascination with the patterns of nature is
as apparent here as in his designs for stylised organic
decoration for his furniture and buildings before 1914.
But it was probably at this time, and possibly as a
result of this holiday and the success of these few
pictures, that he resolved to concentrate more and
more upon painting. By 1923 he had decided to forsake
architecture and design and devote the rest of his life
to producing watercolours.

168 **The Downs, Worth Matravers*** 1920
Watercolour 452 × 537
Signed, lower right, C.R.M.; inscribed, verso, *Worth
 Matravers. The Downs*.
Literature: Howarth, p. 215, note 1; Alison, p. 84;
 Billcliffe, p. 27.
Exhibited: Memorial Exhibition, 1933 (41); Saltire,
 1953 (A8); Milan, 1973 (61).
Provenance: purchased at Memorial Exhibition by
 Miss Marshall.
Collection: Glasgow School of Art.
Illustrated on p. 115.

As in *The Village* (167), there are no figures in this
view of the Dorset countryside. The absolute lack of
human activity gives Mackintosh's pictures an air of
eerie, even surreal, desertion. They are formal
landscapes in which a cart on the road or a ploughman
in the field would break the spell. At the same time,
Mackintosh shows his interest in the man-made
patterns and phenomena: the rectangular houses and
dry-stone walls are as important as the stream, the
slope of the hills, or the waves of the sea; indeed, the
most dominant feature in this work is the tall tele-
graph pole—a formal and unnatural element in this
gentle Dorset landscape.

169 **Abbotsbury** 1920
Watercolour
Literature: Howarth, p. 215, note 1.
Collection: untraced.

Howarth lists a third watercolour, *Abbotsbury*, pro-
duced at the same time as 167 and 168 while Mackintosh
was on holiday in Dorset. No further details of this
picture exist, however, as it has not been traced.

170 **Cyclamen** *c*1920–22
Watercolour 370 × 420
Signed, lower right, C. R. MACKINTOSH.
Exhibited: Memorial Exhibition, 1933 (76).
Provenance: purchased at Memorial Exhibition by
 present owner.
Private collection.

171 **Palm Grove Shadows*** *c*1921
Watercolour 502 × 403
Signed, lower right, C. R. MACKINTOSH.
Exhibited: Memorial Exhibition, 1933 (55); Edin-
 burgh, 1968 (333, plate 31); Glasgow, 1977 (39).

Provenance: purchased at Memorial Exhibition by Mrs Ellen Gibb; purchased from her estate, 1966.
Collection: Glasgow University.
Illustrated on p. 91.

Andrew McLaren Young suggested in the Centenary Exhibition catalogue that this watercolour, although it looks Mediterranean, could well have been made in London in the early 1920s. This theory is supported by notes in Mackintosh's diary for 1921, in which he records a number of visits to Kew Gardens where he could have seen palm trees growing in the glasshouses.

172 Ships* c1922
Watercolour 203 × 297
Exhibited: Memorial Exhibition, 1933 (63); Edinburgh, 1968 (329).
Provenance: purchased at Memorial Exhibition by William Davidson.
Private collection.
Illustrated on p. 112.

Related to a Christmas card which Mackintosh designed for Mr and Mrs W. J. Bassett-Lowke in 1922 (collection: Glasgow University, exhibited: Edinburgh, 1968, no 306, plate 30); another pencil drawing of a sailing ship also exists (collection: Glasgow University).

173 Yellow Tulips c1922–23
Watercolour 495 × 495
Exhibited: Chicago, 4th International Exhibition of Watercolour Paintings, 1924; Memorial Exhibition, 1933 (51); Glasgow, 1977 (41).
Provenance: R. W. B. Morris (as 63).
Collection: R. W. B. Morris, Esq.
Illustrated on p. 102.

There are no photographs of the interiors of Mackintosh's Chelsea studio flat, and this is the only drawing which gives any indication of them. The fireplace in the background, with its adjacent curtain, is reminiscent of the studio fireplace and bookcases of 78 Southpark Avenue, although this one is stained dark and the Glasgow fittings were painted white.

None of the other later watercolours of flowers has such a specific setting. The background is painted with such care that it fights with the flowers for our attention. The Mediterranean watercolours are similarly painted in such a way that the far distance is as detailed as the foreground, which suggests that this picture may be almost contemporary with the French landscapes. A date of c1923 is supported by the fact that Mackintosh chose to send this drawing to the Chicago Exhibition of 1924, and it seems likely that he would want to exhibit a recent work rather than something a few years old.

174 The Grey Iris* c1922–24
Watercolour 431 × 374
Signed, lower right, C.R. MACKINTOSH.
Exhibited: Chicago, 5th International Exhibition of Watercolour Paintings, 1925; Memorial Exhibition, 1933 (70); Saltire, 1953 (A12); Glasgow Art Gallery, 1973, and Hamburg Kunsthalle, 1974, 'Scottish Painting 1880–1930' (32); Glasgow, 1977 (42).
Provenance: purchased at Memorial Exhibition, 1933.

Collection: Glasgow Art Gallery.
Illustrated on p. 103.

175 Pinks* c1922–23
Watercolour 501 × 501
Signed, lower right, C.R. MACKINTOSH.
Literature: The Studio, LXXXVI, 1923, p. 381.
Exhibited: Memorial Exhibition, 1933 (159); Saltire, 1953 (A1); Edinburgh, 1968 (330); Glasgow Art Gallery, 1970, 'Colour in Scottish Painting' (52); Glasgow Art Gallery, 1973, and Hamburg Kunsthalle, 1974, 'Scottish Painting 1880–1930' (33); Glasgow, 1977 (40).
Provenance: purchased at Memorial Exhibition by John Sawyers; by whom presented, 1941.
Collection: Glasgow Art Gallery.
Illustrated on p. 109.

176 A Southern Port* c1923–24
Watercolour 362 × 445
Exhibited: Memorial Exhibition, 1933 (150); Saltire, 1953 (A5).
Provenance: purchased at Memorial Exhibition by Alex Speirs; L. & J. Brown & Co., Edinburgh, from whom purchased, 1947.
Collection: Glasgow Art Gallery.
Illustrated on p. 127.

It is difficult to provide a chronology for these Mediterranean watercolours, for very few are dated. *A Southern Port*, possibly a view of Port Vendres where the Mackintoshes established a base at the Hôtel du Commerce, may well be an early example; the uncertainties of composition and perspective suggest that it was produced before Mackintosh had achieved a settled frame of mind, for none of the other watercolours contains such basic mistakes.

177 The Boulders c1923–26
Watercolour 334 × 380
Signed, lower right, C.R.M.
Literature: The Studio, CV, 1933, p. 350.
Exhibited: Memorial Exhibition, 1933 (46); Edinburgh, 1968 (339).
Provenance: purchased at Memorial Exhibition by Mrs James Salmon; from whom purchased by the present ower.
Private collection.
Illustrated on p. 126.

Possibly another early watercolour, as Mackintosh has not controlled the relationship between the rocks and the houses as well as in some later works such as *Fort Maillert* (215) or *The Rocks* (216).

178 Collioure, Pyrénées-Orientales — Summer Palace of the Queens of Aragon* c1924–26
Watercolour 381 × 432
Signed, lower right, C.R. MACKINTOSH; inscribed, verso, *COLLIOURE—£40/Pyrénées Orientales/C R Mackintosh/2 Cedar Studios/45 Glebe Place Chelsea SW3.*
Exhibited: Memorial Exhibition, 1933 (42); Glasgow, Empire Exhibition, Palace of Arts, 1938 (219); Edinburgh, 1968 (337).
Provenance: Mrs W. W. Blackie; by family descent.
Collection: Mrs Alison Walker.
Illustrated on p. 106.

The Mackintoshes were living in Collioure in 1924 and had possibly settled there when they left London in the autumn of 1923. Only two watercolours of the village exist, however, and Mackintosh was probably spending much of his time painting the forts which were scattered along the coast. Port Vendres, where they were later to settle, was within walking distance and some of the views of the little town were probably made this first summer in France.

179 Collioure c1924
Watercolour 379 × 465
Signed and inscribed, verso, C.R. MACKINTOSH/ COLLIOURE, PYRENEES ORIENTALES.
Exhibited: Memorial Exhjbition, 1933 (131).
Provenance: purchased at Memorial Exhibition by Mrs Farquhar; by family descent.
Private collection.

180 Fetges* c1923–26
Watercolour 465 × 458
Signed, lower right, C.R. MACKINTOSH.
Literature: W. W. Blackie in The Scottish Art Review, XI, no 4, 1968, p. 9.
Exhibited: Edinburgh, Society of Scottish Artists, 1928 (36); Edinburgh, 1968 (341, plate 31).
Provenance: Walter W. Blackie; by whom presented on behalf of the artist.
Collection: The Tate Gallery, London.
Illustrated on p. 113.

There is no record of when Mackintosh visited Spain; the only other Spanish subject is A Spanish Farm (181). In a letter to Margaret Maconald, 11 June 1927 (Glasgow University), Mackintosh was concerned with the value of £30 placed on this watercolour by the Leicester Galleries. In Mackintosh's opinion it was one of his best works of this Mediterranean series.

181 A Spanish Farm* c1923–26
Watercolour 280 × 380
Exhibited: Memorial Exhibition, 1933 (154); Edinburgh, 1968 (336).
Provenance: acquired after Memorial Exhibition by Mackintosh's sister, Mrs Isabel Dingwall; by family descent.
Collection: Miss Margaret Rennie Dingwall.
Illustrated on p. 122.
See also 180.

182 The Road through the Rocks c1924–26
Watercolour 495 × 430 (sight)
Signed, lower right, C.R. MACKINTOSH.
Exhibited: Memorial Exhibition, 1933 (57); Toronto, 1967 (54).
Provenance: purchased at Memorial Exhibition by Dr M. Poldores McCunn (later Mrs Aidan Thomson).
Collection: Professor T. Howarth.
Illustrated on p. 140.

The forts, which were strategically placed along the coast and the border with Spain, intrigued Mackintosh and he produced several watercolours of them, and often included them in the distance of other landscapes. Their smooth, slab-like sides and massive silhouettes both blended with the expansive landscapes and at the same time contrasted with the textures of cliffs and fields.

183 Le Fort Mauresque c1924–26
Watercolour
Signed, lower right, C.R.M.
Exhibited: Paris, Duveen Invited Artists Show, 1927; Memorial Exhibition, 1933 (49).
Provenance: sent to Sylvan MacNair by the executors of the Mackintosh Estate, 1933.
Collection: untraced.
Illustrated on p. 141.

In a letter to Margaret (11 June 1927, collection: Glasgow University), Mackintosh mentions a watercolour with a lighthouse in it; he did not seem fond of the picture ('the lighthouse is a purely fake picture') and suggested that it was only worth £7 or £10.

184 The Fort* c1924–26
Watercolour 450 × 452
Signed, lower right, C.R.MACKINTOSH; inscribed, verso, 'The Fort' C.R.Mackintosh, probably in Margaret Macdonald's hand.
Exhibited: Memorial Exhibition, 1933 (39).
Provenance: purchased at Memorial Exhibition by Professor W. L. Renwick.
Collection: Mrs W. L. Renwick.
Illustrated on p. 117.

185 Port Vendres c1924–26
Watercolour 288 × 396
Signed, lower right, C.R.MACKINTOSH.
Literature: Alison, p. 85.
Exhibited: Memorial Exhibition, 1933 (135).
Provenance: owned in 1933 by Fra Newbery; by family descent.
Collection: Mrs Mary Newbery Sturrock.
Illustrated on p. 121.

Several of his landscapes are concerned with the way paths, tracks and roads scar the land, creating random 'artificial' patterns across the countryside. In the background can be seen one of the forts which were scattered along this part of the coast and which were to provide Mackintosh with a vein of rich material for later drawings.

186 Port Vendres, La Ville* c1924–26
Watercolour 460 × 460
Signed, lower right, C.R. MACKINTOSH.
Literature: Artwork, VI, no 21, p. 28; The Studio, CV, 1933, p. 345.
Exhibited: Memorial Exhibition, 1933 (188a, not in catalogue); Glasgow, Empire Exhibition, Palace of Arts, 1938 (222); Saltire, 1953 (A4); Glasgow Art Gallery, 'Scottish Painting', 1961 (138).
Provenance: purchased at Memorial Exhibition, 1933.
Collection: Glasgow Art Gallery.
Illustrated on p. 123.

187 The Church of La Lagonne* c1924–27
Watercolour 280 × 383
Signed, lower left, C.R. MACKINTOSH.
Exhibited: Memorial Exhibition, 1933 (160); Edinburgh, RSA 1934.
Provenance: purchased at Memorial Exhibition by William Davidson.
Private collection.
Illustrated on p. 133.

The flower drawings (203, 205–207) show that the Mackintoshes spent part of 1924 and 1925 in the mountains around Amélie-les-Bains and Mont Louis. From letters he wrote to Margaret in 1927 (Glasgow University), it becomes clear that they decided to leave the coast during the summer because of the heat, and they found that it was much cooler at Mont Louis. They probably also stayed there in 1926; and they returned to the mountains in July 1927 on Margaret's arrival from London. La Lagonne, Boultenère and Mont Alba were all within easy reach of Mont Louis, and watercolours of all these villages—and more—were painted over the years 1924–27.

188 **The Village of La Lagonne*** c1924–27
Watercolour 457 × 457
Signed, lower right, C.R.MACKINTOSH.
Exhibited: Memorial Exhibition, 1933 (58); Edinburgh, 1968 (342); Glasgow Art Gallery, 'Scottish Painting', 1961 (140); Edinburgh, 1968 (342); Glasgow Art Gallery, 1973, and Hamburg Kunsthalle, 1974, 'Scottish Painting 1880–1930' (34); Sheffield, City Art Galleries, 'British Painting 1900–1960', 1975 (99).
Provenance: purchased at Memorial Exhibition by J. H. Whyte; T. M. Whyte; bought at auction at J. & R. Edmiston, Glasgow, 1960.
Collection: Glasgow Art Gallery.
Illustrated on p. 130.

189 **Mont Alba*** c1924–27
Watercolour 370 × 420
Exhibited: Memorial Exhibition, 1933 (156); Edinburgh, 1968 (334, plate 31); Edinburgh, Fine Art Society, '100 Years of Scottish Painting', 1973 (73).
Provenance: R. W. B. Morris (as 63); Fine Art Society, London.
Collection: Alan Irvine, Esq.
Illustrated on p. 120.

190 **The Poor Man's Village** c1924–26
Watercolour 420 × 420 (sight)
Exhibited: Memorial Exhibition, 1933 (38).
Provenance: sent to Sylvan MacNair by the executors of the Mackintosh Estate, 1933.
Collection: untraced.
Illustrated on p. 129.

191 **A Hill Town in Southern France** c1924–26
Watercolour 420 × 420 (right)
Exhibited: Memorial Exhibition, 1933 (44); Toronto, 1967 (50).
Provenance: purchased at Memorial Exhibition by Miss Nancy Mackintosh, from whom acquired by present owner.
Collection: Professor T. Howarth.
Illustrated on p. 116.

The hill villages, nestling in hollows in the mountainsides or perched precariously at the edge of dramatic cliffs, were frequently drawn. Mackintosh was attracted by the simple shapes of the houses which form a complex pattern against the hillside as they are piled one above the other on the slopes.

192 **A Southern Farm*** c1924–26
Watercolour 434 × 434

Exhibited: Memorial Exhibition, 1933 (56).
Provenance: purchased at Memorial Exhibition by G. Middlemass.
Private collection.
Illustrated on p. 107.

193 **A Southern Town*** c1924–27
Watercolour 322 × 376
Exhibited: Memorial Exhibition, 1933 (142); Edinburgh, 1968 (335).
Provenance: purchased at Memorial Exhibition by present owner.
Collection: Mrs Ruth M. Hedderwick.
Illustrated on p. 110.

194 **Slate Roofs*** c1924–27
Watercolour 370 × 278
Signed, lower right, C.R. MACKINTOSH.
Exhibited: Memorial Exhibition, 1933 (94); Saltire, 1953 (A9).
Provenance: purchased at Memorial Exhibition by Sir John Stirling Maxwell; by whom presented.
Collection: Glasgow School of Art.
Illustrated on p. 131.

195 **Summer in the South*** c1924–27
Watercolour 283 × 385
Exhibited: Memorial Exhibition, 1933 (138).
Provenance: purchased at Memorial Exhibition by William Davidson; by family descent.
Collection: Michael Davidson, Esq.
Illustrated on p. 124.

One of the most brilliantly coloured of these later watercolours.

196 **Village in the Mountains*** c1924–27
Watercolour 375 × 280
Exhibited: Memorial Exhibition, 1933 (26).
Provenance: acquired after Memorial Exhibition by William Davidson.
Private collection.
Illustrated on p. 132.

The manner in which the patchwork fields dissolve into the dense scrub of the mountainside can be seen in the background of *The Village of La Lagonne* (188). Mackintosh painted a number of smaller watercolours concentrating on the strange effects which these dark belts of vegetation have on the landscape.

197 **Mountain Landscape*** c1924–27
Watercolour 375 × 280
Exhibited: Memorial Exhibition, 1933 (68).
Provenance: acquired after Memorial Exhibition by William Davidson.
Private collection.
Illustrated on p. 133.

198 **Mountain Landscape** c1924–27
Watercolour 250 × 350
Signed, lower right, C.R. MACKINTOSH.
Private collection.

199 **Mountain Village** c1924–27
Watercolour
Signed, lower right, C.R.M.
Exhibited: Memorial Exhibition, 1933 (161).

Provenance: purchased at Memorial Exhibition by D. Cleghorn Thomson, West Hoathly, Sussex; by whom sold about five years later.
Collection: untraced.
Illustrated on p. 129.

200 Palalda, Pyrénées-Orientales* c1924–27
Watercolour 515 × 515
Signed, lower right, C.R. MACKINTOSH.
Exhibited: Memorial Exhibition, 1933 (74); Glasgow, Empire Exhibition, Palace of Arts, 1938 (219).
Provenance: purchased at Memorial Exhibition by William Davidson; by family descent.
Collection: Michael Davidson, Esq.
Illustrated on p. 134.

Mackintosh has made an alteration to the lower part of this watercolour by sticking a new piece of paper (cut to the shape of the houses which he wished to retain) over the unsatisfactory drawing below.

201 Boultenère* c1924–27
Watercolour 447 × 447
Signed, lower right, C.R.M.; inscribed, verso, *Boultenère/C.R. Mackintosh,* probably in Margaret Macdonald's hand.
Exhibited: Memorial Exhibition, 1933 (136).
Provenance: R. W. B. Morris (as 63).
Collection: R. W. B. Morris, Esq.
Illustrated on p. 135.

202 Blanc Antoine* c1924–27
Watercolour 392 × 510
Exhibited: Memorial Exhibition, 1933 (40).
Provenance: purchased at Memorial Exhibition by A. C. Robin; J. & R. Edmiston, 29 May 1968, lot 69.
Private collection.
Illustrated on p. 111.

203 Mimosa, Amélie-les-Bains 1924
Pencil and watercolour 257 × 210
Signed, dated and inscribed, bottom centre, MYMOSA (sic) / AMELIE / LES-BAINS / JANUARY / 1924 / CRM.MMM.
Literature: Howarth, plate 80d; Billcliffe, p. 86.
Exhibited: Saltire, 1953 (A14); Edinburgh, 1968 (302); Glasgow, 1977 (27).
Provenance: as 68.
Collection: Glasgow University.
Illustrated on p. 118.

204 Héré de Mallet, Ille-sur-Têt* c1925
Watercolour 460 × 460
Exhibited: Memorial Exhibition, 1933 (53, as Margaret Macdonald Mackintosh).
Provenance: acquired after Memorial Exhibition by William Davidson; by family descent.
Collection: Michael Davidson, Esq.
Illustrated on p. 125.

Mackintosh has obviously been attracted by the geological strata in this cliff or quarry-side; it is unusual to see such a strongly orange-biased palette in these later drawings.

The Mackintoshes spent some months at Ille-sur-Têt in 1925; in a letter to J. D. Fergusson, dated 1 February 1925 (collection: Margaret Morris Fergusson) Mackintosh recorded how much they enjoyed this little village, which was also a very cheap place to live, and hoped that Fergusson and Margaret Morris would join them at Mont Louis, where they were going to spend May and June of that year.

205 Mont Louis—Flower Study 1925
Pencil and watercolour 258 × 202 (sight)
Signed and dated, lower centre, MONT LOUIS/1925/ CRM MMM.
Exhibited: Toronto, 1967 (55).
Collection: Professor T. Howarth.
Illustrated on p. 128.

206 Pine Cones, Mont Louis 1925
Pencil and watercolour 262 × 206
Inscribed and dated, lower right, MONT/LOUIS/1925.
Literature: Billcliffe, p. 28.
Exhibited: Saltire, 1953 (A14); Edinburgh, 1968 (303); Glasgow, 1977 (28).
Provenance: as 68.
Collection: Glasgow University.

207 Mixed Flowers, Mont Louis* 1925
Pencil and watercolour 262 × 205
Signed, dated and inscribed, lower centre, MONT/ LOUIS/JULY 1925/MMM/CRM.
Literature: Alison, p. 84.
Exhibited: Memorial Exhibition, 1933 (87); Saltire, 1953 (A15); Milan, 1973 (62).
Provenance: Professor Randolph Schwabe, before 1933; by family descent.
Collection: Mr and Mrs H. Jefferson Barnes.
Illustrated on p. 144.

208 La Rue du Soleil, Port Vendres* 1926
Watercolour 405 × 390
Signed and dated, lower right, C.R. MACKINTOSH 1927; inscribed, verso, *Port Vendres/March 1926.*
Literature: Artwork, VI, no 21, 1930, p. 26; Howarth, pp. 217, 218, plate 84; Macleod, plate 112; Billcliffe, p. 25.
Exhibited: London, Leicester Galleries, 1928; Memorial Exhibition, 1933 (47); Saltire, 1953 (A2); Edinburgh, 1968 (340).
Provenance: purchased by Desmond Chapman-Huston from the Leicester Galleries, 1928; Sir John Richmond, by whom presented.
Collection: Glasgow University.
Illustrated on p. 138.

Although signed and dated on the front, Howarth records how Mackintosh, before his death in 1928, added both signature and date shortly at Chapman-Huston's request. It seems likely that the inscription, 1926, on the back of the picture is contemporary with its execution and that Mackintosh, in his frail state, was confused about the exact date of his making this watercolour. *The Little Bay* (214), which has an inscription on the back, 1927, was also bought by Chapman-Huston and similarly signed by Mackintosh.

This watercolour is one of the most dramatic of the series, with the reflection of the village and the sunlight caught—frozen almost—in the ripples of the harbour. This dazzling pattern approaches abstraction in its formalisation of an everyday sight.

209 Port Vendres* *c*1926–27
Watercolour 276 × 378
Exhibited: Memorial Exhibition, 1933 (155); Saltire, 1953 (A17).
Provenance: owned in 1933 by Professor Randolph Schwabe; by family descent.
Collection: Mr and Mrs H. Jefferson Barnes.
Illustrated on p. 138.

210 Steamer Moored at the Quayside, with two Gendarmes Standing on the Quay* ?1927
Watercolour and crayon 269 × 209
Provenance: Mackintosh Estate.
Collection: Glasgow University.
Illustrated on p. 137.

Apart from a few flower drawings, all Mackintosh's surviving output in France was of the highly-finished type of watercolour, with the exception of four rapid sketches of workmen and boats in the harbour of Port Vendres. In letters to Margaret in 1927 (Glasgow University) he often mentions the new arrivals and departures in the harbour, with their exotic or mundane cargoes. Perhaps these drawings were made at the same time.

211 Steamers at the Quayside ?1927
Watercolour and crayon 254 × 209
Provenance: Mackintosh Estate.
Collection: Glasgow University.

212 Steamer at the Quayside ?1927
Watercolour and crayon 154 × 209
Provenance: Mackintosh Estate.
Collection: Glasgow University.
Illustrated on p. 136.

213 Men Unloading a Steamer at the Quayside ?1927
Watercolour and crayon 252 × 209
Provenance: Mackintosh Estate.
Collection: Glasgow University.
Illustrated on p. 136.

214 The Little Bay, Port Vendres* 1927
Watercolour 393 × 394
Signed and dated, lower right, C.R. MACKINTOSH 1927; signed, dated and inscribed, verso, *Port Vendres/March 1927/C.R. Mackintosh/£25.*
Literature: Artwork, VI, no 21, p. *28*; Howarth, pp. 217, 218, plate 85.
Exhibited: London, Leicester Galleries, 1928; Memorial Exhibition, 1933 (50); Saltire, 1953 (A3).
Provenance: purchased at Leicester Galleries by Desmond Chapman-Huston, 1928; Sir John Richmond, by whom presented.
Collection: Glasgow University.
Illustrated on p. 139.

Signed in 1928 at Chapman-Huston's request. *See also* 208.

215 Le Fort Maillert* 1927
Watercolour 358 × 285
Signed and dated, lower right, C.R. MACKINTOSH 1927.
Literature: *Revue du Vrai et Beau*, March, 1929, p. *13*; Artwork, VI, no 21, 1930, p. 27; Howarth, p. 216, plate 83; Macleod, plate XIII; Alison, p. 84.

Exhibited: Memorial Exhibition, 1933 (102); Saltire, 1953 (A10); Edinburgh, 1968 (343); Milan, 1973 (63).
Provenance: purchased at Memorial Exhibition by Sir John Stirling Maxwell, by whom presented.
Collection: Glasgow School of Art.
Illustrated on p. 142.

In a letter to Margaret of 30 May 1927 (Glasgow University) Mackintosh writes that he has finished the watercolour of 'our fort'. This was almost certainly *Le Fort Maillert,* for its similarity with the views of the castle on Holy Island, where the Mackintoshes spent their honeymoon in 1900 and several subsequent holidays, must have given this particular fort a special relevance to them both.

216 The Rocks* 1927
Watercolour 305 × 368
Signed and dated, lower right, C.R. MACKINTOSH. 1927.
Literature: The Studio, CV, 1933, p. *348*; Howarth, p. 217, plate 82.
Exhibited: Memorial Exhibition, 1933 (130); Edinburgh, Royal Scottish Academy, 1934; Glasgow, Empire Exhibition, Palace of Arts, 1938 (224); Edinburgh, 1968 (338).
Provenance: purchased at Memorial Exhibition by William Davidson; by family descent.
Collection: Michael Davidson, Esq.
Illustrated on p. 143.

Mackintosh worked on *The Rocks* for over a month (*see* Introduction) and was extremely pleased with it. It has been pointed out by Howarth and Macleod how the rhythmic patterns of the stratified rocks echo the decorative schemes of some of his later architectural projects, such as the Cloister Room at the Ingram Street Tea Rooms, Glasgow, of 1911, and the interiors at 78 Derngate, Northampton, of 1916–17.

Flower Studies
Other flower studies from the Mackintosh Estate, unidentifiable from the catalogue, the sale records, or the installation photographs of the exhibition, were sold at the time of the Memorial Exhibition, 1933, to the following people: Mrs Ellen Gibb, Mrs James Anderson, Miss Anne Knox Arthur, Miss Grace D. Mitchell, Mr J. R. Longwill, and Mrs W. Davidson (1 each), and Mr (later Sir) W. O. Hutchison (2).

85a Flower Study 1908
Pencil and watercolour 272 × 217
Signed, dated and inscribed, lower centre, CRM/MMM/[M]AY 1908.
Provenance: Sotheby's Belgravia, 28 February 1979, lot 97.
Collection: Piccadilly Gallery, London (1979).

110a Larkspur, Walberswick 1914
Pencil and watercolour 180 × 130
Signed, dated and inscribed, LARKSPUR/WALBERSWICK/AUGUST 1914/CRM/MMM
Private collection.

MARGARET MACDONALD (1865–1933)
i **Summer*** c1893
Pencil, pen and ink and watercolour 517 × 218
Paper blindstamped E.S.K. inside an oval.
Exhibited: ? London, ISSPG, 1899 (209); Memorial
 Exhibition, 1933 (165, as by C.R.Mackintosh);
 Edinburgh, 1968 (62).
Provenance: Mackintosh Estate.
Collection: Glasgow University.
Illustrated on p. 62.

One of the earliest of the so-called Spook School drawings by Margaret. The vivid colours, grimacing figures and fragmentation of the drawing were quite unlike anything Mackintosh was to produce during this period.

FRANCES MACDONALD (1874–1921)
ii **Ill Omen*** 1893
Watercolour 518 × 427
Signed, lower right, FRANCES E. MACDONAI D/1893.
Literature: The Yellow Book, X, 1896, p. *173*;
 Howarth, p. 24, plate 6a; L'Arte Moderna (Fabbri,
 Milan) II, 1967, p. *252*.
Exhibited: Munich, 'Secession', 1964 (123); Arts
 Council, 'Art Nouveau in Britain', 1965 (58);
 Edinburgh, 1968 (57).
Provenance: by family descent to Mrs L. A. Dunder-
 dale, from whom purchased.
Collection: Glasgow University.
Illustrated on p. 63.

A drawing which sums up the aims and achievements of the Spook School. Its alternative title, *Girl in the East Wind with Ravens Passing the Moon*, captures the morbidity and the fascination of the twilight world of Celtic or, more simply, northern legend. Death, suffering and mystery were frequent subjects in Frances's work; often the only way to distinguish her pictures from those of Margaret is that her figures are, if anything, more emaciated and anguished.

MARGARET or FRANCES MACDONALD
iii **The Fountain*** c1893–95
Watercolour 413 × 162
Exhibited: Turin, 'Il Sacro e il Profano nell'Arte dei
 Simbolisti', 1969 (277).
Provenance: by family descent to Mrs L. A. Dunder-
 dale, by whom presented.
Collection: Glasgow University.
Illustrated on p. 60.

One of the drawings in which it is impossible to identify Margaret or Frances as the creator, but the figures do bear some resemblance to those in Frances's large watercolour, *Crucifixion and Ascension* (Glasgow University).

MARGARET MACDONALD
iv **Summer*** 1897
Watercolour on vellum 451 × 205
Signed and dated, lower right, MARGARET/MAC-
 DONALD. 1897.
Exhibited: ?London, ISSPG, 1899 (209); Memorial
 Exhibition, 1933 (95).
Provenance: Mrs Alice Morris (widow of Talwin
 Morris), by whom presented.
Collection: Glasgow Art Gallery.
Illustrated on p. 66.

By 1897, Margaret's work had taken on a more whimsical air, but she was still collaborating on joint projects with her sister Frances, such as this series of the four seasons. The beaten lead frames on the four pictures, however, are still typical of the metalwork produced by the girls c1893–95.

FRANCES MACDONALD
v **Spring** 1897
Watercolour on vellum 442 × 131
Signed and dated, lower left, FRANCES. E./MACDONALD
 1897.
Provenance: as iv.
Collection: Glasgow Art Gallery.
Illustrated on p. 66.

FRANCES MACDONALD
vi **Autumn** 1898
Pencil and watercolour on vellum 454 × 147
Signed and dated, lower left, FRANCES MACDONALD
 1898.
Provenance: as iv.
Collection: Glasgow Art Gallery.
Illustrated on p. 67.

A preparatory drawing for this watercolour is at Glasgow University.

MARGARET MACDONALD
vii **Winter** 1898
Pencil and watercolour on vellum 472 × 196
Signed and dated, lower right, MARGARET MACDONALD
 1898.
Exhibited: Memorial Exhibition, 1933 (99).
Provenance: as iv.
Collection: Glasgow Art Gallery.
Illustrated on p. 67.
See iv.

FRANCES MACDONALD
viii **Ophelia** 1898
Watercolour 453 × 1018
Signed and dated, right, FRANCES E/MACDONALD/1898.
Provenance: by family descent to present owner.
Private collection.
Illustrated on pp. 72–73.

One of the largest watercolours by any of The Four. Figures floating in water were a not uncommon subject for Frances, but this is her most accomplished. The gentle, somewhat whimsical mood was to disappear from her work a few years later to be replaced by a return to the symbolism of the Spook School.

FRANCES MACDONALD
ix **The Sleeping Princess** c1895–97
Pastel 190 × 464
Signed, upper left, FRANCES E. MACDONALD.
Literature: Gleeson White, 'Some Glasgow De-
 signers', The Studio, XI, 1897, p. *89*.
Exhibited: Edinburgh, 1968 (75).
Provenance: as iv.
Collection: Glasgow Art Gallery.
Illustrated on p. 70.

Probably dating from c1895–97 when the two sisters and Mackintosh turned away from the eerie world of the Spook School to paint fairy-tale scenes.

MARGARET MACDONALD
x **The Mysterious Garden** *c*1904–06
Pencil and watercolour on tracing paper 288 × 835
Exhibited: Memorial Exhibition, 1933 (145); Turin,
'*Il Sacro e il Profano nell'Arte dei Simbolisti*', 1969
(279).
Provenance: Mackintosh Estate.
Collection: Glasgow University.

Formerly known as *Kysterion's Garden*. Kysterion has
eluded all commentators on the work of The Four, but
the name is almost certainly a misreading of Mar-
garet's writing of the word 'mysterious' by a Glasgow
framemaker, on whose typewritten label the name
first appears. The subject is related to the series of
gesso panels made by Margaret, with the possible help
of Mackintosh, for the Music Room for Herr Wärn-
dorfer in Vienna. Mackintosh designed the room in
1902, but the panels were not installed until 1906.
They were based upon Maeterlinck's story, The Seven
Princesses, in which a 'mysterious garden' certainly
appears. No record of the finished panels exists, other
than a photograph taken in 1906 of the three which
portray the Seven Princesses (collection: Glasgow
University).

MARGARET MACDONALD
xi **St Dorothy** 1905
Watercolour and pencil 764 × 452
Signed and dated, lower left, MARGARET/MACDONALD/
MACKINTOSH/1905.
Exhibited: Edinburgh, 1968 (90).
Provenance: by family descent to Mrs L. A. Dunder-
dale, by whom presented.
Collection: Glasgow University.

After her marriage to Mackintosh, Margaret slowly
changed her style, concentrating her output upon
decorative gesso panels, such as those used at Turin,
the Willow Tea Rooms, Glasgow, and the Wärndorfer
Music Salon, Vienna. This watercolour is very much
in the style of the later panels.

FRANCES MACDONALD
xii **The Choice** *c*1909–15
Watercolour, pencil and gold paint 350 × 306
Signed, lower right, FRANCES MACNAIR.
Provenance: by family descent to Mrs L. A. Dunder-
dale, from whom purchased.
Collection: Glasgow University.
Illustrated on p. 100.

In 1899, Frances married Herbert MacNair, a friend
and colleague of Mackintosh and the other member of
The Four. They lived in Liverpool until 1908, when
they were forced to return to Glasgow, living for a time
with the Mackintoshes at 78 Southpark Avenue. Their
life together was difficult and they must have been
faced with many such 'choices' imposed by Frances's
family, who came to disapprove of MacNair, or, more
often, by Herbert's inability to earn a living for his
family from his design work, or the succession of jobs
he took to produce an income. While Margaret's
relatively settled life until 1913 is reflected in her work,
Frances's unpredictable existence is perhaps echoed
in a group of mysterious late works given philosophical
titles like *Man makes the beads of life but woman must
thread them* or *'Tis a long path which wanders to desire*
(xiii).

FRANCES MACDONALD
xiii **'Tis a long path which wanders to desire**
 *c*1909–15
Watercolour and pencil on vellum 352 × 301
Signed, lower right, FRANCES MACNAIR.
Exhibited: Edinburgh, 1968 (99).
Provenance: by family descent to Mrs L. A. Dunder-
dale, from whom purchased.
Collection: Glasgow University.
Illustrated on p. 101.

FRANCES MACDONALD
xiv **The Sleeping Princess** *c*1909–15
Watercolour and gold on vellum 127 × 445
Signed, lower left, FRANCES MACDONALD MACNAIR.
Private collection.

MARGARET MACDONALD
xv **The Mysterious Garden** 1911
Watercolour and ink on vellum 457 × 483
Signed and dated, lower right, MARGARET/MAC-
DONALD/MACKINTOSH/1911.
Exhibited: Glasgow, RSW, 1911 (96) and 1912 (240);
Memorial Exhibition, 1933 (75, as '*Kysterion's
Garden*'); Edinburgh, 1968 (94).
Provenance: R.W.B. Morris (as 63).
Private collection.
Illustrated on p. 104.

The allusion to 'Kysterion' is a mistake on the part of
the organisers of the Memorial Exhibition (*see* x).
These larger finished watercolours which Margaret
began to exhibit after 1910 almost certainly inspired
Mackintosh, or at least reinforced his determination
to turn to watercolour painting as a full-time occupa-
tion. While his subject matter remained firmly based
on nature, Margaret retained her interest in obscure
legend and myth or the stories of Maeterlinck.

MARGARET MACDONALD
xvi **The Pool of Silence** 1913
Watercolour and ink 758 × 635
Signed and dated, lower left, MARGARET/MACDONALD
MACKINTOSH/1913.
Exhibited: Glasgow, RSW, 1913 (125) and 1914 (135);
Memorial Exhibition, 1933 (132); Edinburgh, 1968
(95).
Provenance: R.W.B. Morris (as 63); Lady Artists'
Club, Glasgow.
Private collection.
Illustrated on p. 105.

MARGARET MACDONALD
xvii **The Child** *c*1922–23
Watercolour 26 × 37
Collection: Her Majesty Queen Elizabeth, The Queen
Mother.
Illustrated on p. 104.

The last known work by Margaret, who seems to have
produced no drawings while in France with her
husband from 1923 to 1927. This tiny drawing, com-
missioned *c*1922 for The Queen's Dolls' House, was
shown at the British Empire Exhibition of 1924 and is
now at Windsor Castle.

Index

Abbotsbury (169) 41
Anemone and Pasque, Walberswick (142) 16, 38, *87*
Anemones (152) 16, 39, *94*
Angel (35) 27
Antique Relief, An (4) 24, *49*
Arbutus, Walberswick (134) 37
Arch of Titus, Rome (17) 25
Aster, Bowling (100) 34
At the Edge of the Wood (85) 33, *81*
Aubrietia, Walberswick (109) 35, *88*
Autumn (42) 29
Autumn (FM, vi) 46, *67*
Baptistry, Siena Cathedral, The (19) 25, *51*
Basket of Flowers, A (157) 17, 39, *108*
Bean Flower, Walberswick (151) 39
Beech Leaf, Chiddingstone (96) 34
Begonias (153) 16, 39, *95*
Berberis, Walberswick (146) 38
Black Thorn, The (60) 31
Blackthorn, Chiddingstone (89) 33
Blanc Antoine (202) 44, *111*
Blind Window, Certosa di Pavia (32) 26
Borage, Walberswick (114) 36, *82*
Boulders, The (177) 42, *126*
Boultenère (201) 44, *135*
Bouquet (159) 17, 39
Bouquet (160) 17, 40
Bouquet (161) 17, 40
Bouquet (163) 17, 40
Brook Weed, Holy Island (70) 32
Bugloss, Holy Island (103) 35, *85*
Butterfly Flower, Bowling (99b) 34
Cabbages in an Orchard (40) 12, 28, *57*
Cactus Flower, Walberswick (123) 16, 37, *83*
Campanile Martorana, Palermo (16) 25, *52*
Canary Creeper (*Tropaeolum canariense*) (122) 36
Ceiling Decoration, Certosa di Pavia (33) 27
Centaurea, Withyham (87) 33, *84*
Chicory, Walberswick (107) 35, *85*
Child, The (MM, xvii) 47, *104*
Chionodoxa, Walberswick (147) 38
Choice, The (FM, xii) 47, *100*
Church of La Lagonne, The (187) 43, *133*
Church Tower (36) 27, *53*
Cloisters, Monreale (15) 25, *55*
Collioure (179) 42
Collioure, Pyrénées-Orientales, Summer Palace of the Queens of Aragon (178) 42, *106*
Cottage in a Landscape (3) 24
Cowslip, Chiddingstone (99) 34, *84*
Cranesbill, Holy Island (73) 32
Cuckoo Flower, Chiddingstone (92) 34, *84*
Cyclamen, (170) 41
Daisy, Walberswick (148) 38
Decoration from Roof of S. Miniato, Florence (23a) 26
Della Robbia Frieze, Florence (24a) 26
Descent of Night, The (39) 12, 28, *59*
Detail of a Buttress, Milan Cathedral (31) 26
Detail of Angel and Saints from a Mosaic in Sant'Apollinare Nuovo, Ravenna (25) 26
Details of Buttress, Siena Cathedral (20) 25
Details of the Roof, Napton Church, Norfolk (53) 30
Doorway, Certosa di Pavia (32b) 26
Doorway of Library, Siena Cathedral (21) 25
Doorway, Trinità Maggiore, Naples (14) 25
Downs, Worth Matravers, The (168) 17, 40, *115*
Elder, Walberswick (137) 38
Entrance Gateway, Certosa di Pavia (32a) 26
Faded Roses (83) 33, *80*
Fairies (58) 13, 31, *70*
Fetges (180) 19, 20, 42, *113*
Field Pea, Walberswick (144) 38
Fig Leaf, Chelsea (154) 39, *119*
Flower Drawing, Holy Island (66) 31
Flower Drawing (Mallow?), Walberswick (145) 38
Flowering Ash, Chiddingstone (93) 34
Flowering Chestnut, Cowden (97) 34
Flower Studies (115) 36
Flower Studies (unidentified) 46
Flower Study (2) 24
Fort, The (184) 42, *117*
Fort Maillert, Le (215) 20, 45, *142*
Fort Mauresque, Le (183) 42, *141*
Fountain, The (MM or FM, iii) 12, 46, *60*
Free Copy of Part of an Indian Carpet (5) 24

Free Copy of Part of an Indian Carpet (6) 24
Fritillaria, Walberswick (128) 16, 37, *96*
Gaillardia, Walberswick (117) 36
Garden Bouquet (158) 17, 39
Garden Bouquet (162) 17, 40
Glasgow Cathedral at Sunset (13) 10, 25
Gorse, Walberswick (141) 38, *86*
Green Hellebore, Walberswick (124) 37, *88*
Grape Hyacinth, Walberswick (121) 36
Grey Iris, The (174) 16, 41, *103*
Harvest Moon, The (37) 11, 27, *58*
Hazel Bud, Chiddingstone (90) 33
Hazel Tree, Lambs' Tails, Walberswick (127) 37
Hellebore, Walberswick (138) 38
Henbane, Holy Island (102) 35
Héré de Mallet, Ille-sur-Têt (204) 44, *125*
Hill Town in Southern France, A (191) 43, *116*
Honeysuckle, Walberswick (125) 37
Hound's Tongue, Holy Island (72) 32, *74*
Ill Omen (FM, ii) 12, 46, *63*
In Fairyland (52) 13, 30, *77*
In Poppyland (56) 30
Intarsia Panel, Certosa di Pavia (33a) 27
Intarsia Panel, Certosa di Pavia (33b) 27
Intarsia Panel, Certosa di Pavia (33c) 27
Intarsia Panel, Certosa di Pavia (33d) 27
Intarsia Panel, Certosa di Pavia (33e) 27
Iris (75) 32
Iris Seed, Walberswick (150) 39, *96*
Ivy Geranium, St Mary's, Scilly (80) 32, *75*
Ivy Seed, Walberswick (139) 38
Ixias, St Mary's, Scilly (81) 32
Japanese Witch Hazel, Walberswick (126) 37
Japonica, Chiddingstone (91) 34, *79*
Jasmine, Walberswick (132) 37
Kingcups, Walberswick (149) 38
Larkspur, Walberswick (110) 35, *88*
Laurel, Chelsea (155) 39
Lavender, Walberswick (140) 38
Leycesteria, Walberswick (104) 35, *85*
Lido, Venice, The (28) 10, 26, *56*
Little Bay, Port Vendres, The (214) 45, *139*
Lupin, Walberswick (135) 38
Men Unloading a Steamer at the Quayside (213) 45, *136*
Milk Thistle, Holy Island (64) 31
Mimosa, Amélie-les-Bains (203) 19, 44, *118*
Mixed Flowers, Mont Louis (207) 19, 44, *144*
Mont Alba (189) 43, *120*
Mont Louis—Flower Study (205) 19, 44, *128*
Mosaic Bands, Orvieto Cathedral (18b) 25
Mosaics in Sant'Apollinare in Classe, Ravenna (26) 26
Moss Rose, The (61) 31
Moth Mullein, Walberswick (116) 36
Mountain Landscape (197) 44, *133*
Mountain Landscape (198) 44
Mountain Village (199) 44, *129*
Mustard-seed Flower, Holy Island (65) 31
Mysterious Garden, The (MM, x) 47
Mysterious Garden, The (MM, xv) 47, *104*
Oasthouses, Chiddingstone (94) 34
Old High Church, Stirling (12) 24
Old Tomb, Cathedral Graveyard, Elgin (9) 24
Ophelia (FM, viii) 46, *72*
Orange Blossom, St Mary's, Scilly (77) 32
Palace of Timber, A (120) 17, 36, *92*
Palalda, Pyrénées-Orientales (200) 44, *134*
Palazzo Ca d'Oro, Venice (27) 26
Palazzo Pubblico, Siena, The (22) 26, *53*
Palm Grove Shadows (171) 41, *91*
Part of the North Façade Orvieto Cathedral (18) 25, *54*
Part Seen, Imagined Part (51) 13, 30, *71*
Peonies (165) 16, 40, *99*
Petunia, Walberswick (111) 16, 35
Pimpernel, Holy Island (69) 32, *74*
Pine Cone and Needles, Walberswick (130) 37, *88*
Pines Cones, Mont Louis (206) 19, 44
Pine, Walberswick (136) 38, *89*
Pinks (175) 16, 41, *109*
Pitti Bridge, Florence, The (24) 26
Polyanthus, Walberswick (151a) 39
Pool of Silence, The (MM, xvi) 47, *105*
Poor Man's Village, The (190) 43, *129*
Porch and Wisteria, Chiddingstone (95) 34
Porlock Weir (50) 30, *65*
Port Vendres (185) 42, *121*
Port Vendres (209) 45, *138*
Port Vendres, la Ville (186) 43, *123*
Princess Ess (54) 13, 30
Princess Uty (55) 13, 30
Purple Mallows, Holy Island (63) 31

Reflections (57) 31, *70*
Road through the Rocks, The (182) 42, *140*
Rocks, The (216) 19, 45, *143*
Rosemary, Walberswick (133) 37, *97*
Rue du Soleil, Port Vendres, La (208) 19, 45, *138*
St Dorothy (MM, xi) 47
St Jerome, Milan Cathedral (30) 26
Salvia pratensis (105) 35
Scabious and Toadflax, Blakeney (82) 33, *75*
Sea Pink, Holy Island (68) 31, *74*
Semi-stylised Aconitum (74) 32
Shadow, The (49) 12, 30, *76*
Ships (172) 41, *112*
Slate Roofs (194) 43, *131*
Sleeping Princess, The (FM, ix) 47, *70*
Sleeping Princess, The (FM, xiv) 47
Sorrel, Walberswick (106) 35, *85*
Southern Farm, A (192) 43, *107*
Southern Port, A (176) 41, *127*
Southern Town, A (193) 19, 43, *110*
Spiral Column, Orvieto Cathedral (18a) 25
Spanish Farm, A (181) 42, *122*
Spring (38) 12, 28
Spring (FM, v) 46, *66*
Spurge, Withyham (88) 33, *84*
Stagthorn, Walberswick (108) 35
Steamer at the Quayside (212) 45, *136*
Steamer Moored at the Quayside, with two Gendarmes Standing on the Quay (210) 45, *137*
Steamers at the Quayside (211) 45
Study of a Carved Angel, Certosa di Pavia (32c) 27
Study of Leaves, A (1) 24
Stylised Plant Form (41) 29, *61*
Summer (MM, i) 12, 46, *62*
Summer (MM, iv) 46, *66*
Summer in the South (195) 19, 43, *124*
Tacsonia, Cintra, Portugal (86) 33, *78*
'Tis a long path which wanders to desire (FM, xiii) 47, *101*
Tobacco Flower, Bowling (84) 33, *75*
Tomb, Elgin (10) 24, *50*
Tomb of Carlo Marsuppini, Santa Croce, Florence (23) 26
Tree, A (43) 29
Tree of Influence, The (45) 12, 29, *68*
Tree of Personal Effort, The (44) 12, 29, *68*
Triumphal Arch (34) 27
Venetian Palace (29) 26
Venetian Palace, Blackshore on the Blyth (118) 17, 36, *90*
Veronica, Walberswick (129) 37
Veronica, Walberswick (131) 37, *96*
Village in the Mountains (196) 44, *132*
Village of La Lagonne, The (188) 43, *130*
Village, Worth Matravers, The (167) 17, 40, *114*
Walberswick (119) 36, *93*
Wareham (46) 29, *65*
Wassail, The (62) 13, 31, *73*
'Whether the Roses be your lips . . .' (59) 31
White Carnation, St Mary's, Scilly (79) 32
White Rose (66) 16, 40, *99*
White Tulips (156) 16, 39, *98*
Wild Carrot (76) 32
Wild Pansy and Wood Violet, Chiddingstone (99a) 34.
Willow Catkins, Walberswick (143) 38
Willow-herb, Buxstead (164) 40
Window in Chapter House, Elgin Cathedral (7) 24
Window in South Aisle, Elgin Cathedral (8) 24
Window, Spynie, Morayshire (11) 24
Winter (47) 12, 29, *65*
Winter (48) 29, *64*
Winter (MM, vii) 46, *67*
Winter Stock, Walberswick (112) 36
Winter Stock, Walberswick (113) 36
Woody Nightshade, St Mary's, Scilly (78) 32, *75*
Yellow Clover, Holy Island (71) 32, *74*
Yellow Rose, Chiddingstone (98) 34
Yellow Tulips (173) 41, *102*
Yew Tree at Night, A (101) 34

The numbers in parentheses refer to the *catalogue raisonné*. Numbers in italic are page numbers of illustrations. All pictures are by Charles Rennie Mackintosh except those marked MM (Margaret Macdonald) or FM (Frances Macdonald).

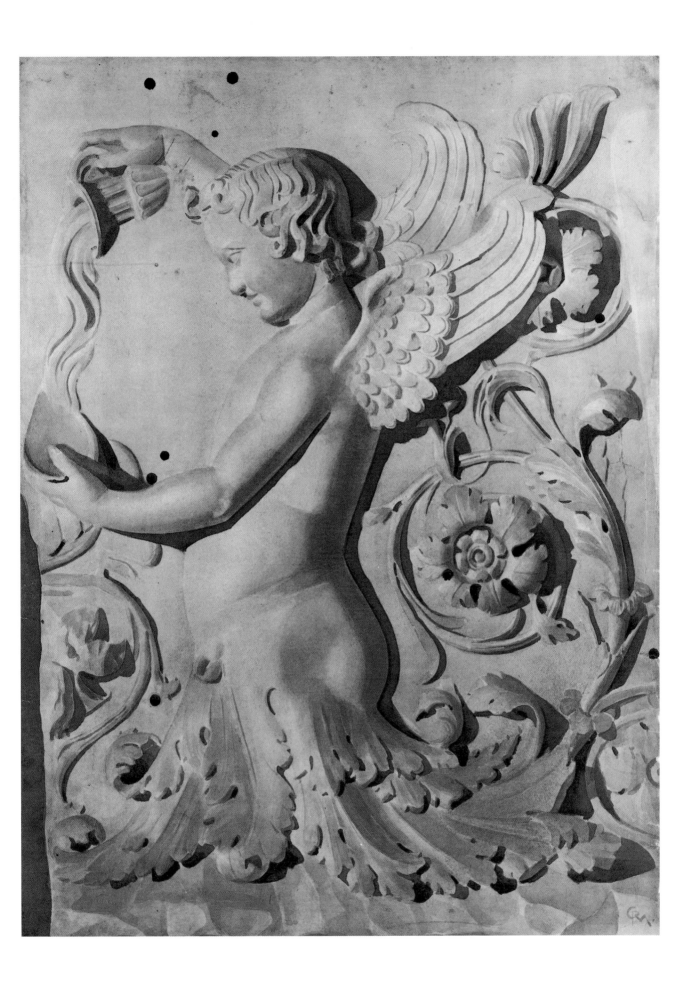

An Antique Relief (*c*1886). 723 × 548. Collection:
Glasgow University. Catalogue 4.

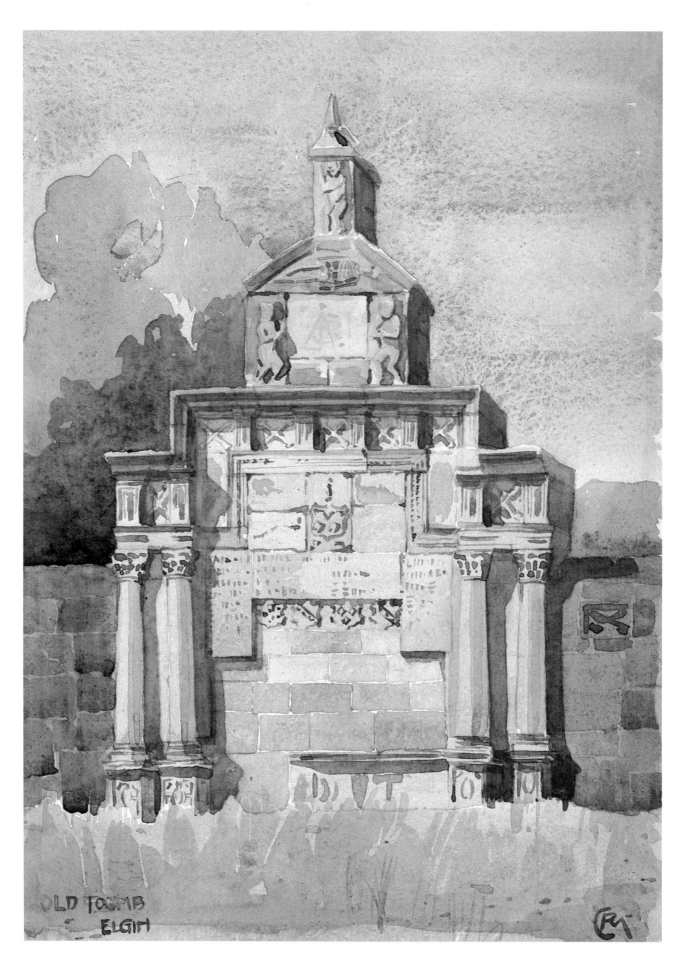

Tomb, Elgin (1889). 318 × 241. Collection: Glasgow
University. Catalogue 10.

C.R. McINTOSH.

The Baptistry, Siena Cathedral (1891). 391 × 279.
Collection: James Meldrum, Esq. Catalogue 19.

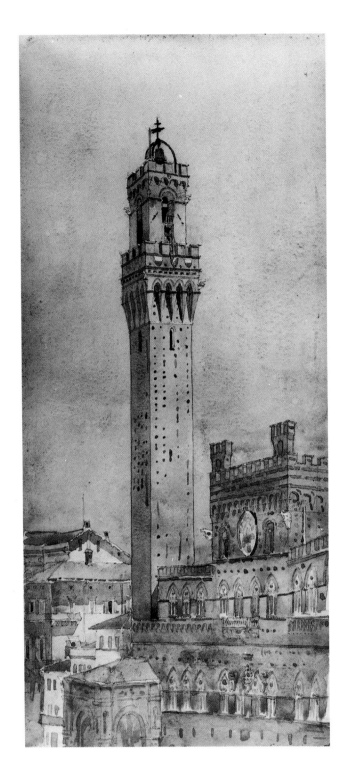

The Palazzo Pubblico, Siena (1891). 369 × 165.
Collection: Miss Moira Dingwall. Catalogue 22.

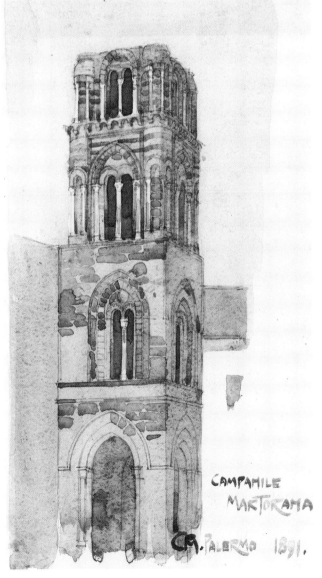

Campanile Martorana, Palermo (1891). 318 × 178.
Collection: Professor T. Howarth. Catalogue 16.

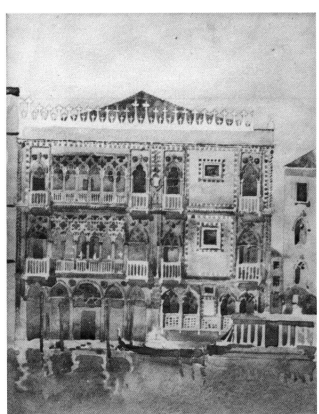

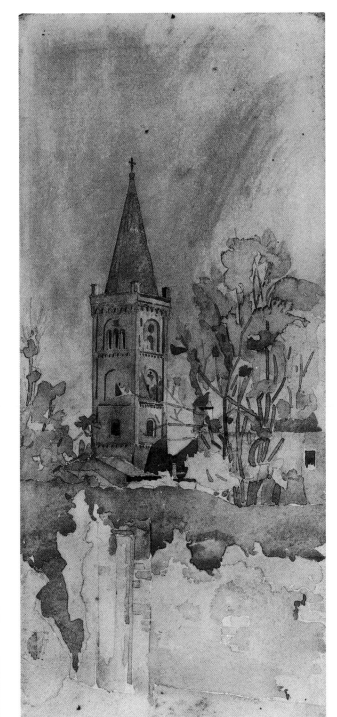

Palazzo Ca d'Oro, Venice (1891). Untraced.
Photograph from Memorial Exhibition. Catalogue 27.

Church Tower (*c*1891). 365 × 171. Collection: Miss
Moira Dingwall. Catalogue 36.

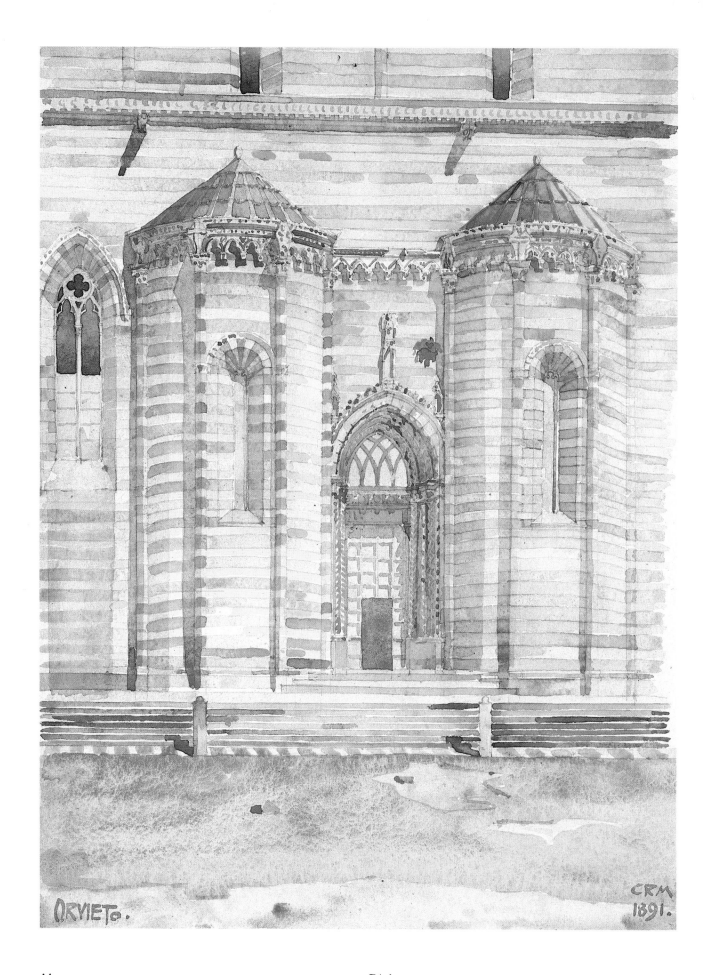

Above
Orvieto Cathedral (1891). 318 × 242. Collection:
Glasgow University. Catalogue 18.

Right
Cloisters, Monreale (1891). 368 × 165. Collection:
James Meldrum, Esq. Catalogue 15.

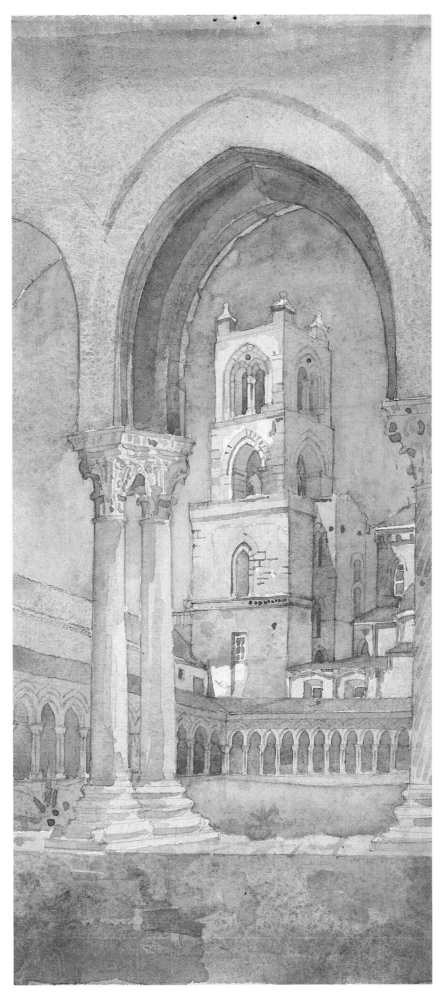

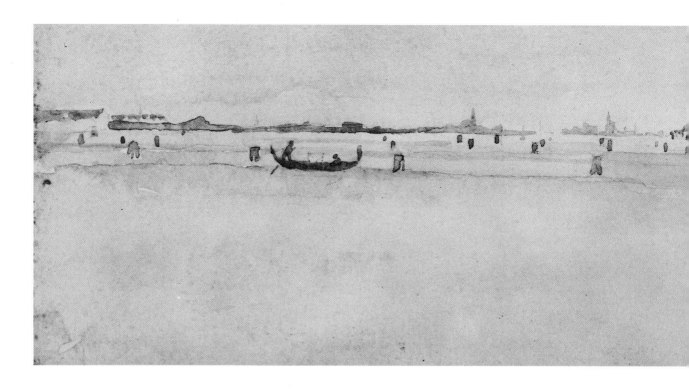

The Lido, Venice (1891). 117 × 343. Collection:
Glasgow University. Catalogue 28.

Cabbages in an Orchard (1894). 86 × 236. Collection: Glasgow School of Art. Catalogue 40.

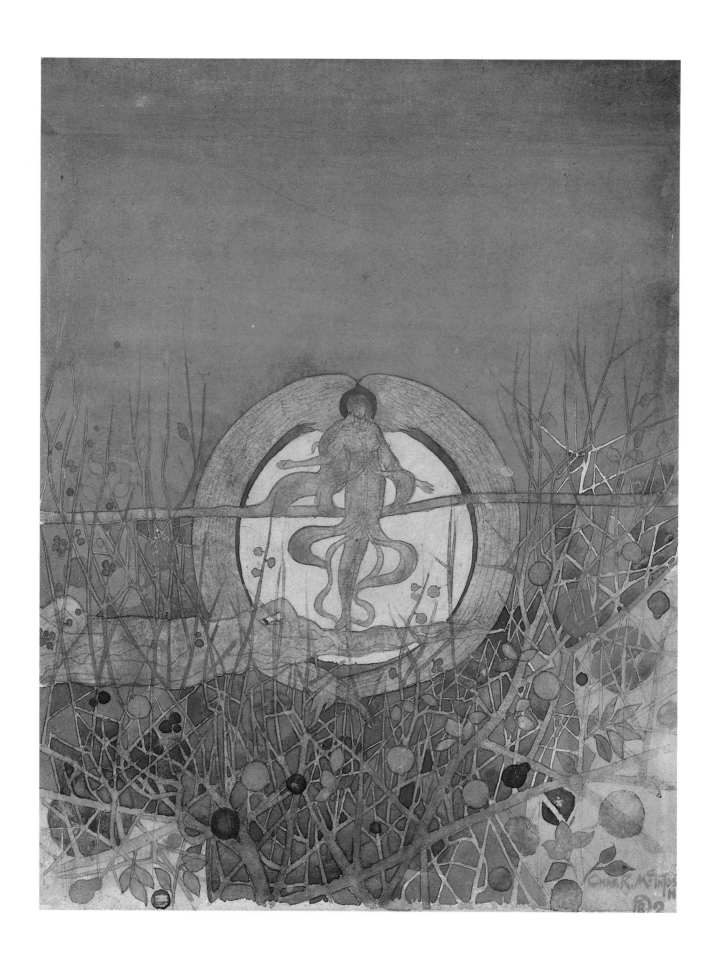

The Harvest Moon (1892). 352 × 276. Collection:
Glasgow School of Art. Catalogue 37.

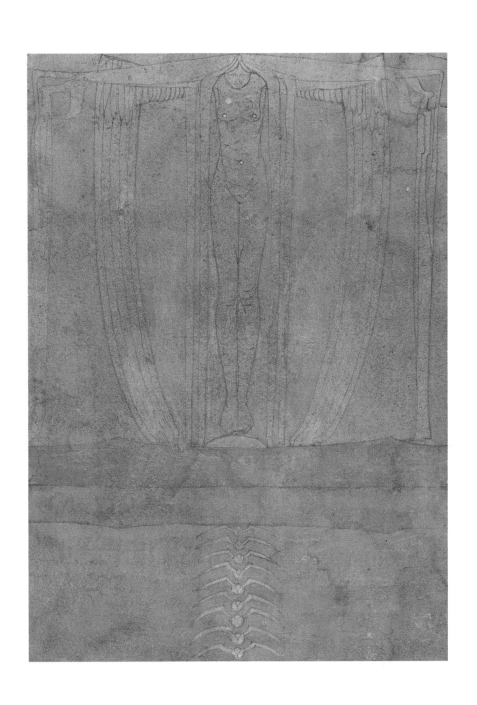

The Descent of Night (c1893–94). 240 × 170.
Collection: Glasgow School of Art. Catalogue 39.

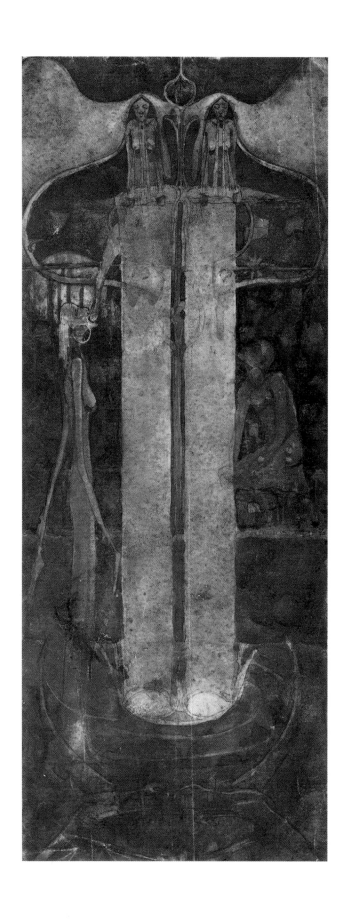

MARGARET or FRANCES MACDONALD
The Fountain (*c*1893–95). 413 × 162. Collection:
Glasgow University. Catalogue iii.

Stylised Plant Form (*c*1894).
255 × 107. Collection: Glasgow
School of Art. Catalogue 41.

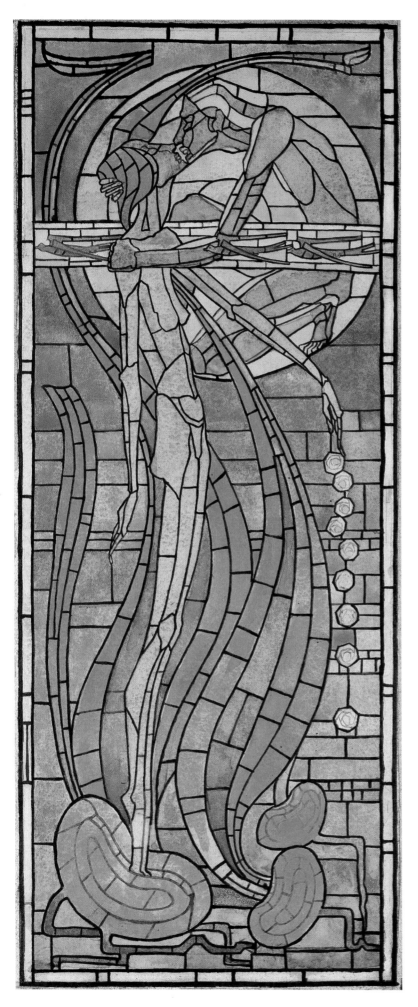

MARGARET MACDONALD
Summer (c1893). 517 × 218.
Collection: Glasgow University.
Catalogue i.

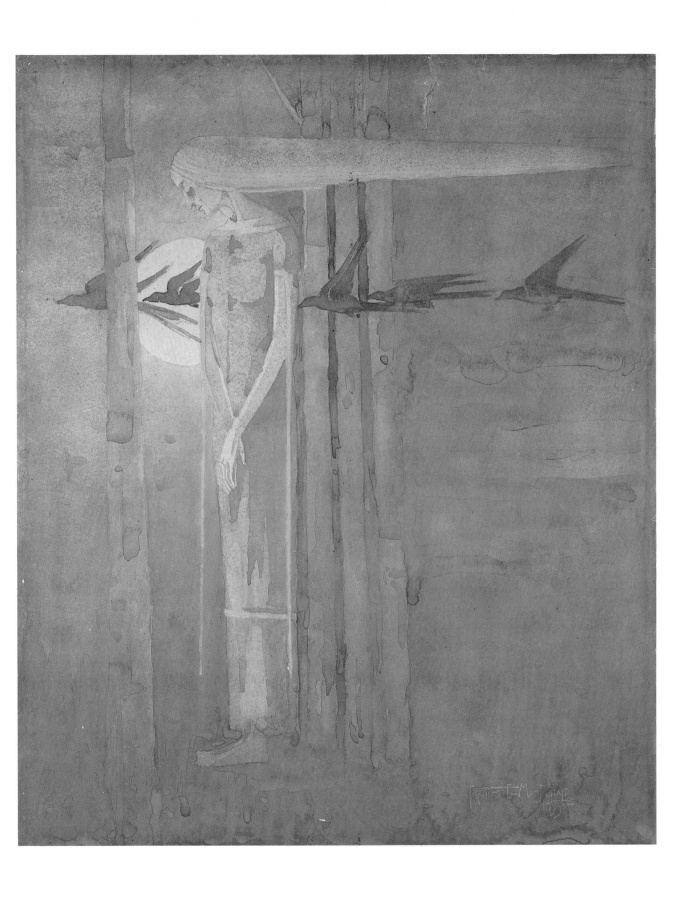

FRANCES MACDONALD *Ill Omen* (1893).
518 × 427. Collection: Glasgow University.
Catalogue ii.

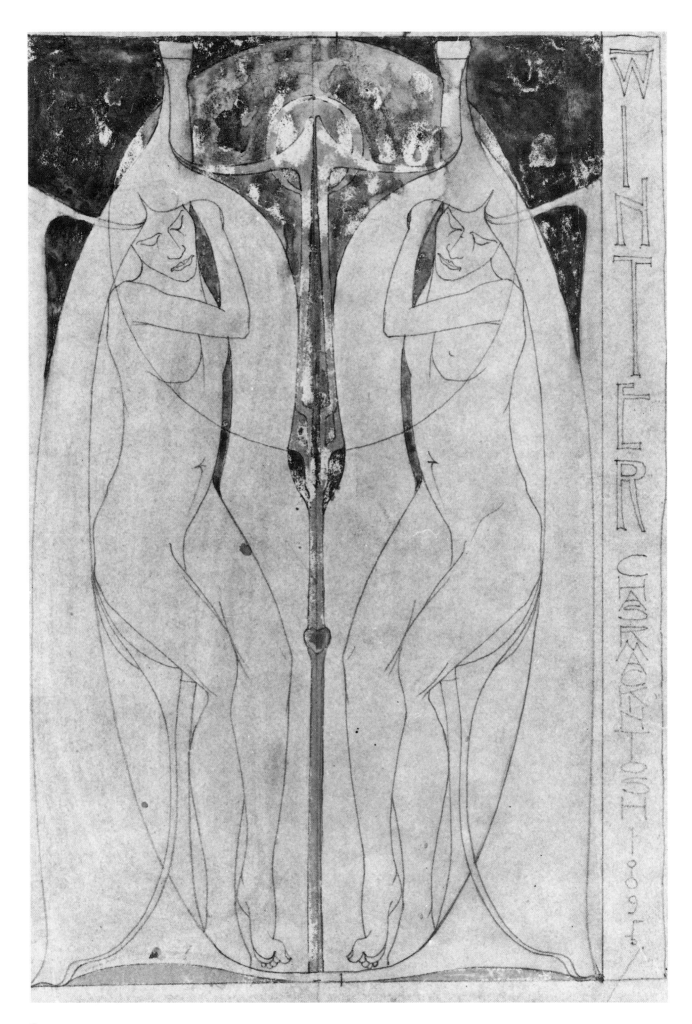

Porlock Weir (c1895–98). 274 × 413. Private
collection. Catalogue 50.

Wareham (1895).
Collection: Professor T. Howarth.
Catalogue 46.

Left
Winter (1895). 313 × 208.
Collection: Glasgow University.
Catalogue 48.

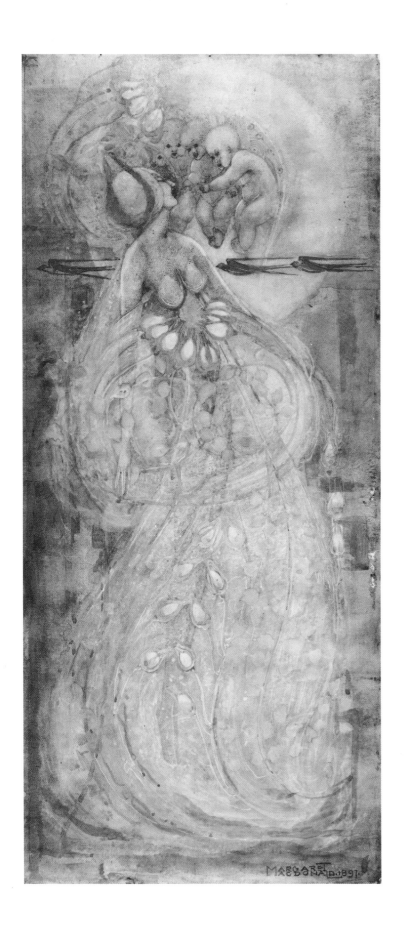

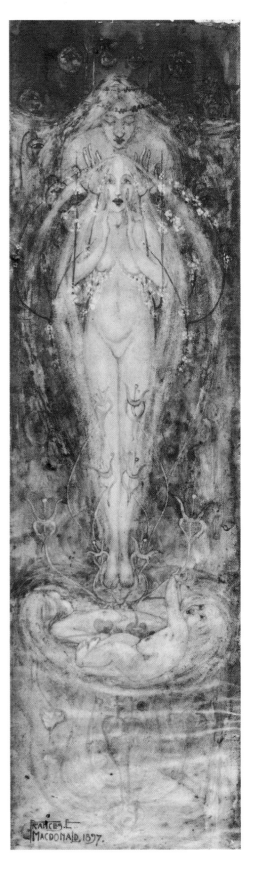

MARGARET MACDONALD
Summer (1897). 451 × 205.
Collection: Glasgow Art Gallery.
Catalogue iv.

FRANCES MACDONALD
Spring (1897). 442 × 131.
Collection: Glasgow Art Gallery.
Catalogue v.

66

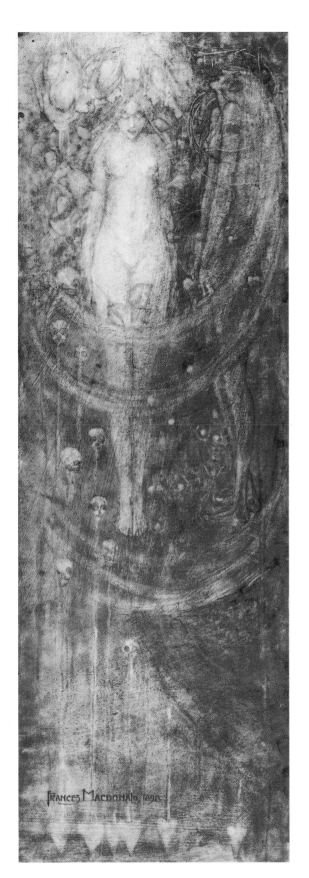

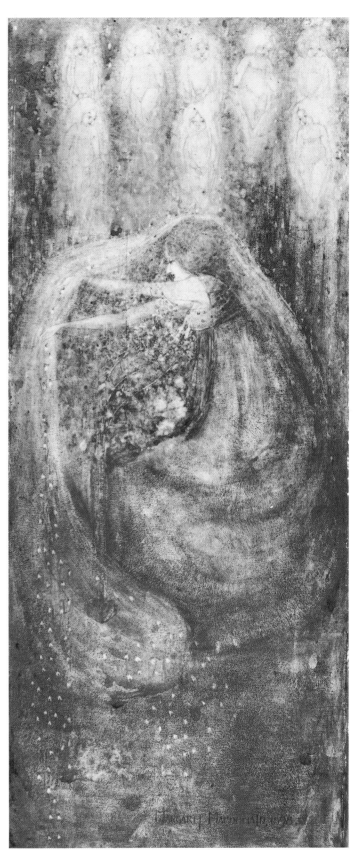

FRANCES MACDONALD
Autumn (1898). 454 × 147.
Collection: Glasgow Art Gallery.
Catalogue vi.

MARGARET MACDONALD
Winter (1898). 472 × 196.
Collection: Glasgow Art Gallery.
Catalogue vii.

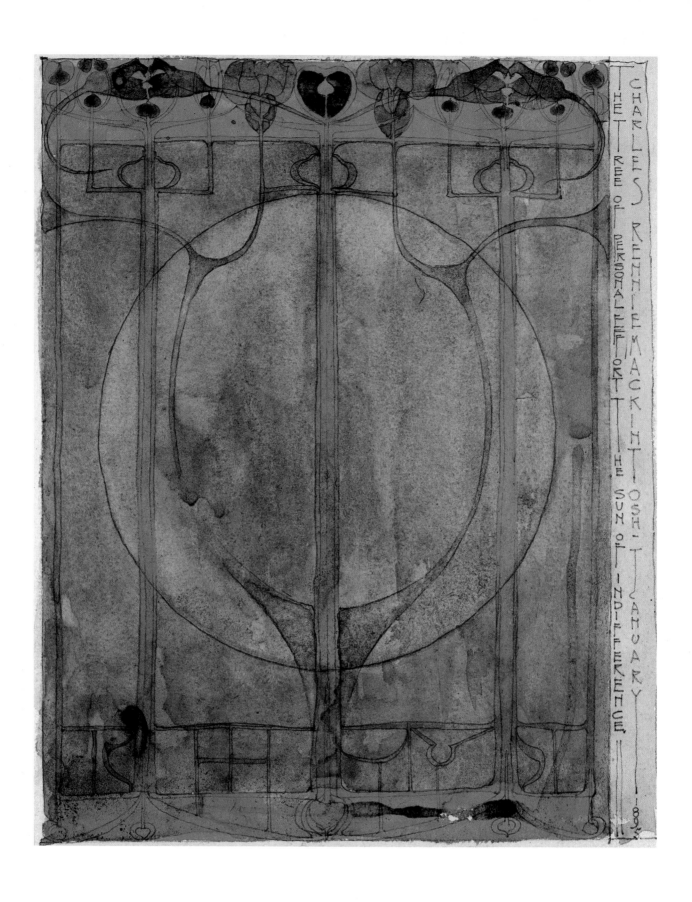

The Tree of Personal Effort (1895). 211 × 174.
Collection: Glasgow School of Art. Catalogue 44.

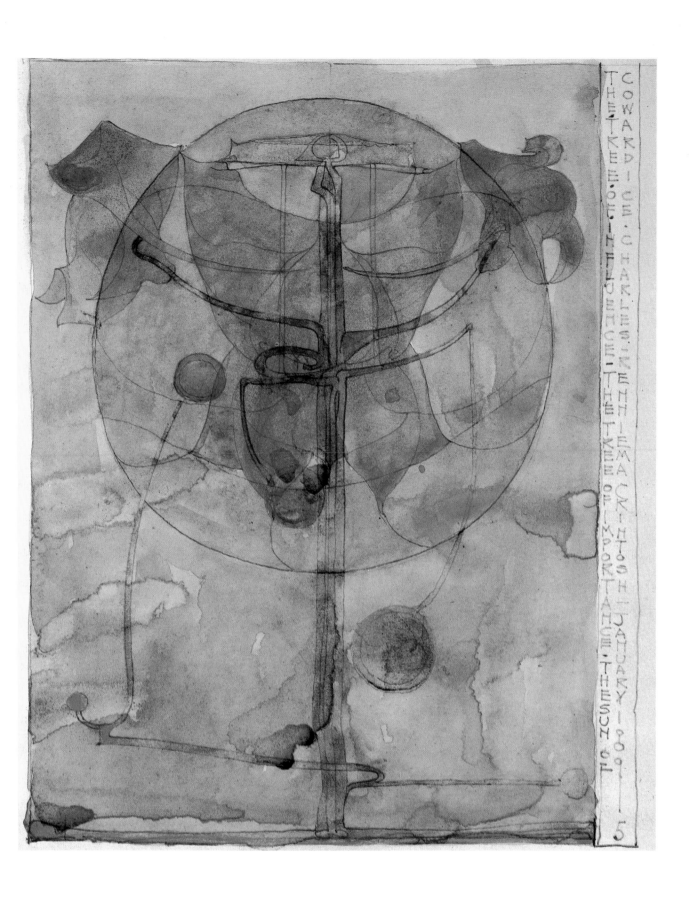

The Tree of Influence (1895). 214 × 172. Collection:
Glasgow School of Art. Catalogue 45.

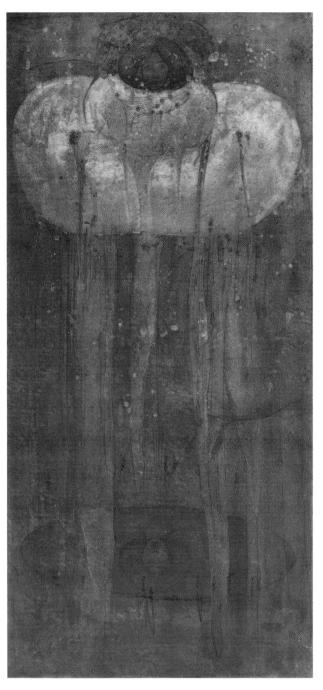

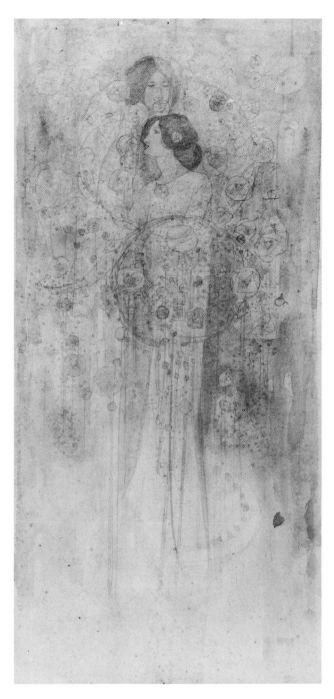

Reflections (1898). 511 × 248. Collection: Glasgow University. Catalogue 57.

Fairies (1898). 527 × 256. Collection: Glasgow School of Art. Catalogue 58.

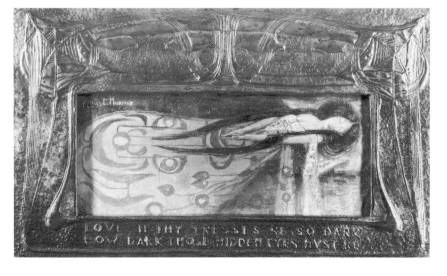

FRANCES MACDONALD
The Sleeping Princess (c1895–97). 190 × 464. Collection: Glasgow Art Gallery. Catalogue ix.

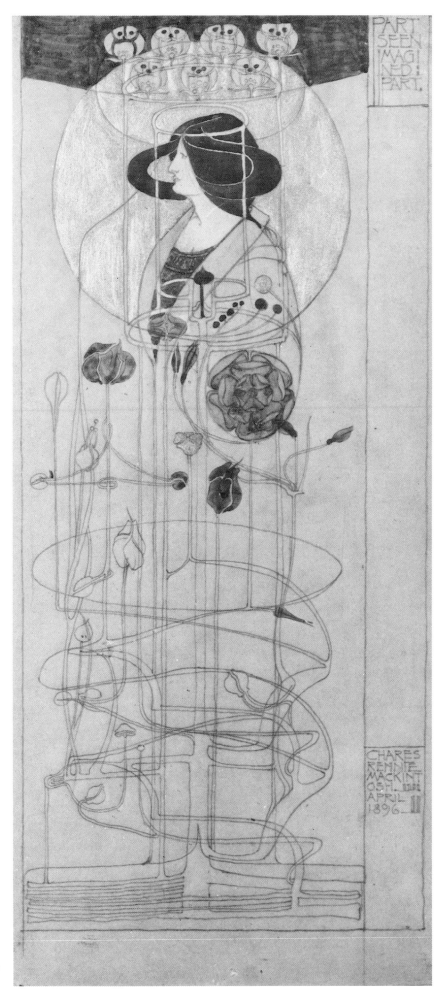

Part Seen, Imagined Part (1896).
390 × 195. Collection: Glasgow Art.
Gallery. Catalogue 51.

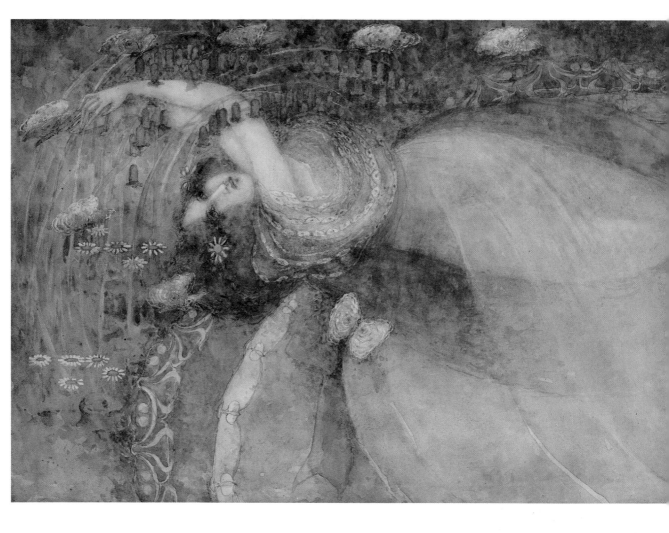

Right
The Wassail (1900). 320 × 680. Collection: Professor
T. Howarth. Catalogue 62.

FRANCES MACDONALD *Ophelia* (1898).
453 × 1018. Private collection. Catalogue viii.

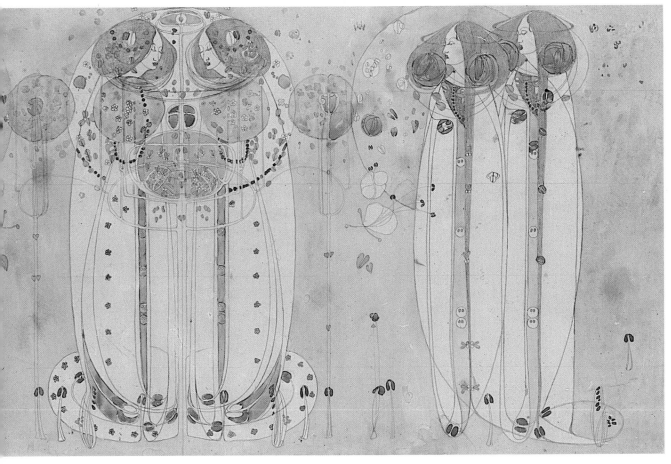

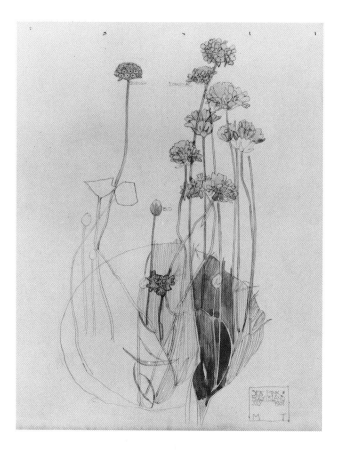

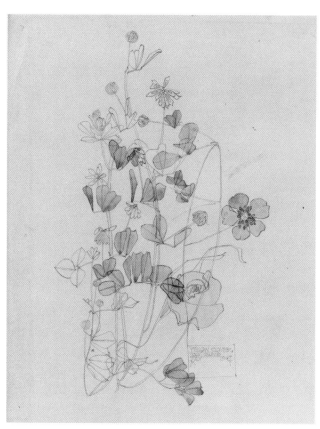

Sea Pink, Holy Island (1901). 258 × 202. Collection: Glasgow University. Catalogue 68.

Yellow Clover, Holy Island (1901). 261 × 203. Collection: Victoria and Albert Museum, London. Catalogue 71.

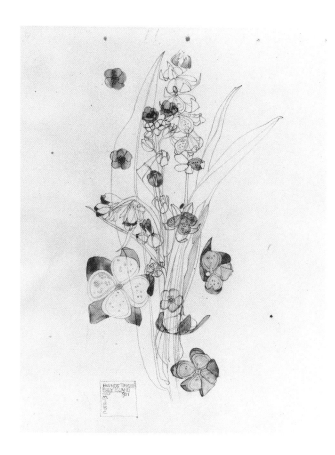

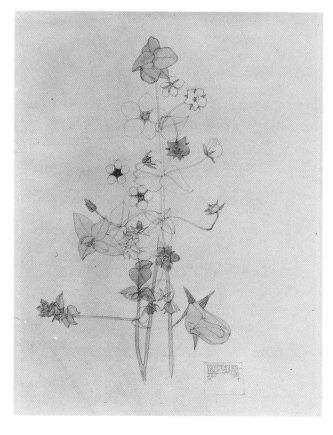

Hound's Tongue, Holy Island (1901). 258 × 202. Untraced. Catalogue 72.

Pimpernel, Holy Island (1901). 258 × 202. Private collection. Catalogue 69.

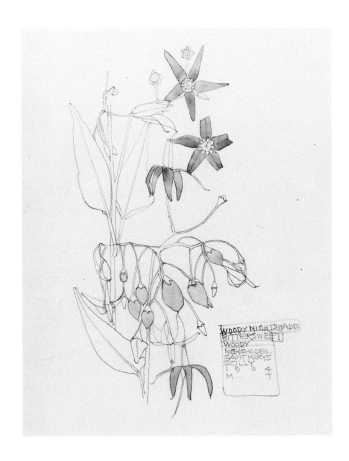

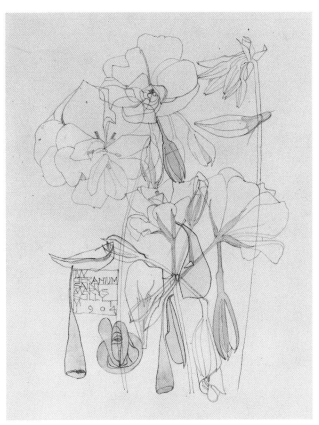

Woody Nightshade, St Mary's, Scilly (1904).
258 × 202. Private collection. Catalogue 78.

Ivy Geranium, St Mary's, Scilly (1904). 258 × 202.
Private collection. Catalogue 80.

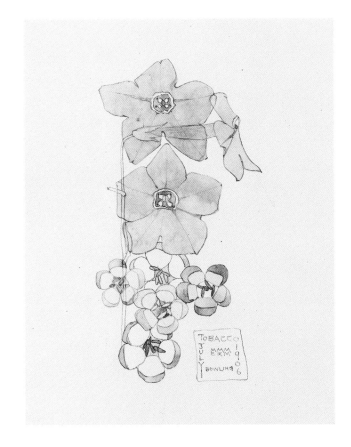

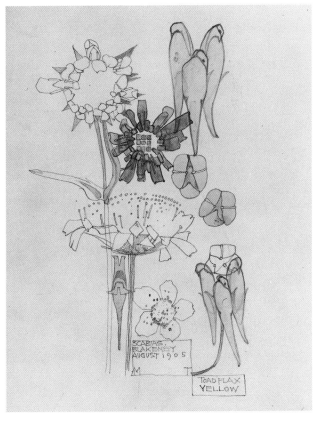

Tobacco Flower, Bowling (1906). 258 × 202. Private
collection. Catalogue 84.

Scabious and Toadflax, Blakeney (1905). 258 × 202.
Collection: Piccadilly Gallery, London. Catalogue 82.

The Shadow (c1895–96). 300 × 180. Collection:
Glasgow School of Art. Catalogue 49.

In Fairyland (1897). 370 × 176. Private collection.
Catalogue 52.

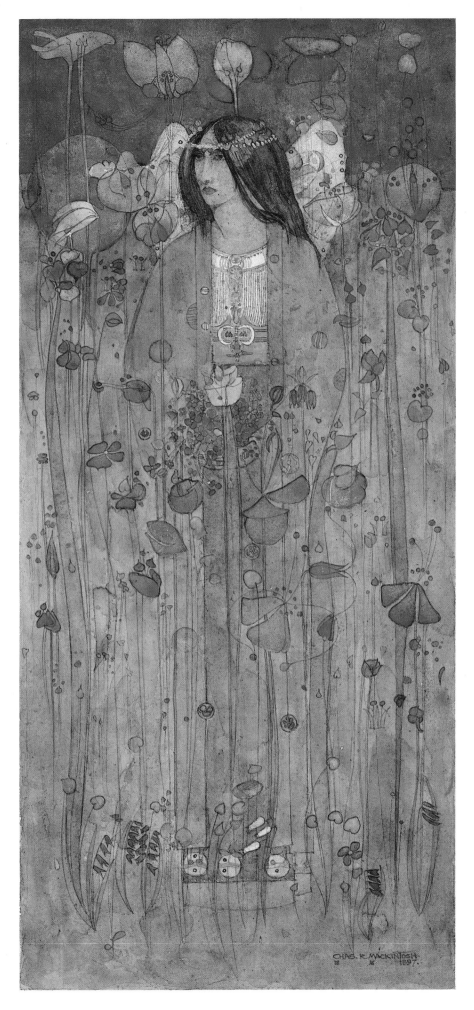

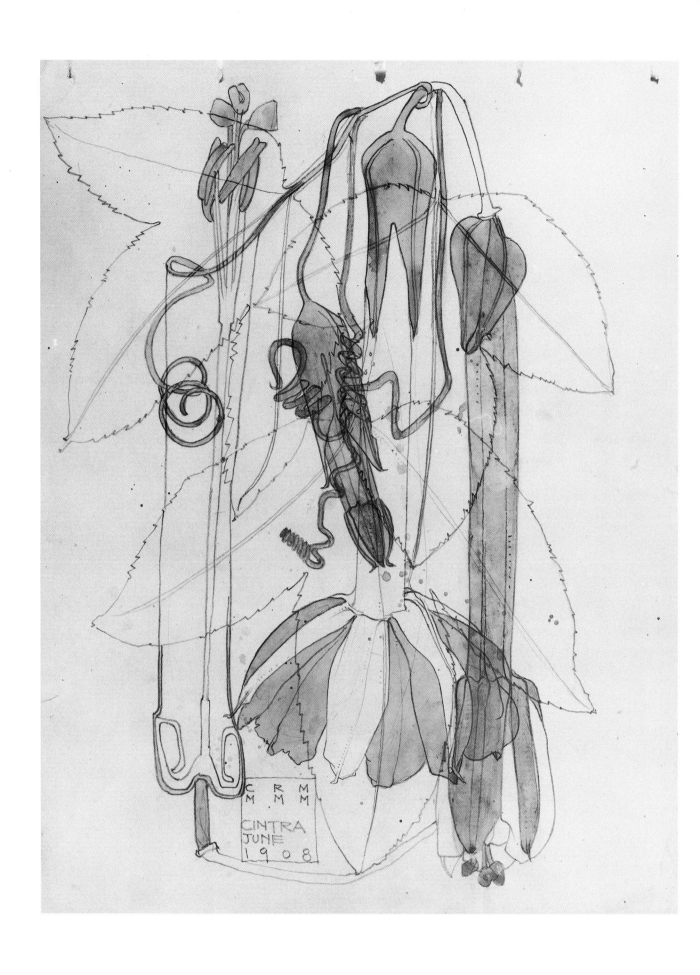

Tacsonia, Cintra, Portugal (1908). 258 × 202.
Untraced. Catalogue 86.

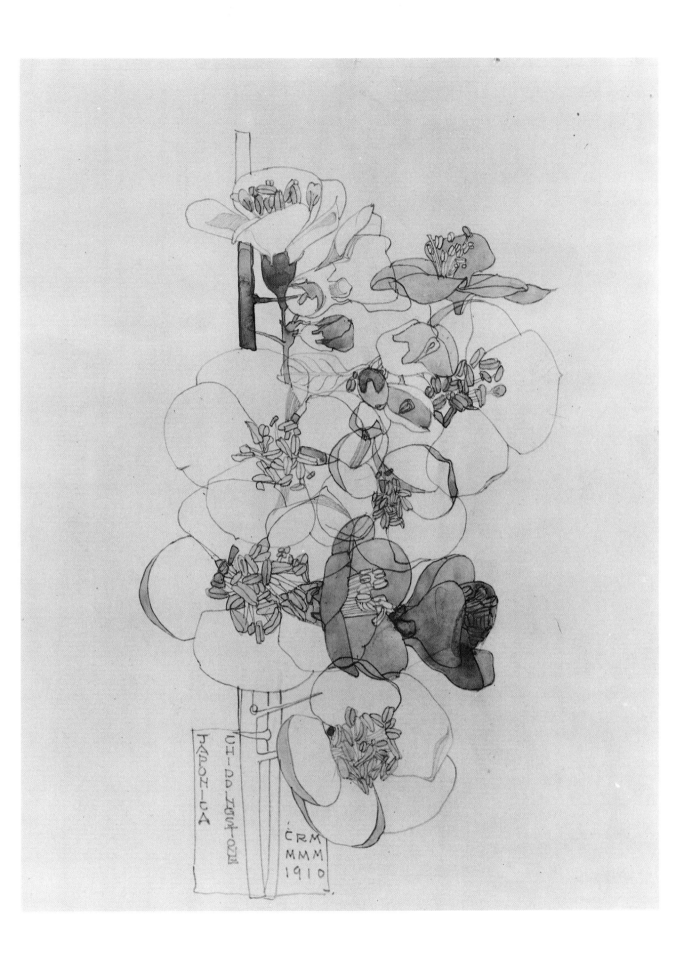

Japonica, Chiddingstone (1910). 258 × 200. Collection:
Glasgow University. Catalogue 91.

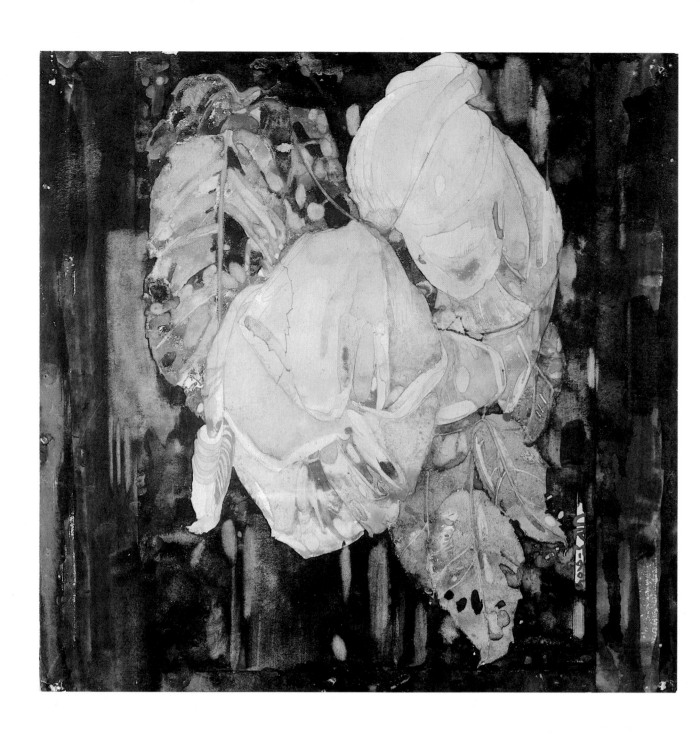

Faded Roses (1905). 285 × 291. Collection: Glasgow
Art Gallery. Catalogue 83.

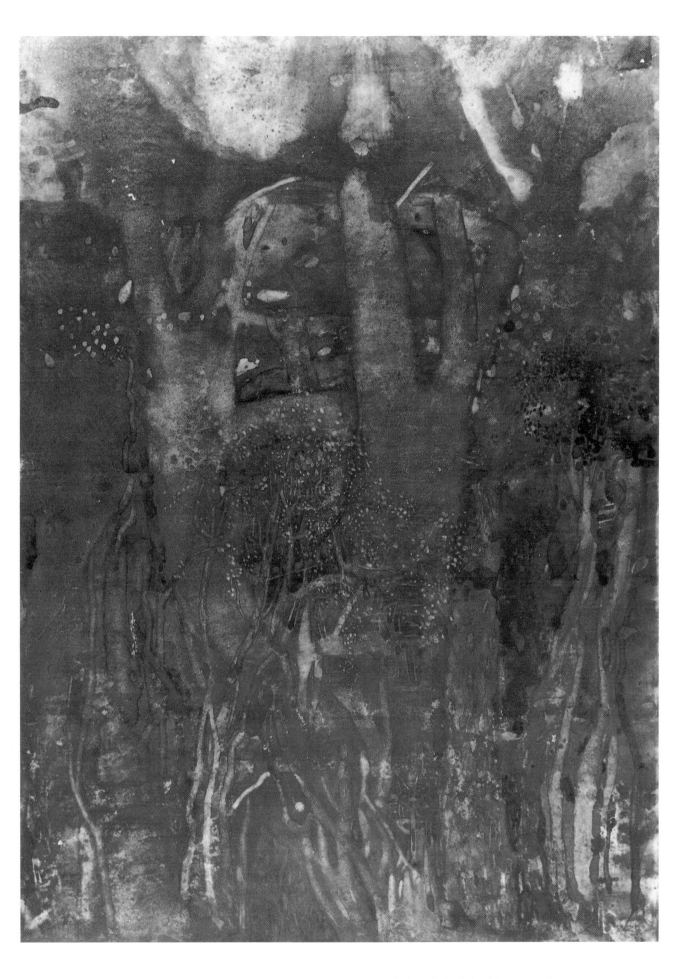

At the Edge of the Wood (*c*1905–06). 500 × 370.
Private collection. Catalogue 85.

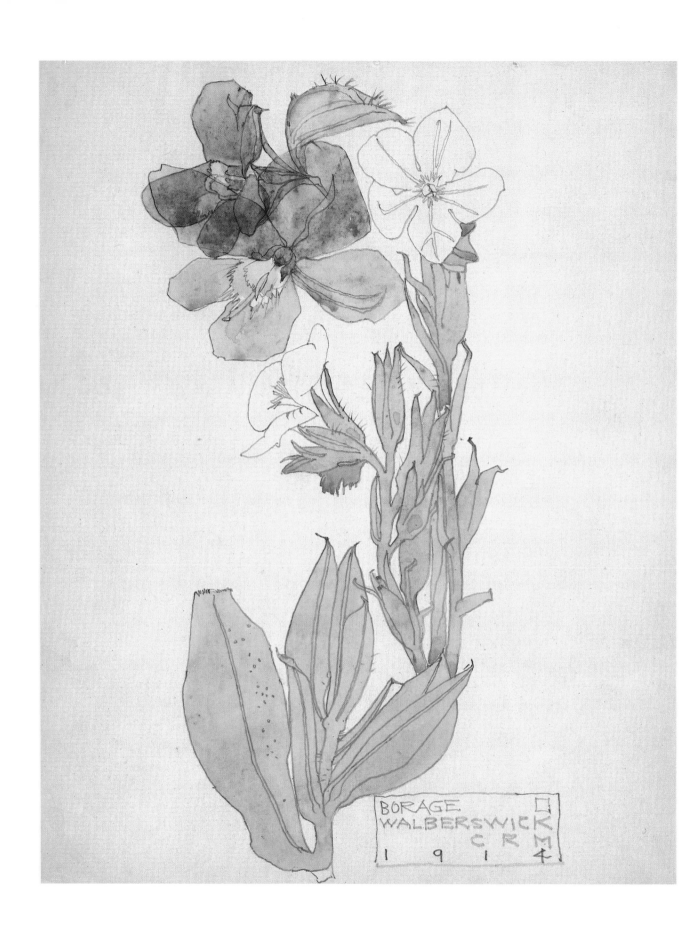

Borage, Walberswick (1914). 258 × 202. Collection:
James Meldrum, Esq. Catalogue 114.

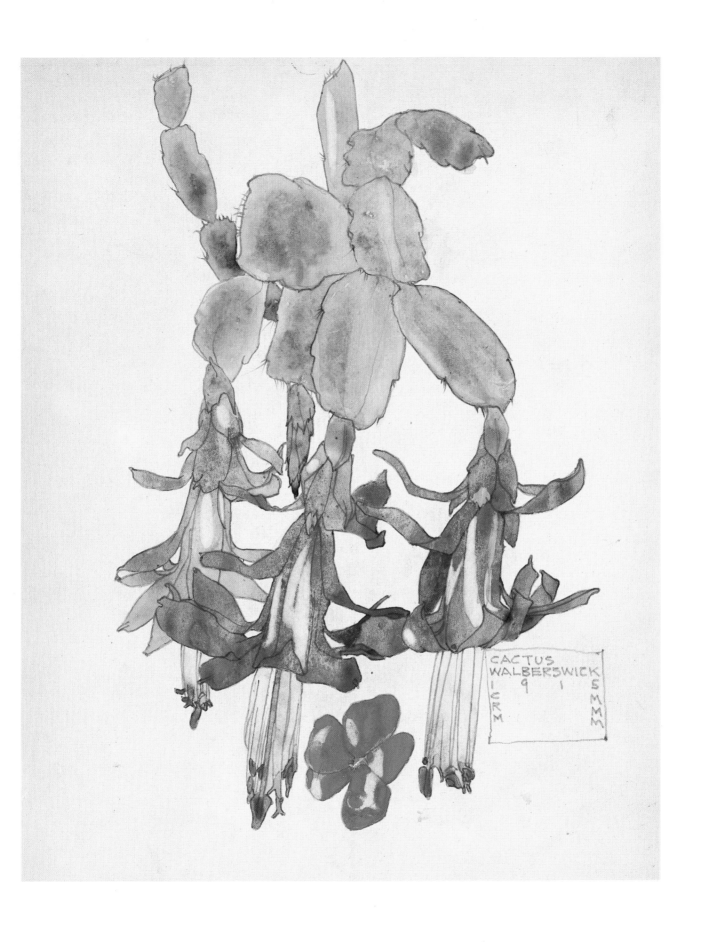

Cactus Flower, Walberswick (1915). 258 × 202.
Collection: James Meldrum, Esq. Catalogue 123.

Centaurea, Withyham (1909). 258 × 202. Collection:
Piccadilly Gallery, London. Catalogue 87.

Spurge, Withyham (1909). 258 × 202. Collection:
Glasgow University. Catalogue 88.

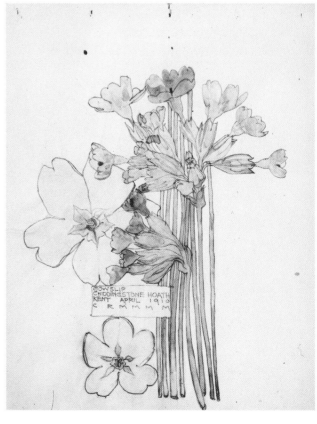

Cuckoo Flower, Chiddingstone (1910). 258 × 203.
Collection: Glasgow University. Catalogue 92.

Cowslip, Chiddingstone (1910). 256 × 200. Collection:
Dr Tazzoli. Catalogue 99.

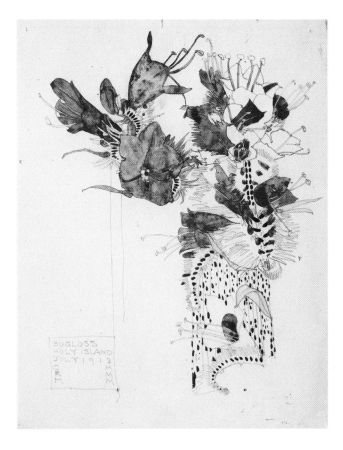

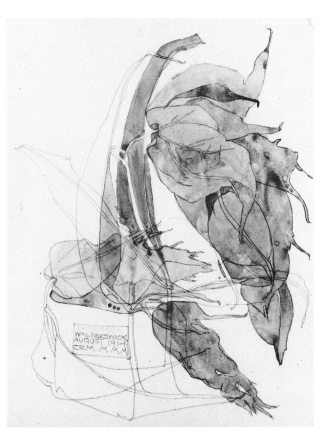

Bugloss, Holy Island (1913). 256 × 200. Collection: Dr Tazzoli. Catalogue 103.

Leycesteria, Walberswick (1914). 258 × 202. Untraced. Catalogue 104.

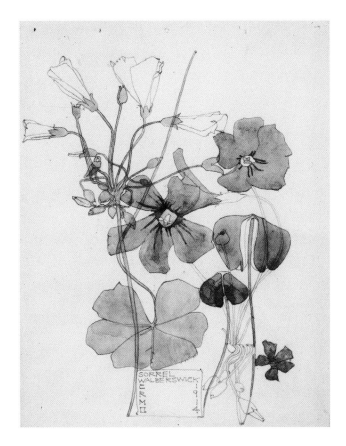

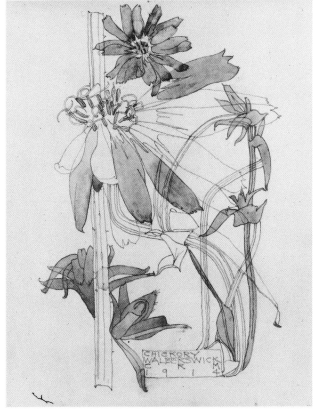

Sorrel, Walberswick (1914). 266 × 200. Collection: Dr Tazzoli. Catalogue 106.

Chicory, Walberswick (1914). Untraced. Catalogue 107.

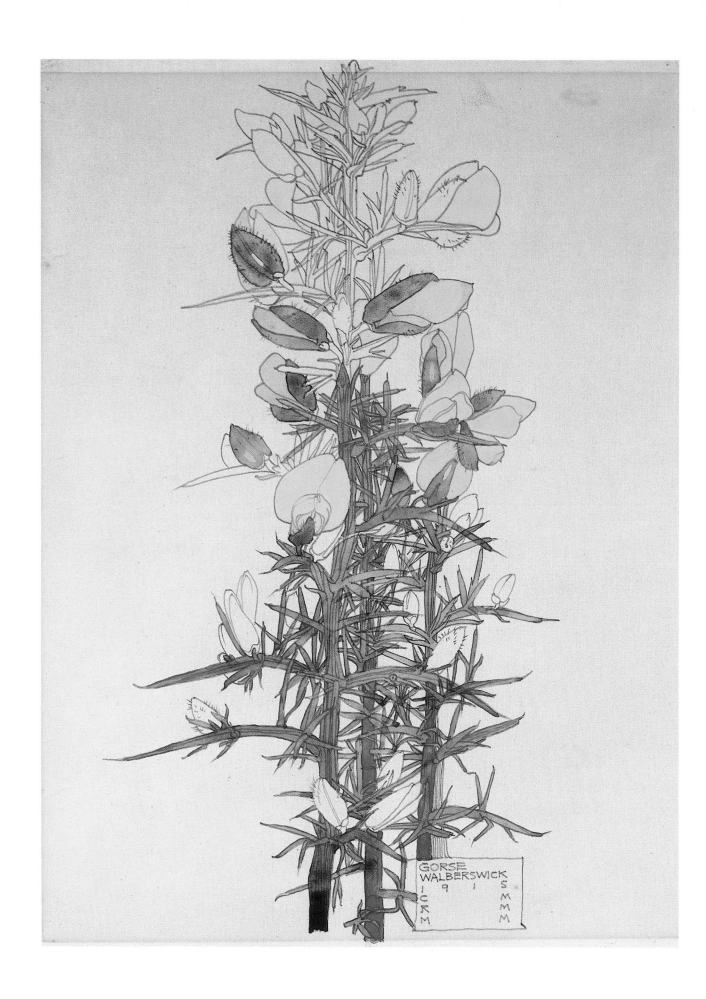

Gorse, Walberswick (1915). 272 × 210. Collection:
Mr and Mrs H. Jefferson Barnes. Catalogue 141.

86

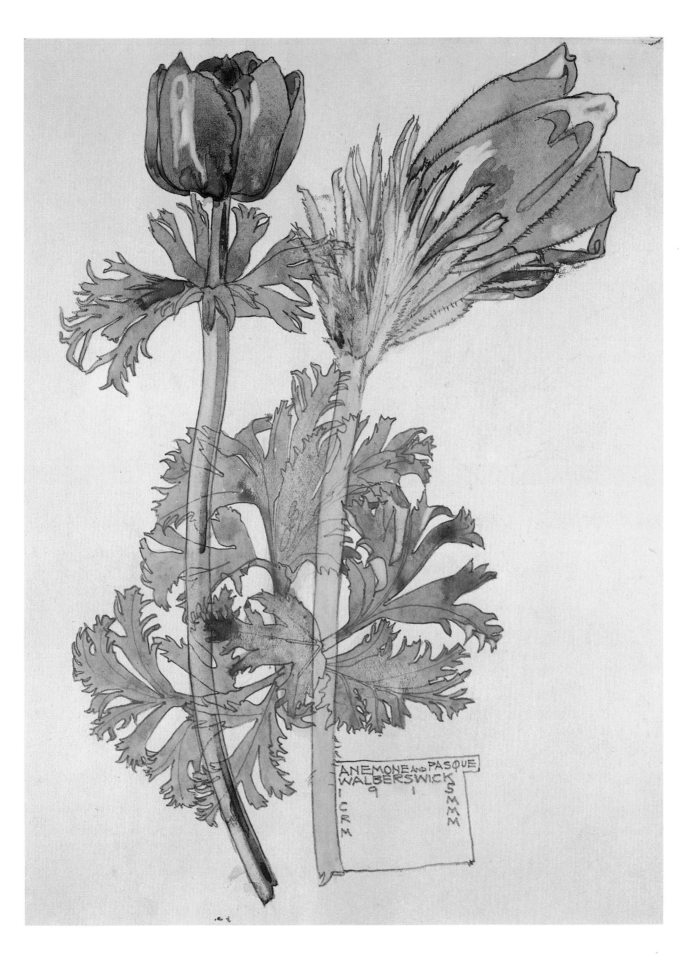

Anemone and Pasque, Walberswick (1915). 263 × 208.
Collection: Mr and Mrs H. Jefferson Barnes.
Catalogue 142.

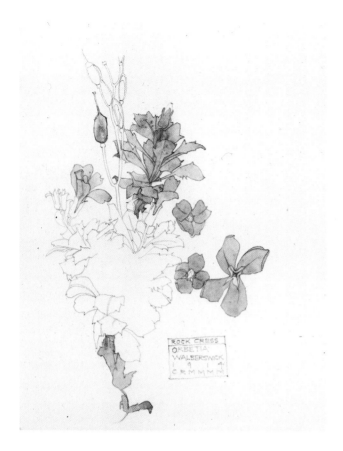

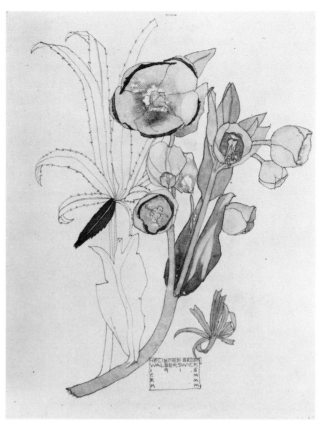

Aubretia, Walberswick (1914). 269 × 220. Private collection. Catalogue 109.

Green Hellebore, Walberswick (1915). 261 × 210. Collection: Victoria and Albert Museum, London. Catalogue 124.

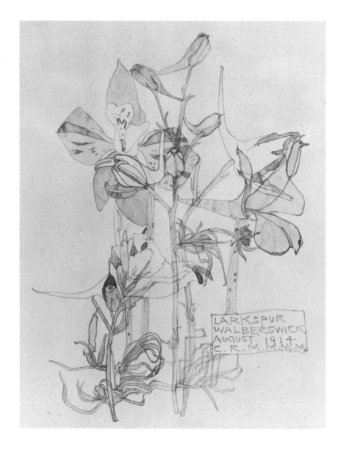

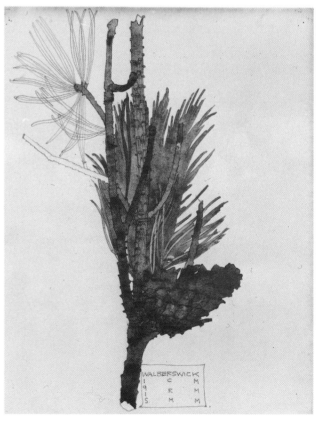

Larkspur, Walberswick (1914). 258 × 202. Collection: Glasgow University. Catalogue 110.

Pine Cone and Needles, Walberswick (1915). 269 × 208. Collection: Glasgow University. Catalogue 130.

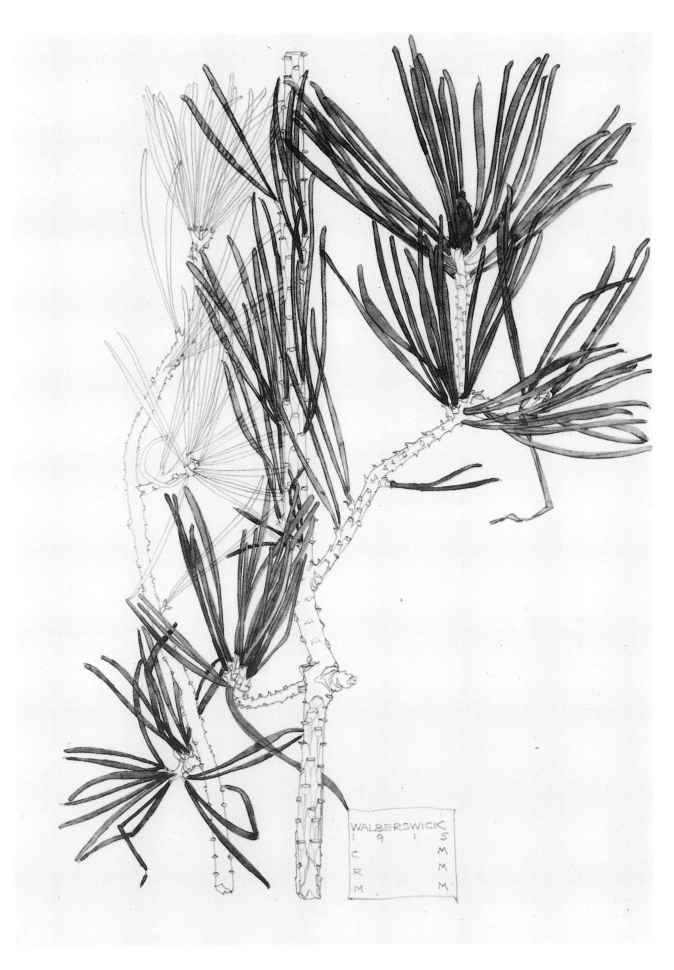

Pine, Walberswick (1915). 273 × 209. Untraced.
Catalogue 136.

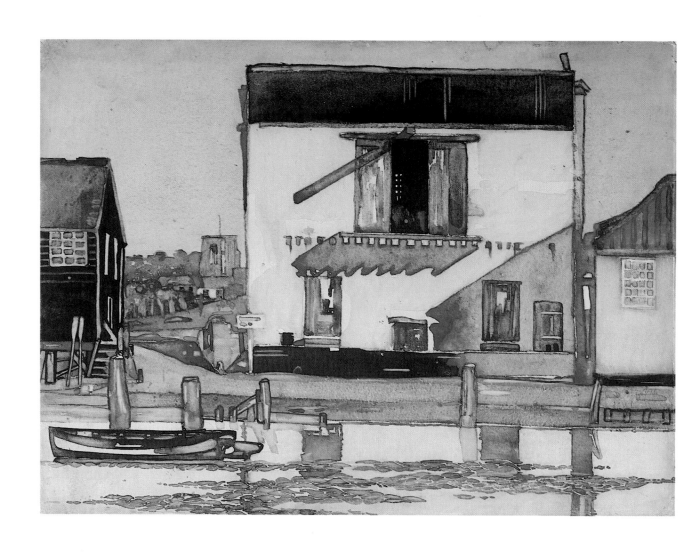

Venetian Palace, Blackshore on the Blyth (1914).
410 × 564. Private collection. Catalogue 118.

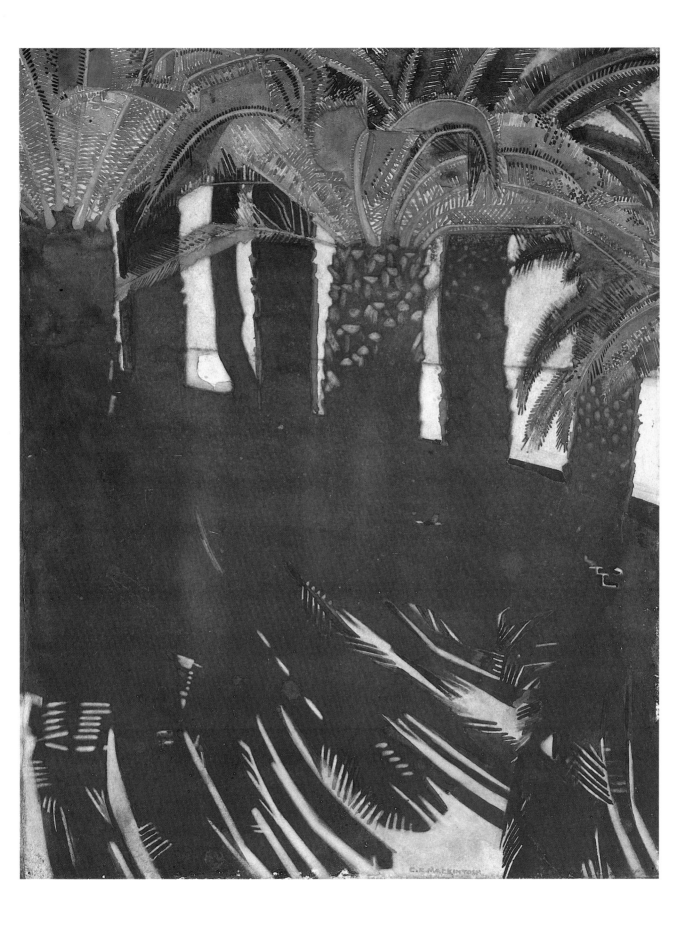

Palm Grove Shadows (*c1921*). 502 × 403. Collection:
Glasgow University. Catalogue 171.

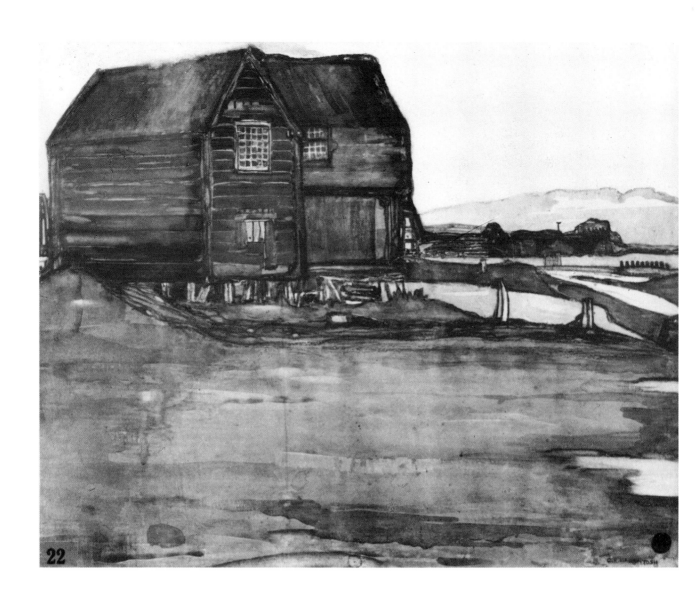

A Palace of Timber (*c*1914). Destroyed. Photograph
from Memorial Exhibition. Catalogue 120.

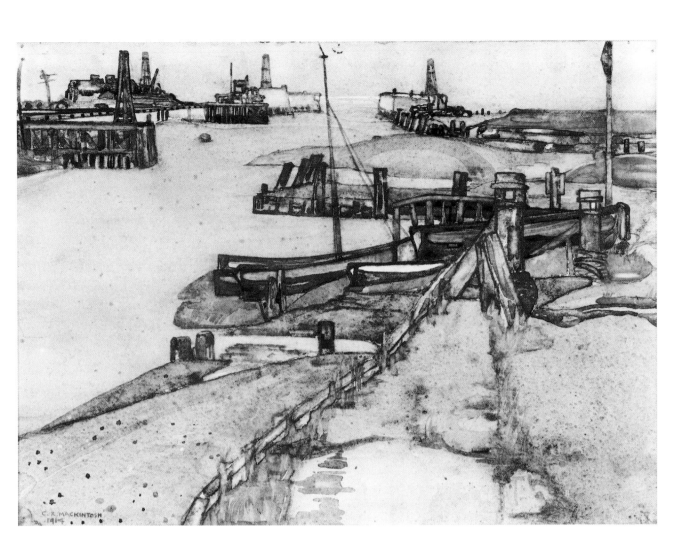

Walberswick (1914). 280 × 382. Private collection.
Catalogue 119.

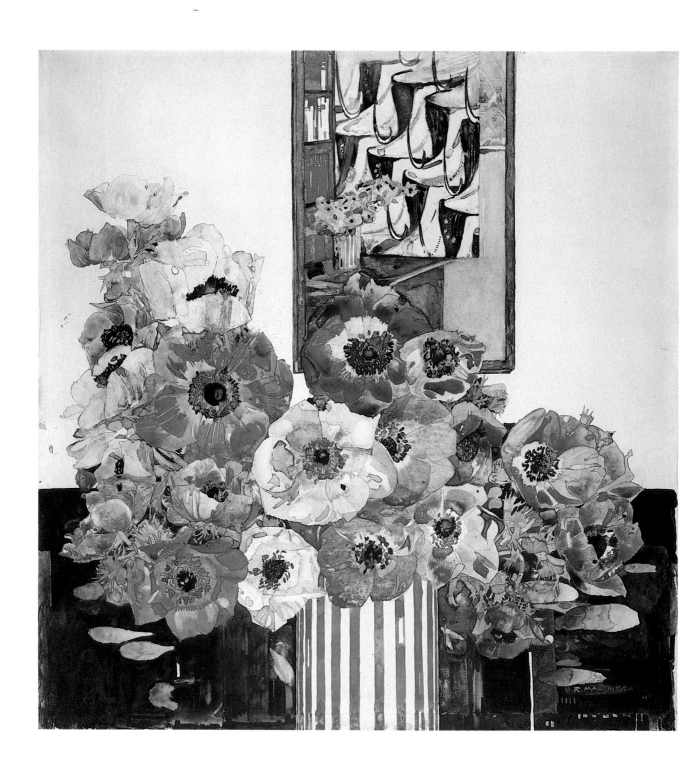

Anemones (c1916). 505 × 495. Private collection.
Catalogue 152.

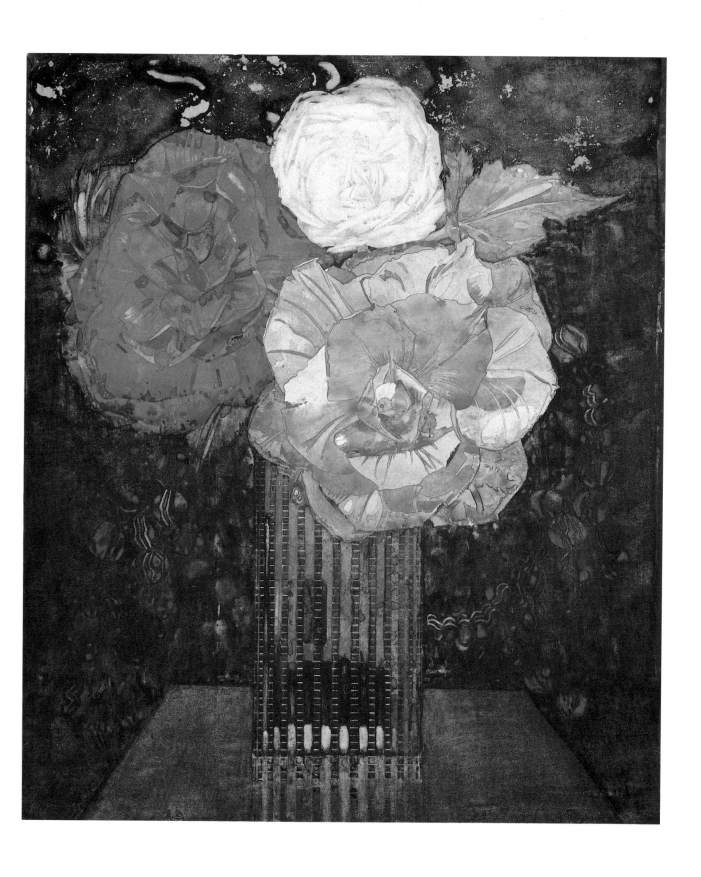

Begonias (1916). 425 × 373. Private collection.
Catalogue 153.

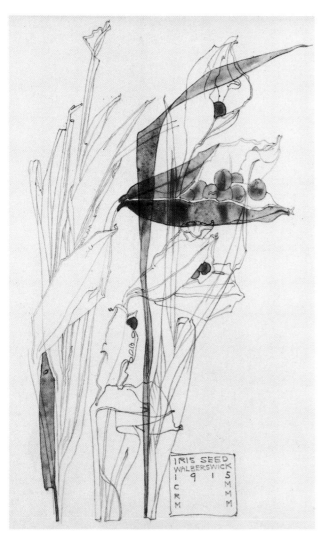

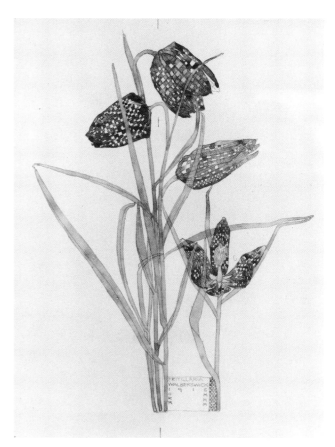

Fritillaria, Walberswick (1915). 253 × 202.
Collection: Glasgow University. Catalogue 128.

Iris Seed, Walberswick (1915). Untraced. Catalogue 150.

Veronica, Walberswick (1915). 276 × 209. Collection: Glasgow University. Catalogue 131.

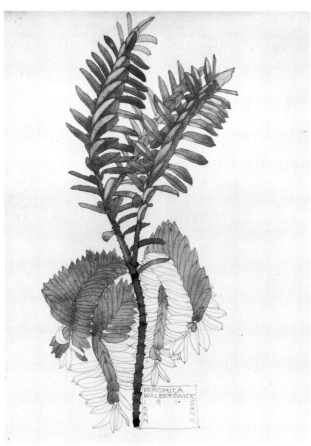

Right
Rosemary, Walberswick (1915). 269 × 204. Collection: Glasgow University. Catalogue 133.

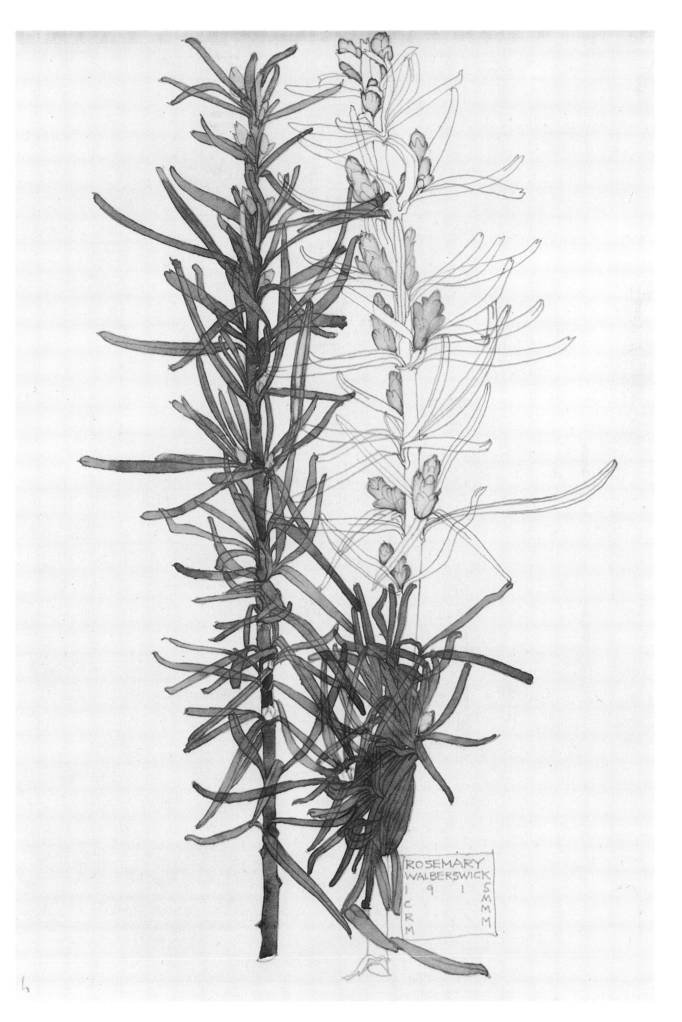

ROSEMARY
WALBERSWICK
1 9 1 5
CRM SMM

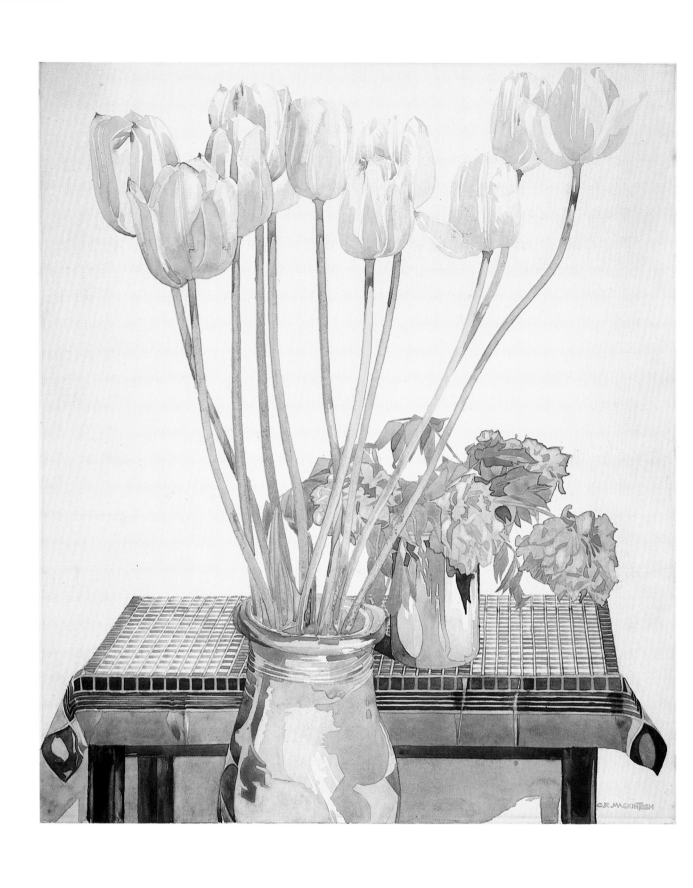

White Tulips (*c*1918–20). 405 × 352. Collection:
H. L. Hamilton, Esq. Catalogue 156.

98

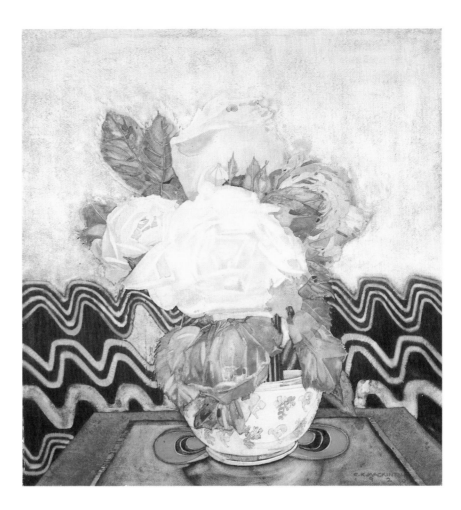

White Roses (1920). 502 × 472. Collection: Glasgow School of Art. Catalogue 166.

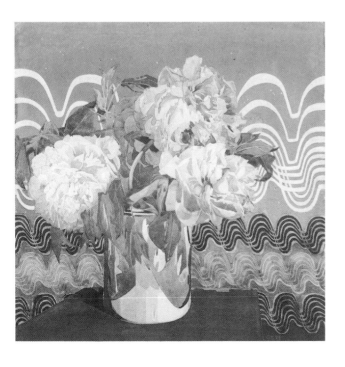

Peonies (c1919–20). 428 × 426. Private collection. Catalogue 165.

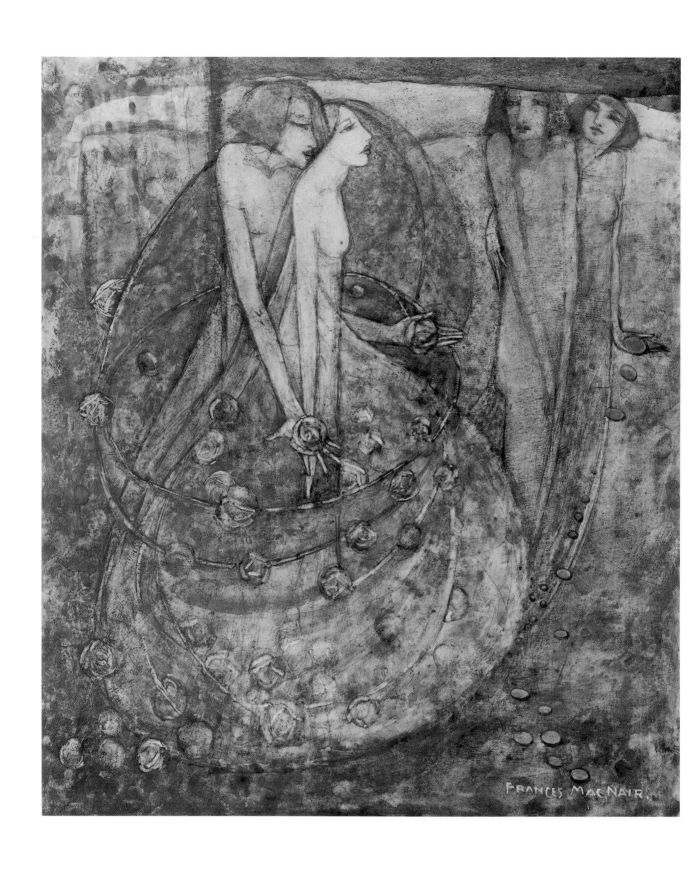

FRANCES MACDONALD *The Choice* (*c*1909–15).
350 × 306. Collection: Glasgow University.
Catalogue xii.

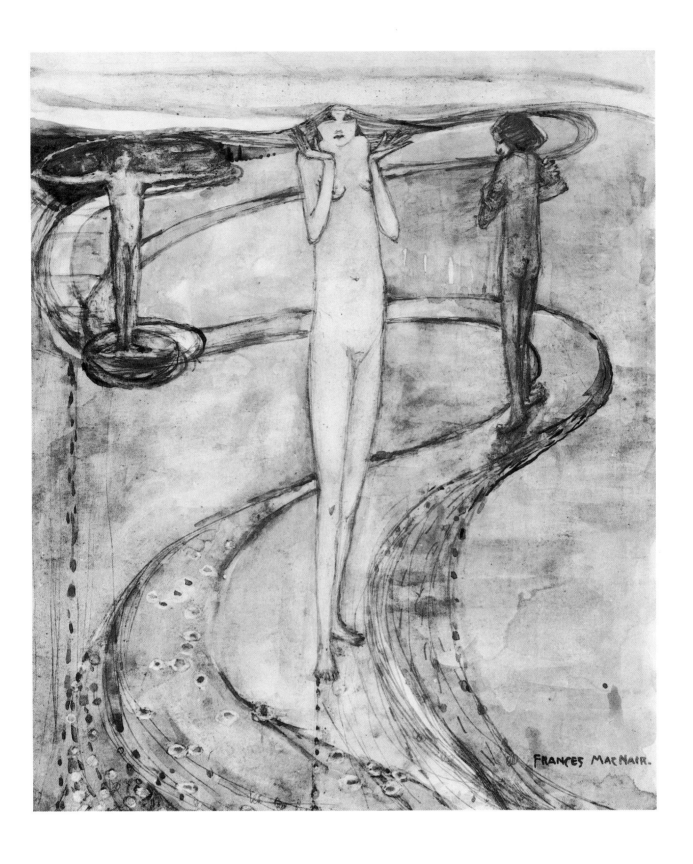

FRANCES MACDONALD 'Tis a long path which
wanders to desire (c1909–15). 352 × 301. Collection:
Glasgow University. Catalogue xiii.

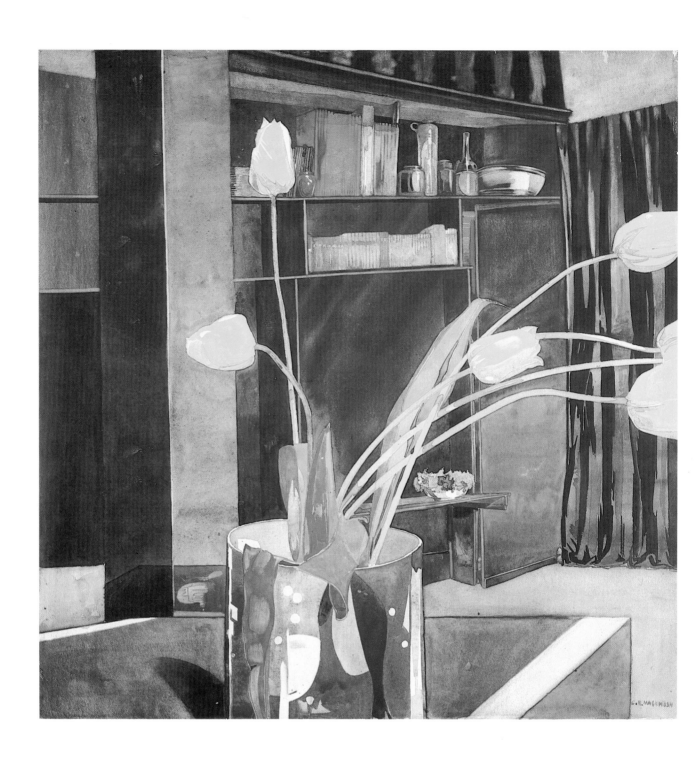

Yellow Tulips (*c*1922–23). 495 × 495. Collection:
R. W. B. Morris, Esq. Catalogue 173.

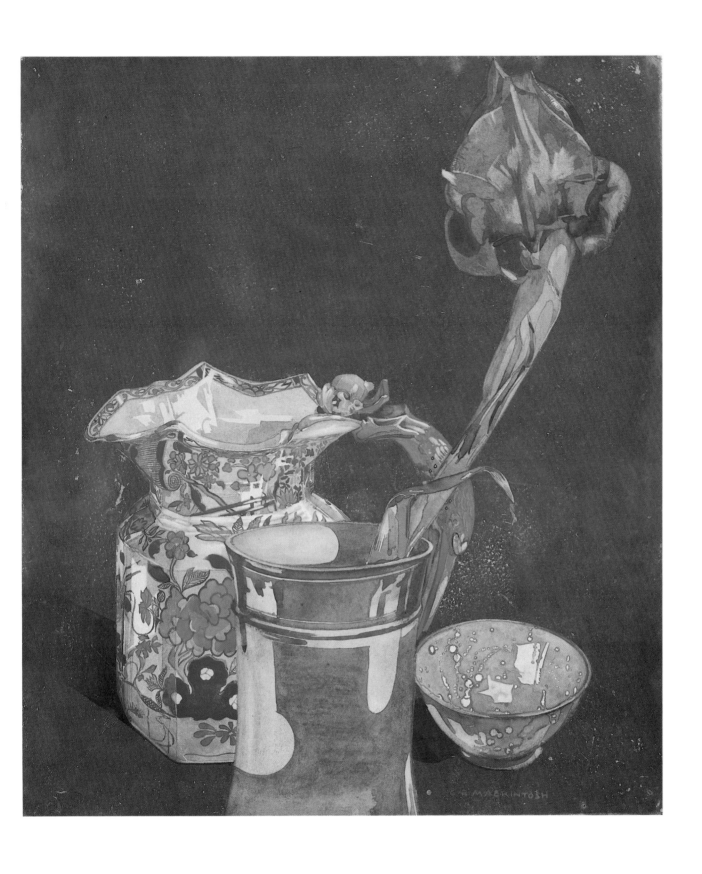

The Grey Iris (c1922–24). 431 × 374. Collection:
Glasgow Art Gallery. Catalogue 174.

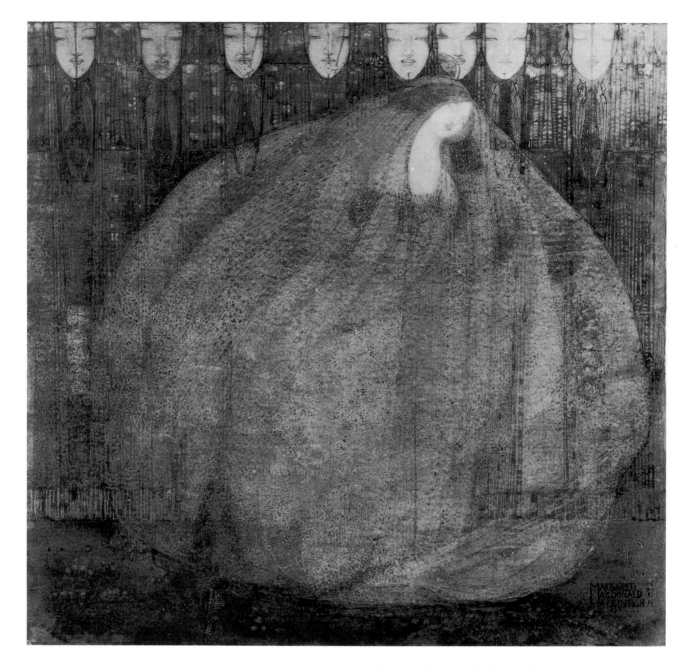

MARGARET MACDONALD *The Mysterious Garden* (1911). 457 × 483. Private collection. Catalogue xv.

MARGARET MACDONALD *The Child* (c1922–23). 26 × 37. Collection: Her Majesty Queen Elizabeth, The Queen Mother. Reproduced by gracious permission of Her Majesty the Queen. Catalogue xvii.

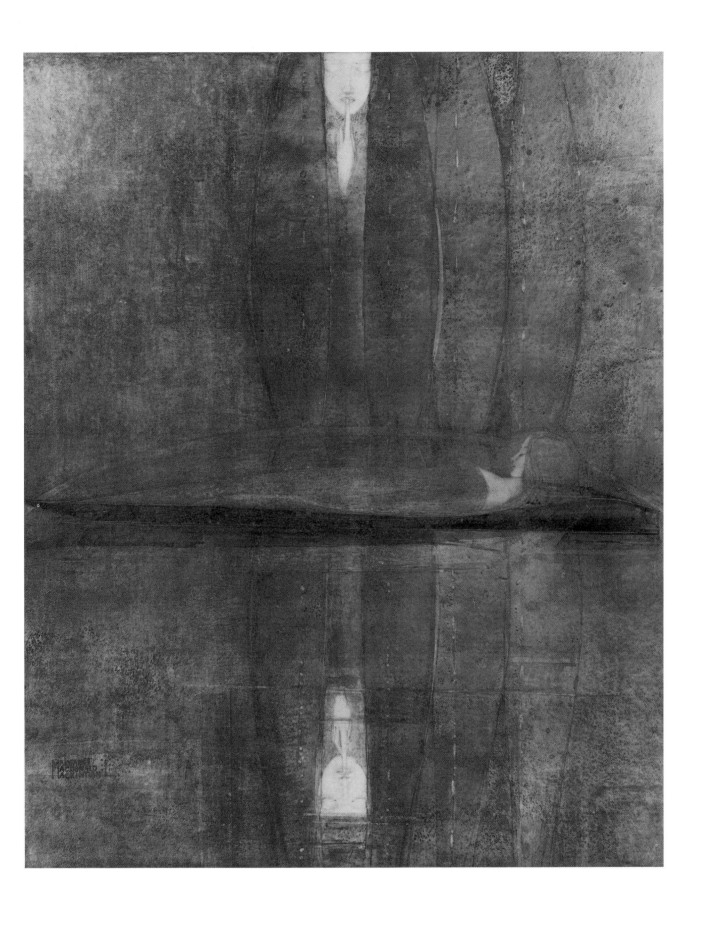

MARGARET MACDONALD *The Pool of Silence*
(1913). 758 × 635. Private collection. Catalogue xvi.

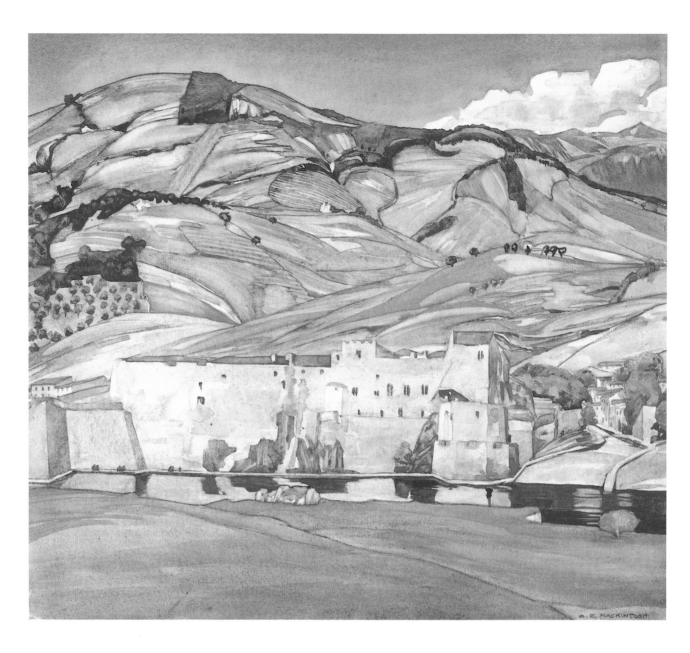

*Collioure, Pyrénées-Orientales—Summer Palace of the
Queens of Aragon* (c1924–26). 381 × 432. Collection:
Mrs Alison Walker. Catalogue 178.

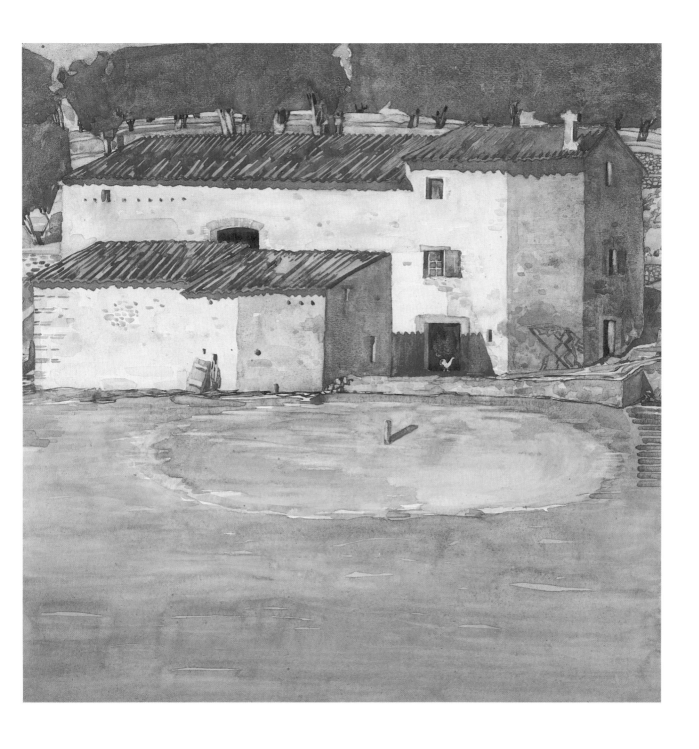

A Southern Farm (*c*1924–26). 434 × 434. Private
collection. Catalogue 192.

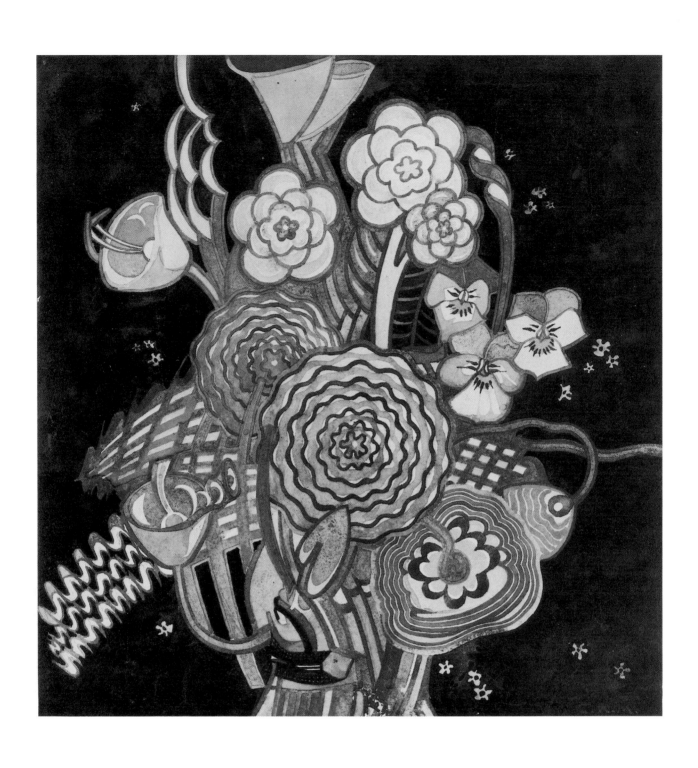

A Basket of Flowers (c1918–20). 317 × 300.
Collection: Glasgow University. Catalogue 157.

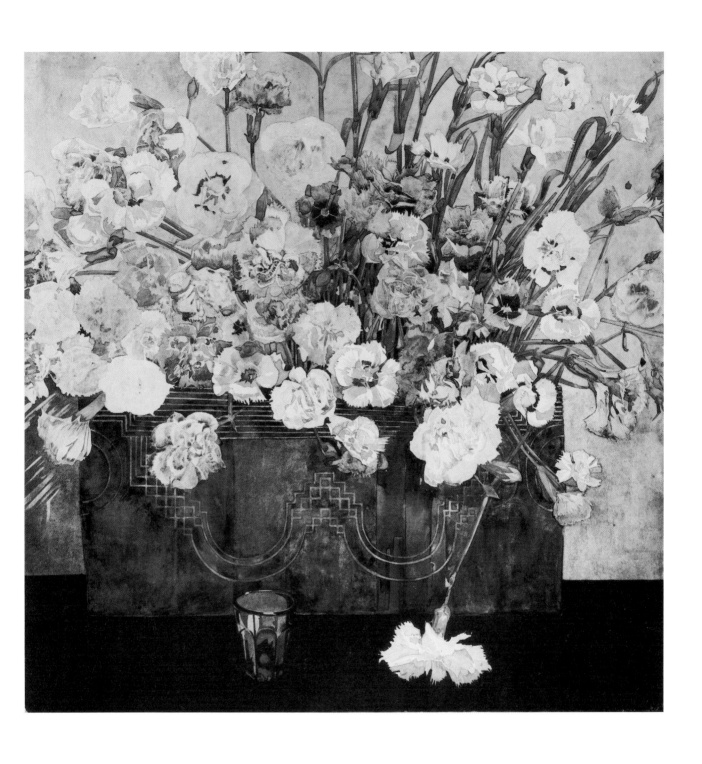

Pinks (*c*1922–23). 501 × 501. Collection: Glasgow
Art Gallery. Catalogue 175.

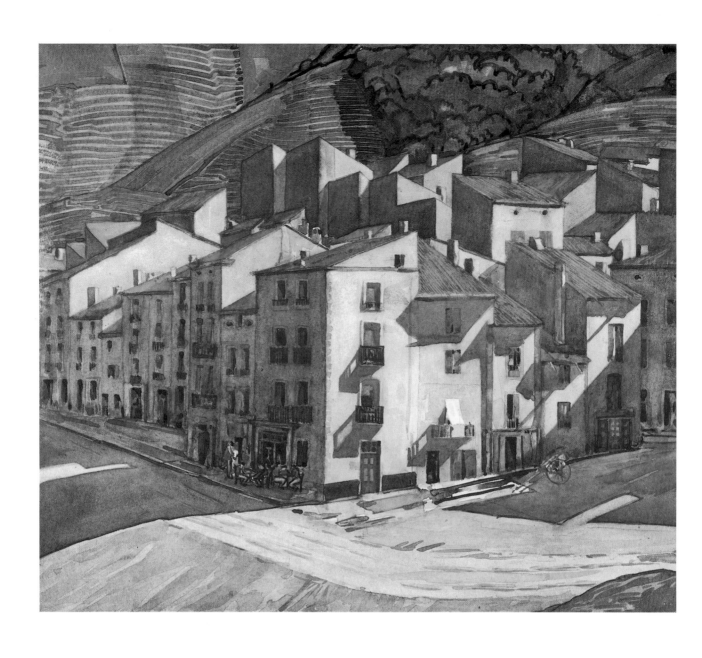

A Southern Town (c1924–27). 322 × 376. Collection:
Mrs Ruth M. Hedderwick. Catalogue 193.

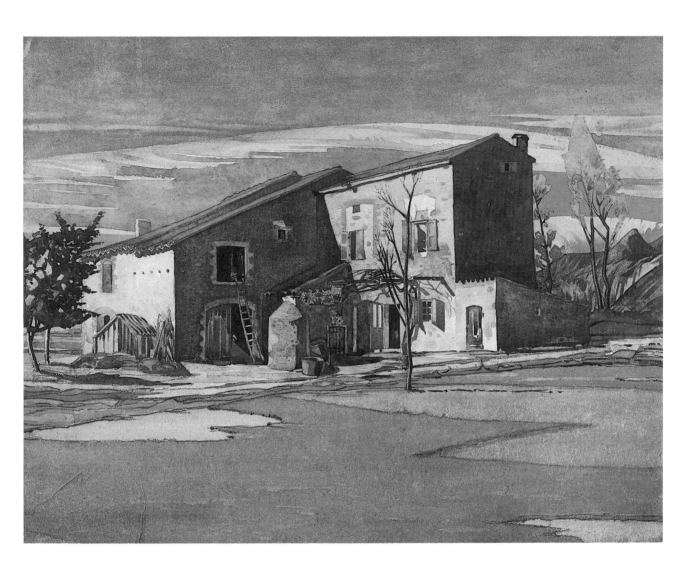

Blanc Antoine (*c*1924–27). 392 × 510. Private collection. Catalogue 202.

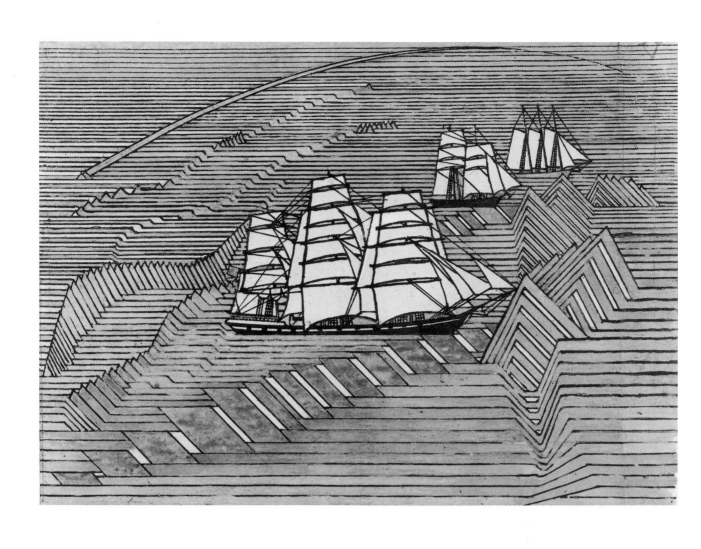

Ships (c1922). 203 × 297. Private collection.
Catalogue 172.

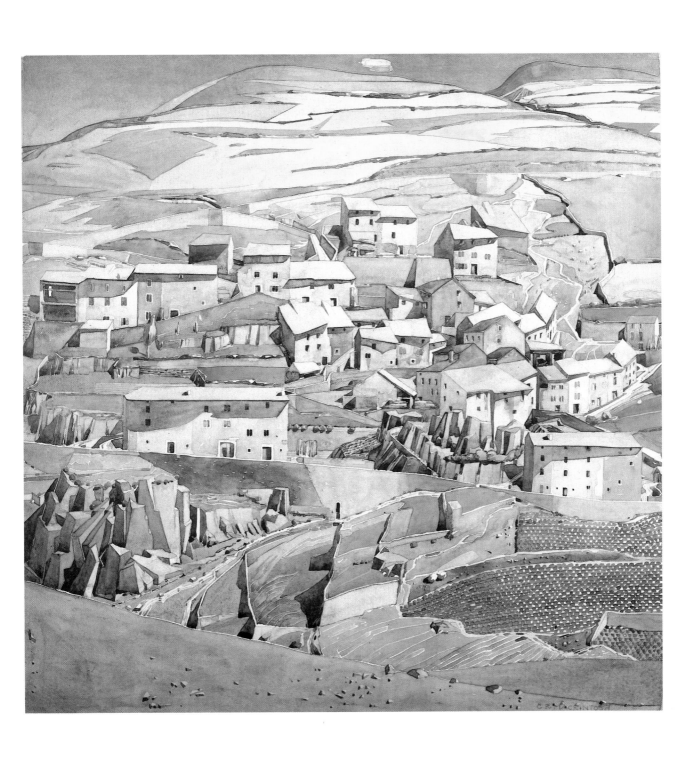

Fetges (*c*1923–26). 465 × 458. Collection: The Tate
Gallery, London. Catalogue 180.

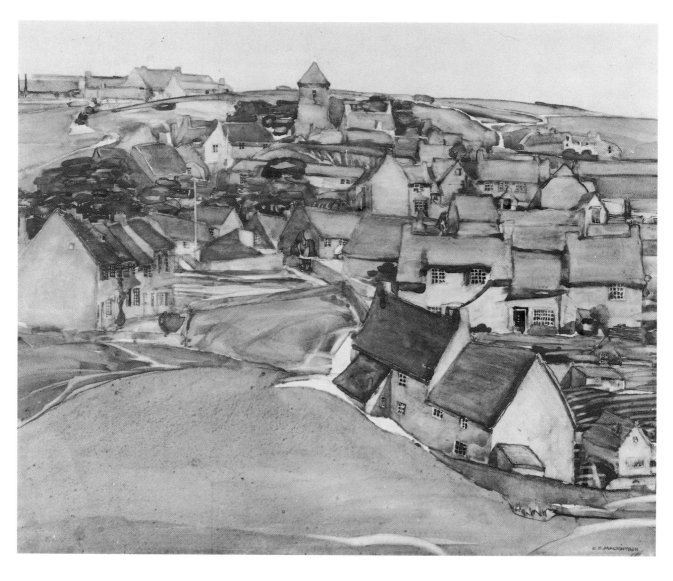

The Village, Worth Matravers (1920). 460 × 569.
Collection: Glasgow School of Art. Catalogue 167.

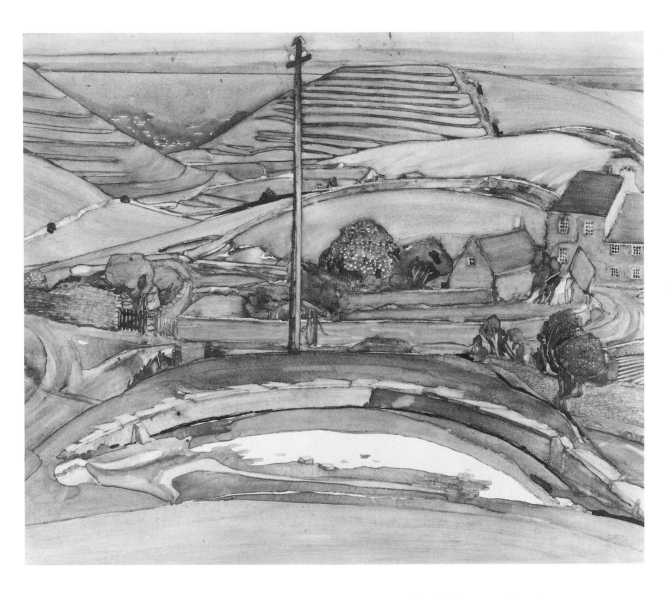

The Downs, Worth Matravers (1920). 452 × 537.
Collection: Glasgow School of Art. Catalogue 168.

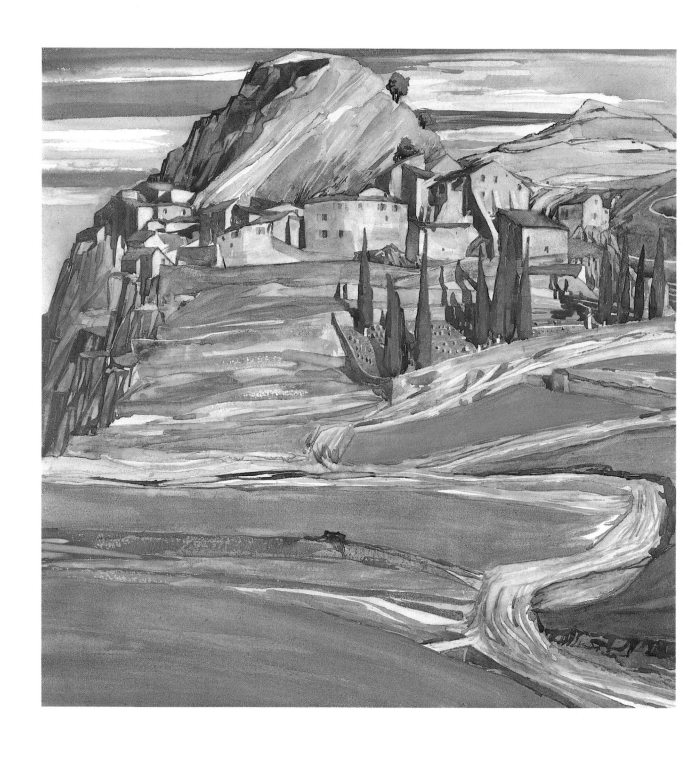

A Hill Town in Southern France (c1924–26).
420 × 420. Collection: Professor T. Howarth.
Catalogue 191.

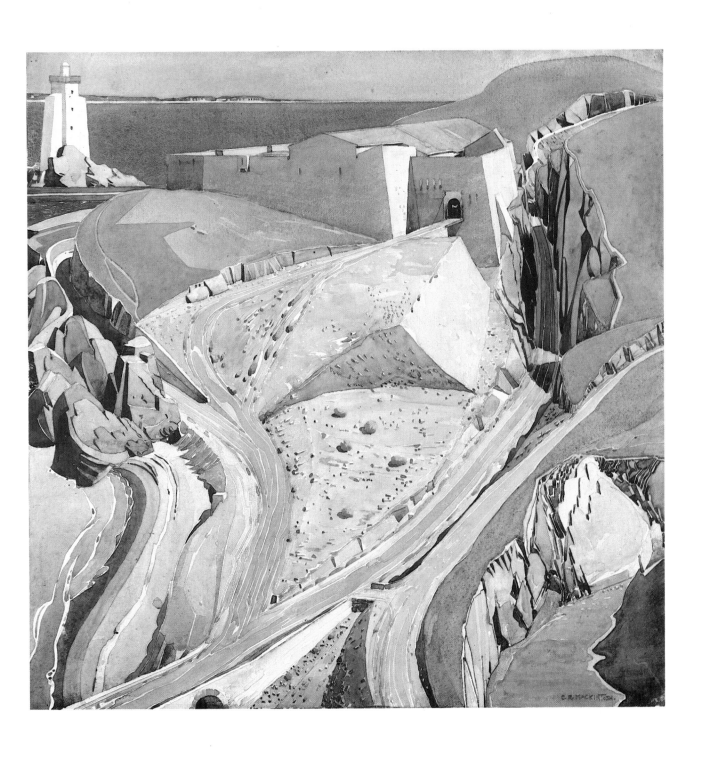

The Fort (*c*1924–26). 450 × 452. Collection:
Mrs W. L. Renwick. Catalogue 184.

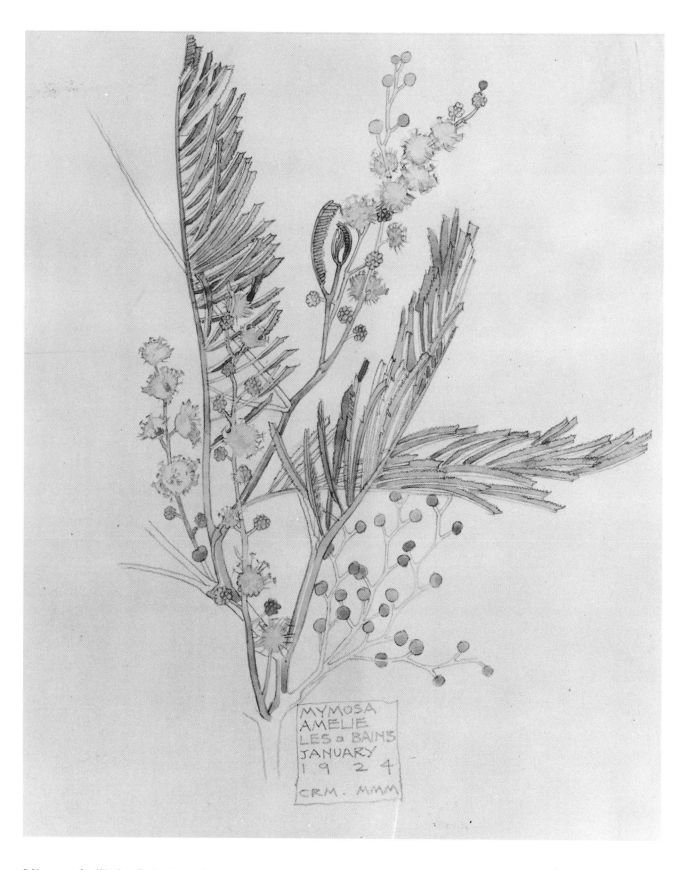

Mimosa, Amélie-les-Bains (1924). 257 × 210.
Collection: Glasgow University. Catalogue 203.

Fig Leaf, Chelsea (1918). 267 × 204. Untraced.
Catalogue 154.

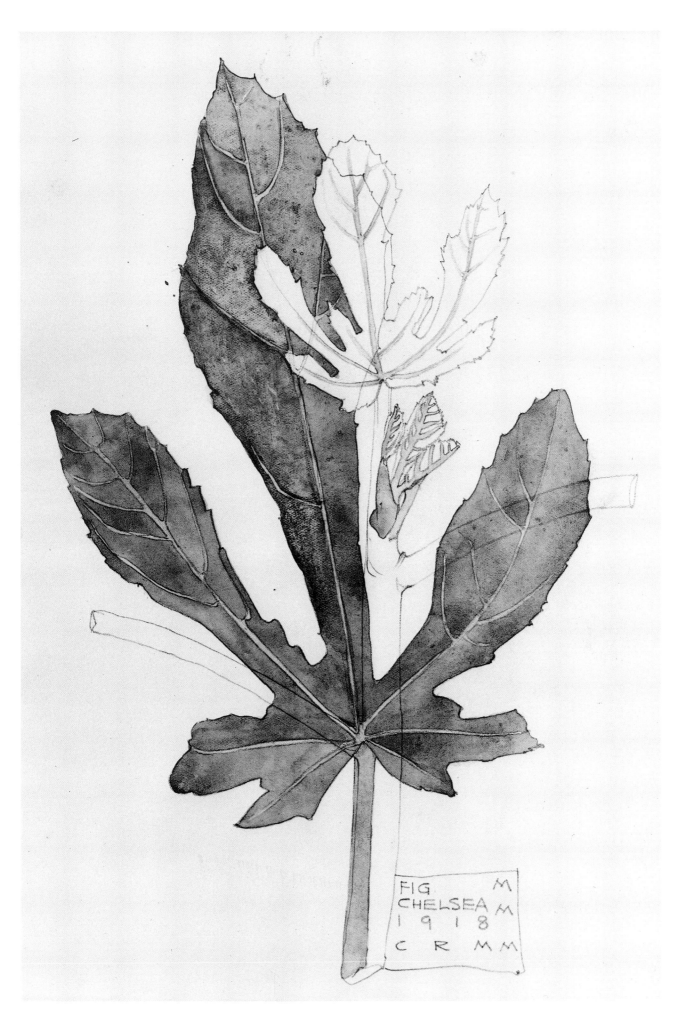

FIG M
CHELSEA M
1 9 1 8
C R M M

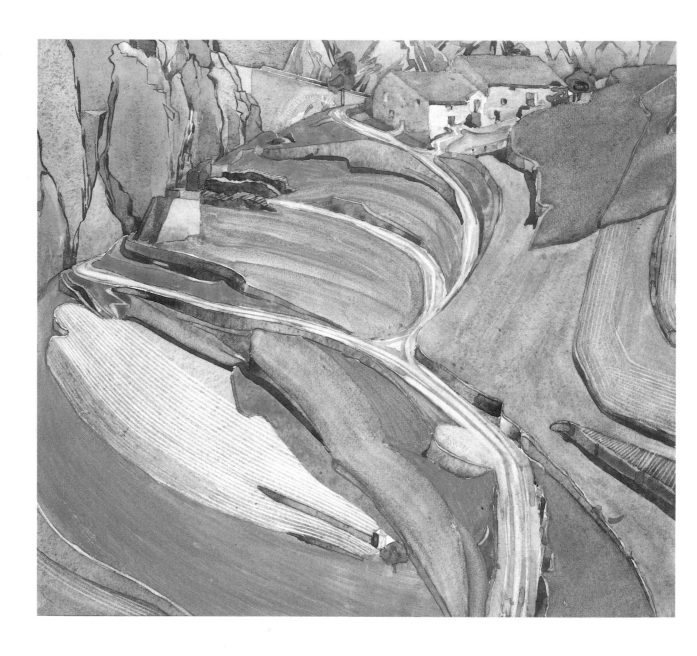

Mont Alba (*c*1924–27). 370 × 420. Collection: Alan
Irvine, Esq. Catalogue 189.

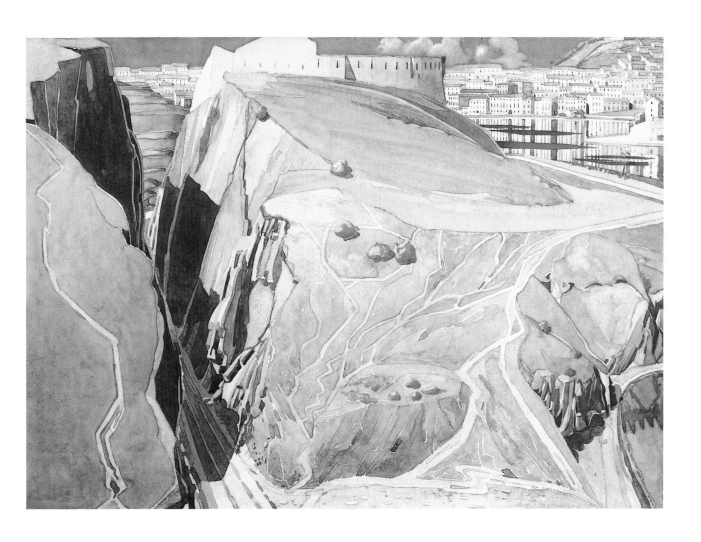

Port Vendres (*c*1924–26). 288 × 396. Collection:
Mrs Mary Newbery Sturrock. Catalogue 185.

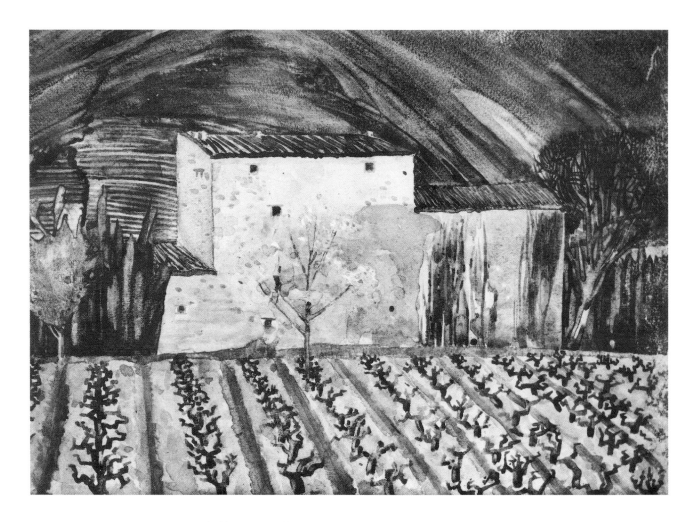

A Spanish Farm (c1923 × 26). Collection: Miss
Margaret Rennie Dingwall. Catalogue 181.

Port Vendres, La Ville (c1924–26). 460 × 460.
Collection: Glasgow Art Gallery. Catalogue 186.

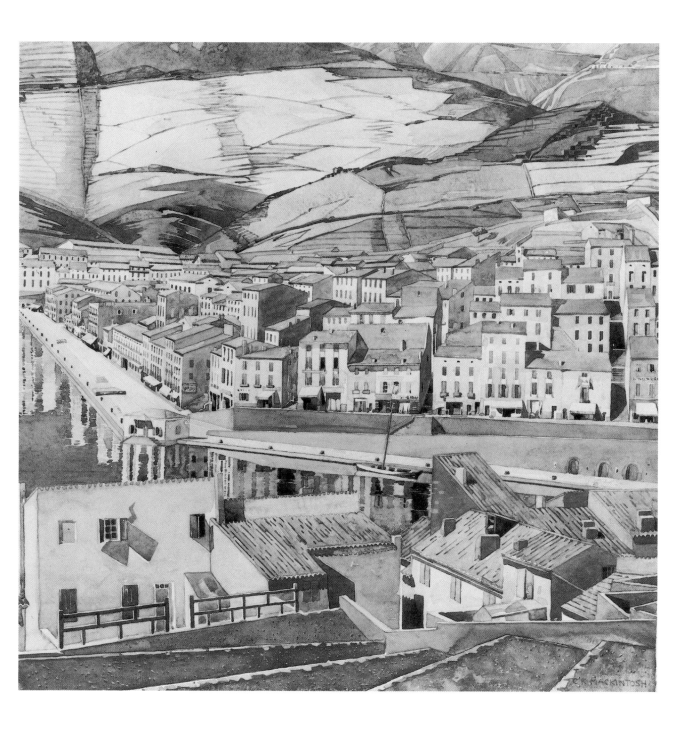

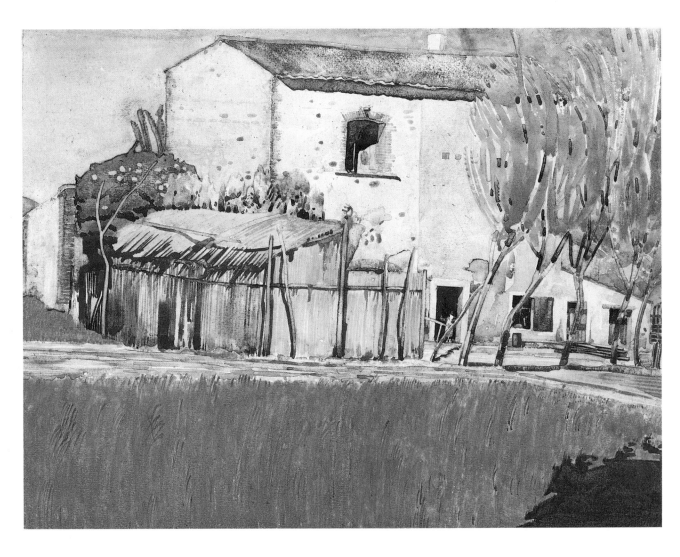

Summer in the South (*c*1924–27). 283 × 385.
Collection: Michael Davidson, Esq. Catalogue 195.

Héré de Mallet, Ille sur Têt (*c*1925). 460 × 460.
Collection: Michael Davidson, Esq. Catalogue 204.

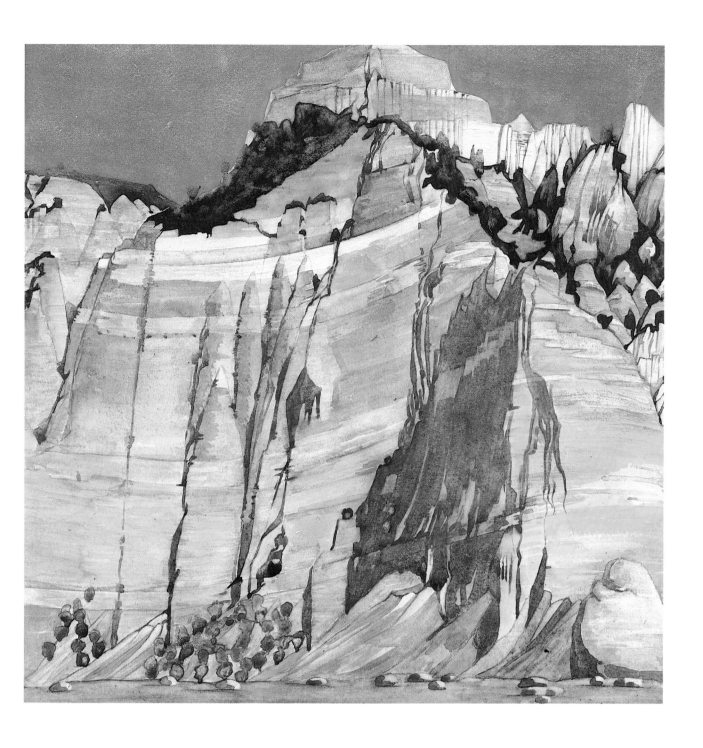

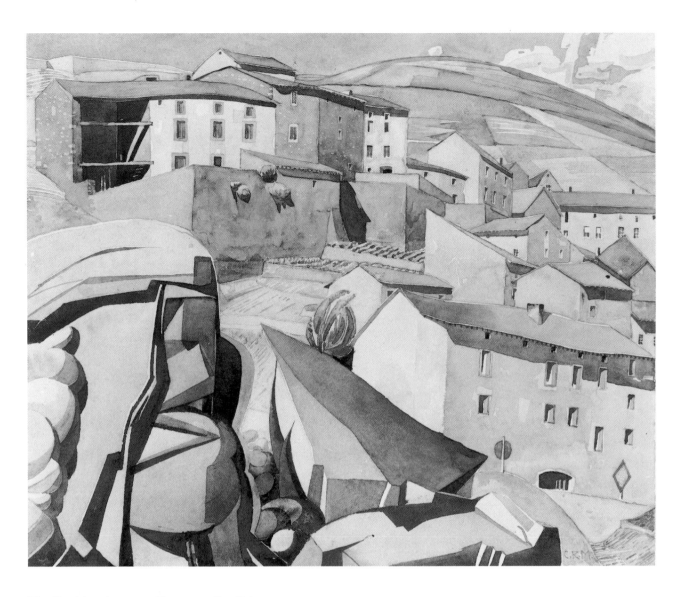

The Boulders (*c*1923–26). 334 × 380. Private
collection. Catalogue 177.

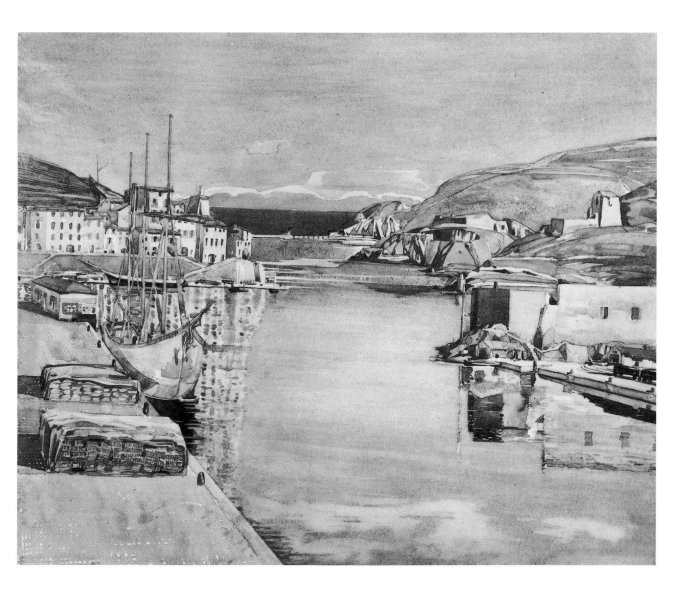

A Southern Port (*c*1923–24). 362 × 445. Collection:
Glasgow Art Gallery. Catalogue 176.

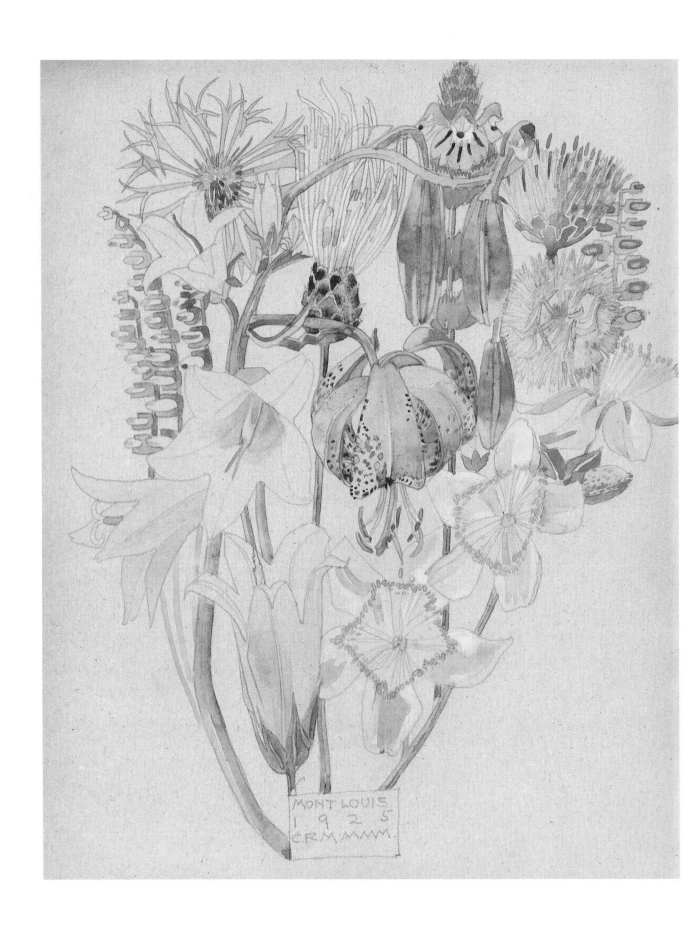

Mont Louis—Flower Study (1925). 258 × 202.
Collection: Professor T. Howarth. Catalogue 205.

The Poor Man's Village (*c*1924–26). Untraced. Photograph from Memorial Exhibition. Catalogue 190.

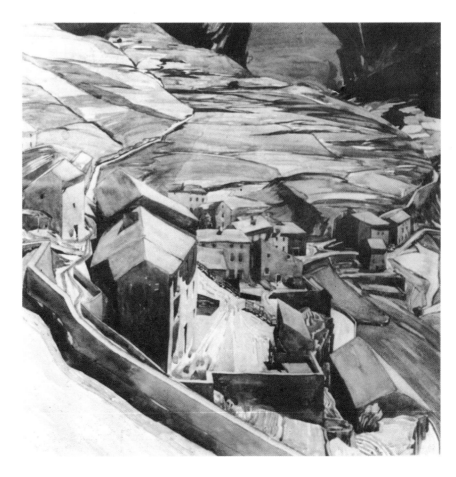

Mountain Village (*c*1924–27). Untraced. Photograph from Memorial Exhibition. Catalogue 199.

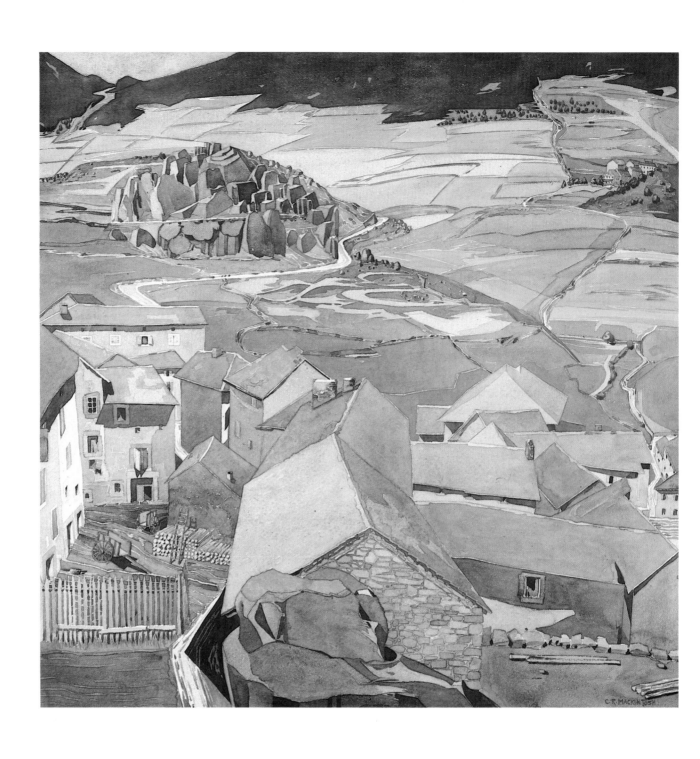

The Village of La Lagonne (*c*1924–27). 457 × 457.
Collection: Glasgow Art Gallery. Catalogue 188.

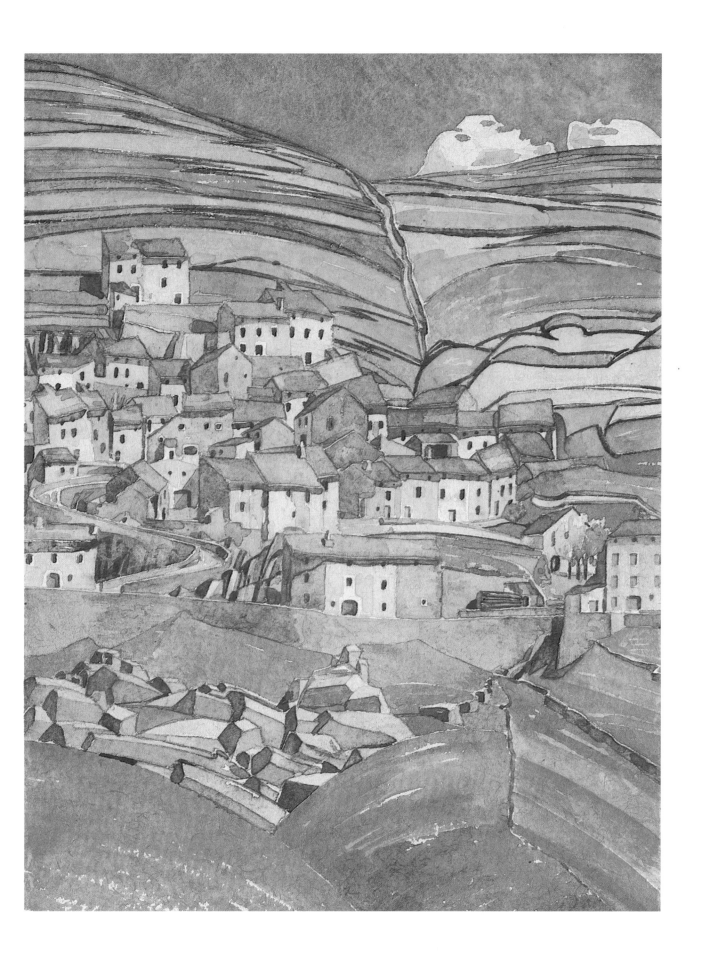

Slate Roofs (c1924–27). 370 × 278. Collection:
Glasgow School of Art. Catalogue 194.

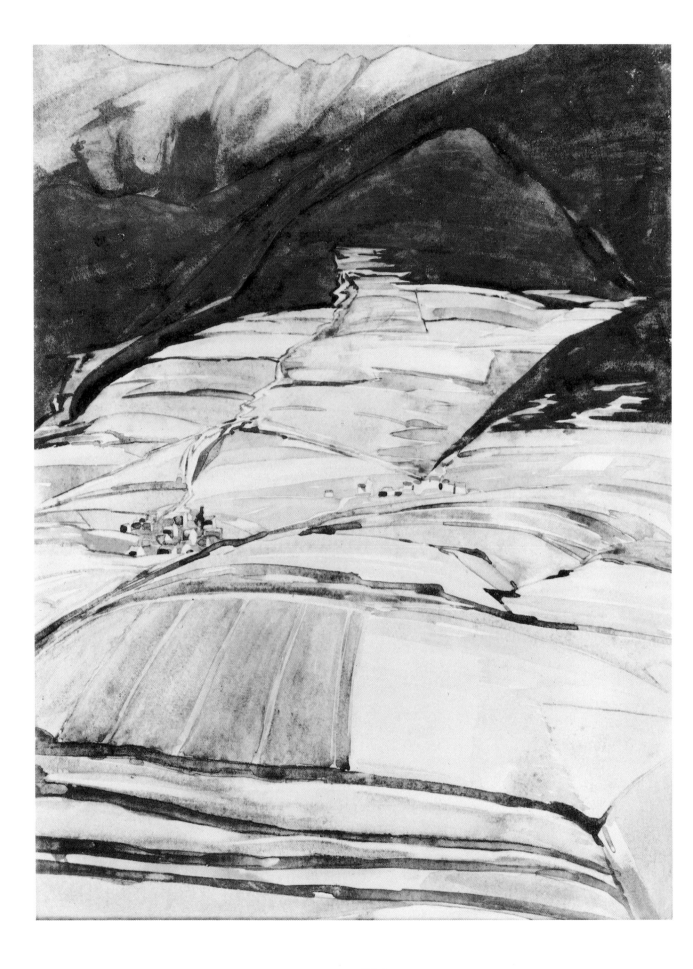

Village in the Mountains (c1924–27). 375 × 280.
Private collection. Catalogue 196.

Right
The Church of La Lagonne (c1924–27). 280 × 383.
Private collection. Catalogue 187.

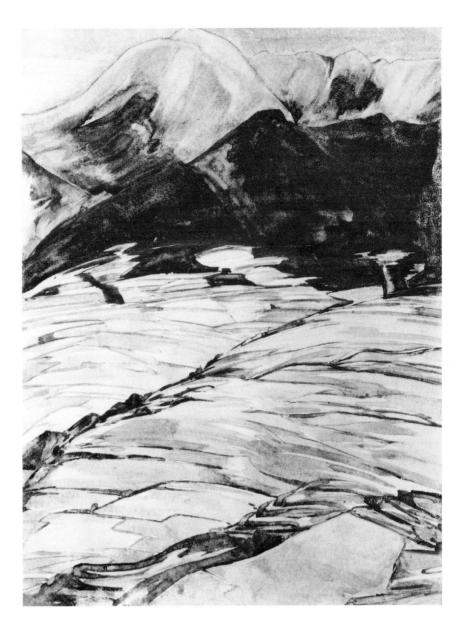

Mountain Landscape (c1924–27). 375 × 280. Private
collection. Catalogue 197.

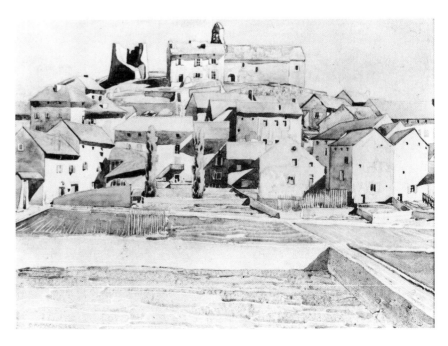

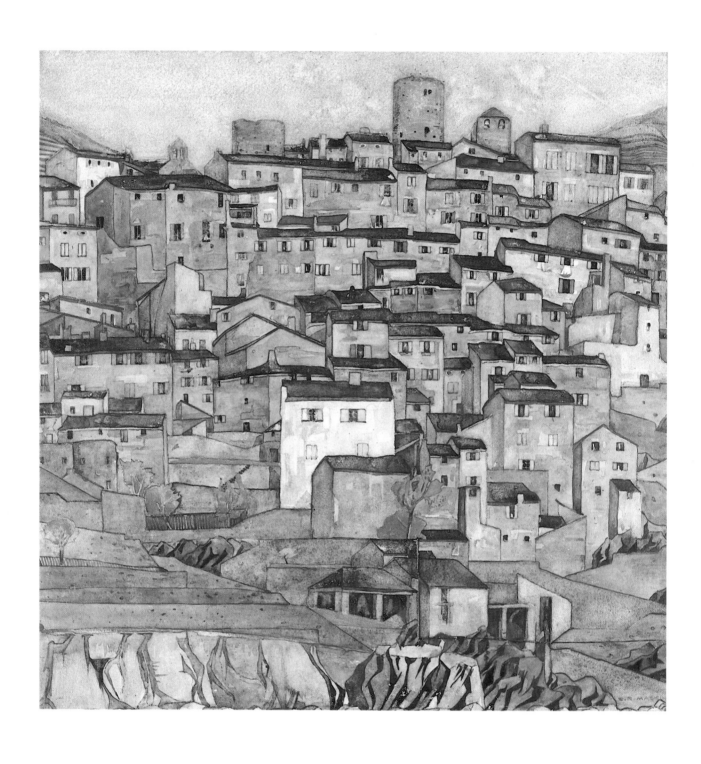

Palalda, Pyrénées-Orientales (*c*1924–27). 515 × 515.
Collection: Michael Davidson, Esq. Catalogue 200.

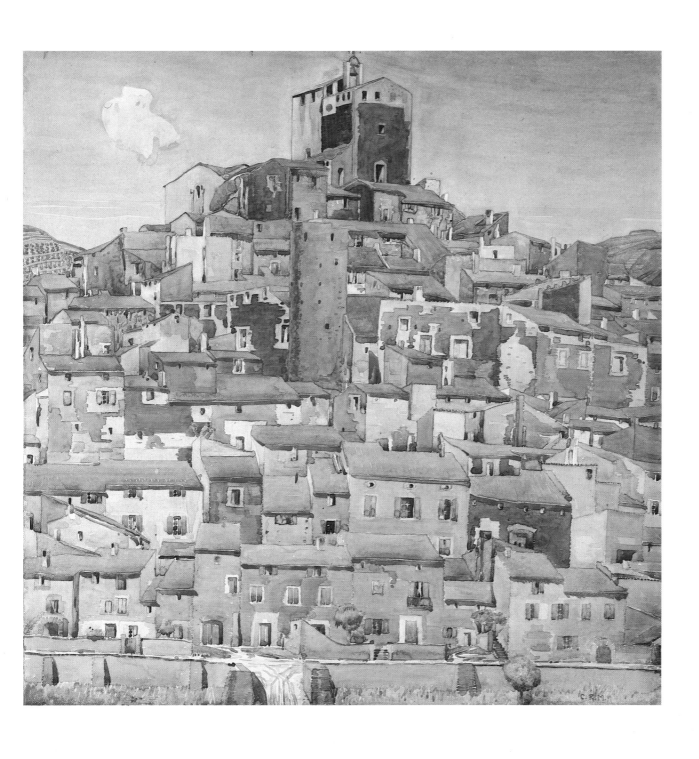

Boultenère (*c*1924–27). 447 × 447. Collection:
R. W. B. Morris, Esq. Catalogue 201.

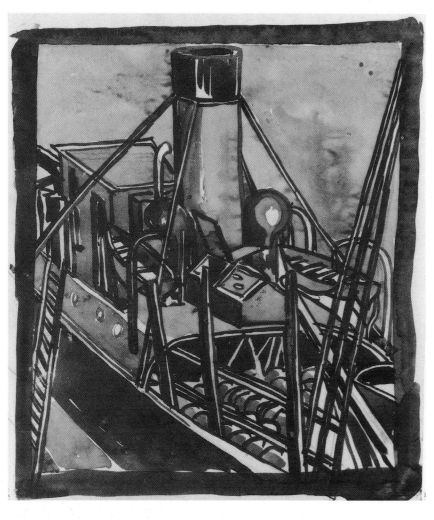

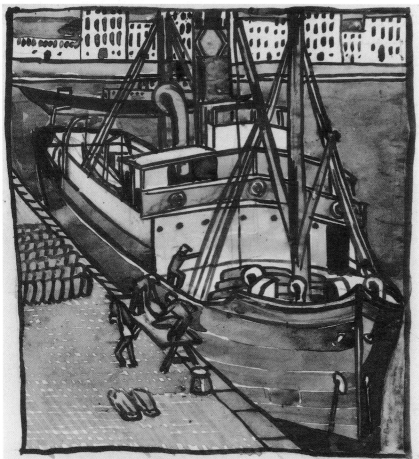

136

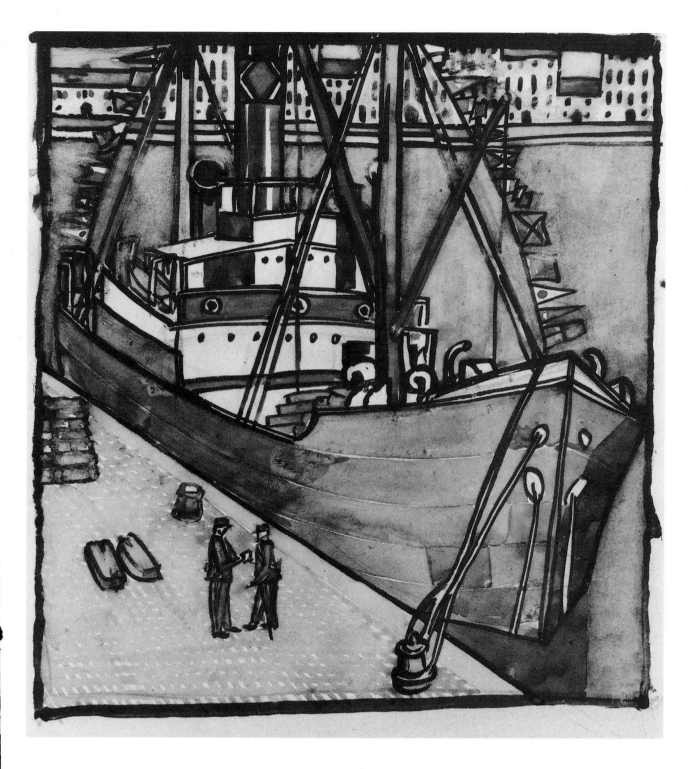

Steamer Moored at the Quayside, with two Gendarmes Standing on the Quay (?1927). 269 × 209. Collection: Glasgow University. Catalogue 210.

Left

Steamer at the Quayside (?1927). 154 × 209. Collection: Glasgow University. Catalogue 212.

Men Unloading a Steamer at the Quayside (?1927). 252 × 209. Collection: Glasgow University. Catalogue 213.

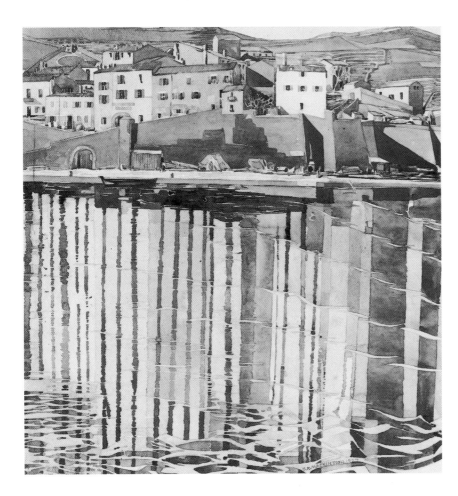

La Rue du Soleil, Port Vendres
(1926). 405 × 390. Collection:
Glasgow University.
Catalogue 208.

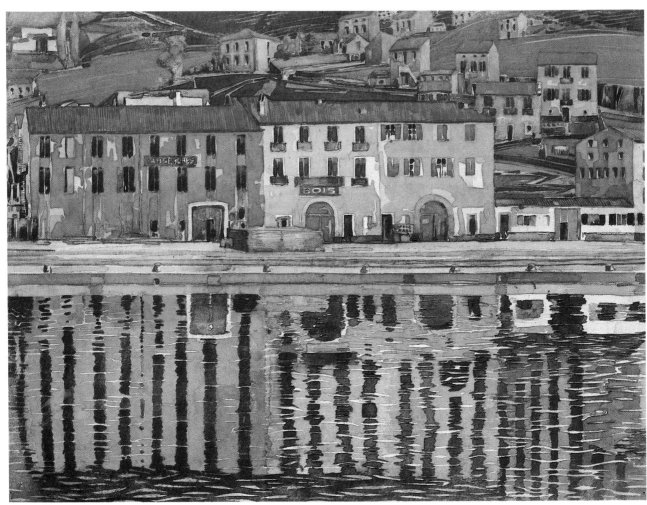

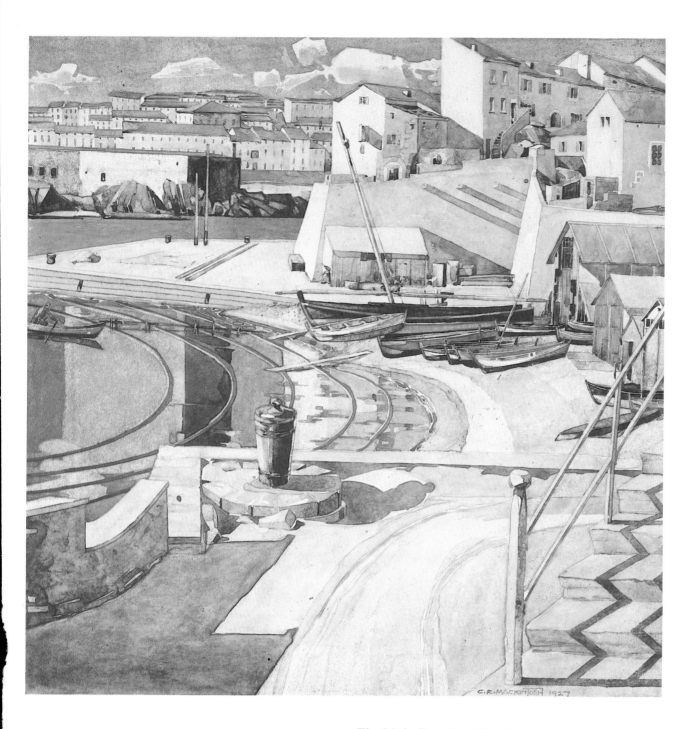

The Little Bay, Port Vendres (1927). 393 × 394.
Collection Glasgow University. Catalogue 214.

Port Vendres (c1926–27). 276 × 378. Collection:
Mr and Mrs H. Jefferson Barnes. Catalogue 209.

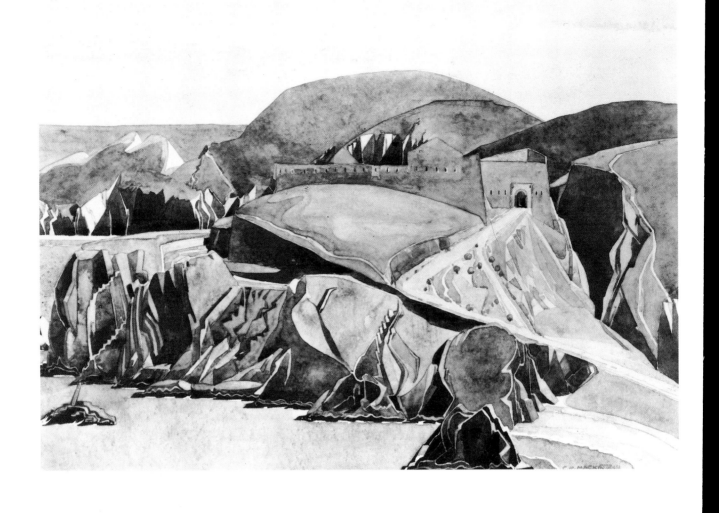

The Road through the Rocks (c1924–26). 495 × 430.
Collection: Professor T. Howarth. Catalogue 182.

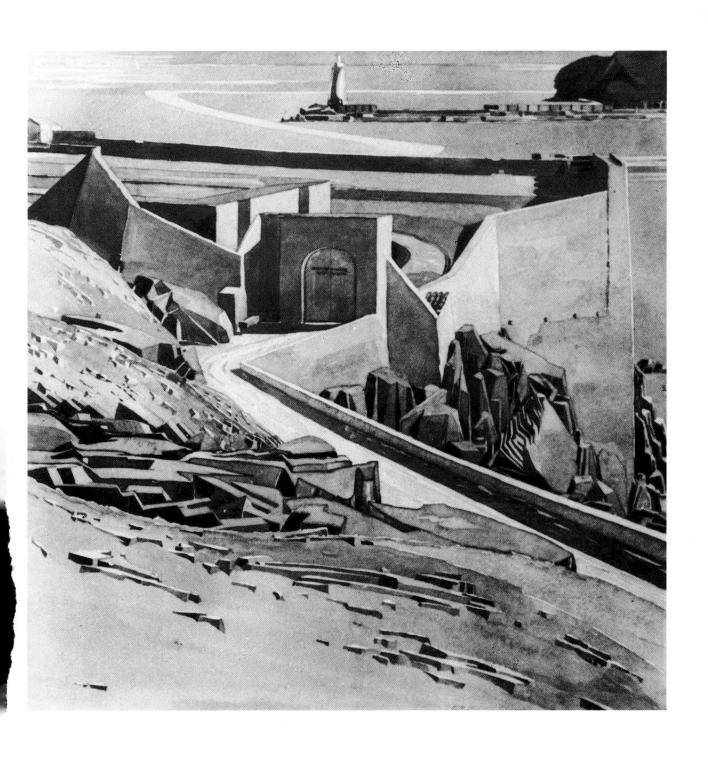

Le Fort Mauresque (*c*1924–26). Untraced.
Photograph from Memorial Exhibition.
Catalogue 183.

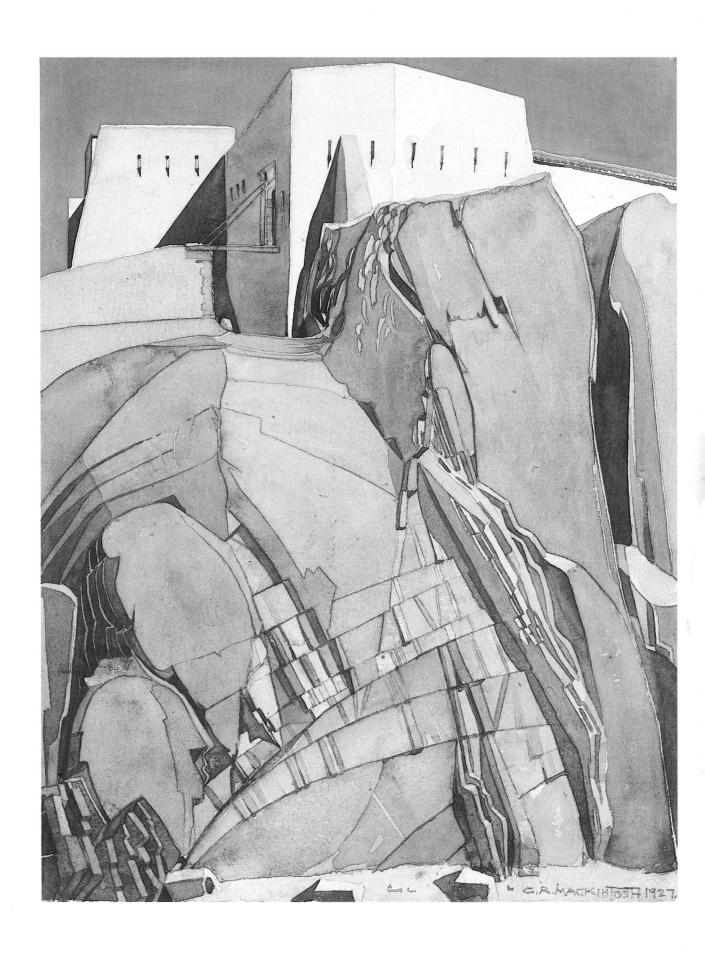

Le Fort Maillert (1927). 358 × 285. Collection:
Glasgow School of Art. Catalogue 215.

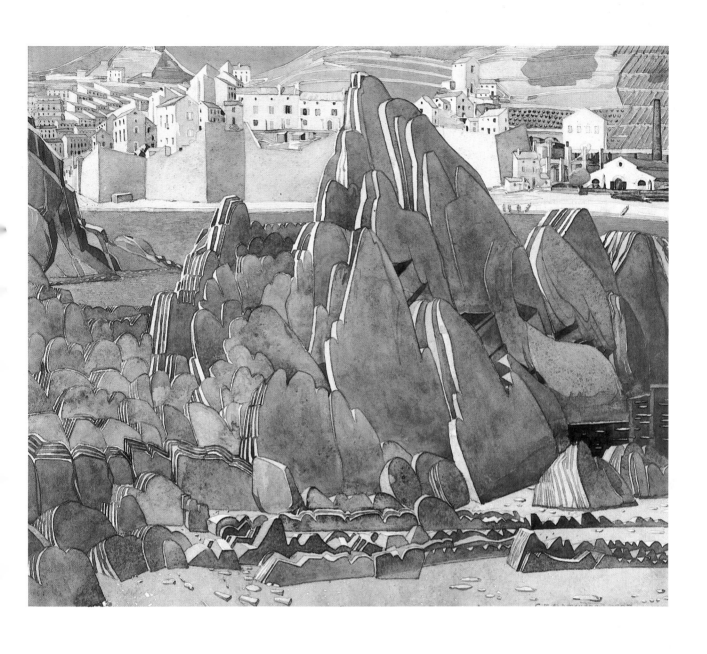

The Rocks (1927). 305 × 368. Collection: Michael Davidson, Esq. Catalogue 216.

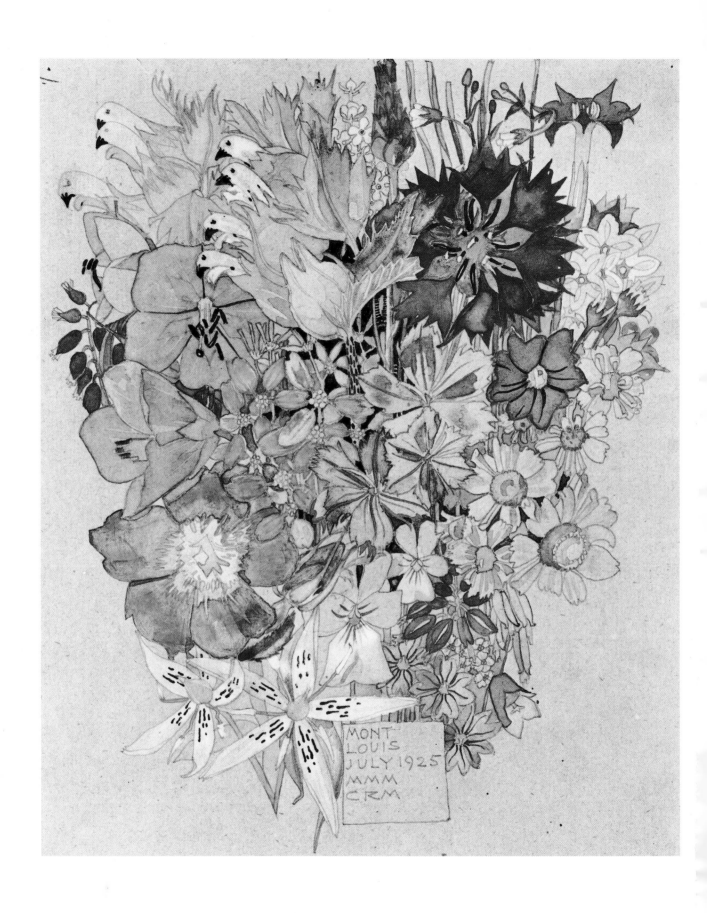

Mixed Flowers, Mont Louis (1925). 262 × 205.
Collection: Mr and Mrs H. Jefferson Barnes.
Catalogue 207.